HOW TO KNOW
AMERICAN ANTIQUE
FURNITURE

HOW TO KNOW AMERICAN ANTIQUE FURNITURE

E. P. DUTTON NEW YORK

ROBERT
BISHOP

Museum Editor and Consulting
Curator of Furniture,
Greenfield Village and
Henry Ford Museum

10 9

Published simultaneously in Canada by
Clarke, Irwin & Company Limited, Toronto and Vancouver.

ISBN 0-525-47337-8

Designed by The Etheredges

*This book is dedicated to Muriel and Charles Bishop,
my mother and father, who suffered in silence for so
many years while their teen-age son stripped, sanded,
and refinished countless pieces of furniture in the
middle of their living room.*

ACKNOWLEDGMENTS

I wish to express my sincere gratitude to the many individuals and institutions who have generously provided pictorial and textual material for this volume. It gives me great pleasure to make special acknowledgments to my editor, Cyril I. Nelson, and to Patricia Coblentz, Copy Editor for the Henry Ford Museum and Special Editor for this project; to Carl Wesenberg for the line drawings included in this book; and to Charles T. Miller, Carl Malotka, and Rudy Ruzicska, staff photographers for the Henry Ford Museum, who are responsible for the great majority of the photographs included. A special thank you is extended to Dr. Donald A. Shelley, President, Mr. Frank Caddy, Vice-President, and Mr. Robert G. Wheeler, Vice-President of the Henry Ford Museum, for allowing me to use the many illustrations of objects in the fabulous collections at Greenfield Village and Henry Ford Museum.

<div align="right">R.B.</div>

PREFACE

While serving as Consulting Curator of the magnificent and wide-ranging collection of American antique furniture formed by the late Henry Ford and exhibited at Greenfield Village and the Henry Ford Museum established by him at Dearborn, Michigan, I have frequently been asked by visitors: "How do you know that a piece of furniture is old?"

As most curators will readily confirm, a good portion of every week is spent on the telephone assisting inexperienced collectors by explaining the characteristics of period furniture.

Unfortunately, a curator is many times faced with the unhappy task of telling novice collectors that grandmother's rocking chair and other family treasures are almost valueless. The monetary worth of personal sentiment is virtually nonexistent, and people are often dismayed to learn that their "marble-topped, handcarved washstand that is almost seventy-five years old" probably first saw the light of day on the shipping dock of Sears, Roebuck & Company.

7

Not everything that is old is valuable. If a piece was poorly made originally, its worth has not increased just because it has aged. To understand the value of a piece of furniture, one must fully analyze it. When was it made? Where was it made? Who made it? How was it made? Is it aesthetically pleasing? Does it have its original finish? What does it mean as a cultural document? If it is to be used in the home, is it sturdy? Has there been any restoration? If there has, how does it affect the overall appearance of the piece and will it alter its market value?

It is my hope that this elementary guide will assist those who are interested in collecting American antique furniture by answering many of the above questions and by giving them a quick, easy reference work that will enable them to recognize the essential characteristics of many types of furniture. In addition to providing illustrations of a large number of individual pieces, as well as line drawings of significant details, I have also included both black-and-white photographs and color plates showing typical American room settings from the seventeenth century to approximately 1870. These should prove an important aid to the collector in assimilating the complete makeup of a room—its furniture and accessories—for the various periods discussed in this book. I hope that my readers will find this guide a worthwhile addition to their library shelves as well as a valuable companion on many collecting trips.

ROBERT BISHOP

CONTENTS

PREFACE 7

THE STORY OF COLLECTING 13

PILGRIM STYLES 15
FURNITURE WITH CARVED DECORATION 18 | FURNITURE WITH
PAINTED DECORATION 20 | TURNED FURNITURE AND FURNITURE
WITH TURNED AND APPLIED DECORATION 23 | CROMWELLIAN FUR-
NITURE 28 | WILLIAM AND MARY FURNITURE 30 | SPACE SAVERS
35

THE QUEEN ANNE STYLE 38
MASSACHUSETTS FURNITURE 40 | CONNECTICUT FURNITURE 42
RHODE ISLAND FURNITURE 45 | NEW YORK FURNITURE 46
PHILADELPHIA FURNITURE 48 | SOUTHERN FURNITURE 52 | JA-
PANNED FURNITURE 54 | UPHOLSTERED FURNITURE 58

THE CHIPPENDALE STYLE 62
MASSACHUSETTS FURNITURE 68 | BLOCK-FRONT FURNITURE 70

RHODE ISLAND FURNITURE 73 | CONNECTICUT FURNITURE 75
NEW YORK FURNITURE 77 | PHILADELPHIA FURNITURE 80
SOUTHERN FURNITURE 83 | UPHOLSTERED FURNITURE 85
COUNTRY FURNITURE 87 | PENNSYLVANIA GERMAN FURNI-
TURE 92

THE WINDSOR STYLE 95

THE FEDERAL STYLE 103
NEW ENGLAND FURNITURE 104 | NEW YORK FURNITURE 107
PHILADELPHIA FURNITURE 109 | FURNITURE FROM BALTIMORE
AND THE SOUTH 111 | UPHOLSTERED FURNITURE 117 | THE
CHINESE INFLUENCE 120

THE EMPIRE STYLE 123
PILLAR-AND-SCROLL FURNITURE 129

THE EARLY VICTORIAN STYLES 134
GOTHIC REVIVAL FURNITURE 134 | ROCOCO REVIVAL FURNITURE
140 | EGYPTIAN REVIVAL FURNITURE 145 | RENAISSANCE REVIVAL
FURNITURE 148 | ELIZABETHAN REVIVAL FURNITURE 151
LOUIS XVI REVIVAL FURNITURE 153 | METAL FURNITURE 155
EASTLAKE FURNITURE 159 | JAPANESE REVIVAL FURNITURE 162
RUSTIC FURNITURE 166 | TURKISH FRAME FURNITURE 168
BENTWOOD FURNITURE 171

THE NINETEENTH-CENTURY COUNTRY STYLES 174
PAINTED AND DECORATED FURNITURE 174 | REGIONAL COUNTRY
FURNITURE 177 | SOUTHERN COUNTRY FURNITURE 178 | SHAKER
FURNITURE 181 | NINETEENTH-CENTURY WINDSOR FURNITURE
183

THE LATE VICTORIAN STYLES 188
COLONIAL REVIVAL FURNITURE 188 | ART NOUVEAU FURNITURE
193 | CRAFT FURNITURE 197 | SORRENTO FURNITURE 202 | FUR-
NITURE OF HAIR, HIDE, AND HORN 203 | MISSION FURNITURE 207

BIBLIOGRAPHY 215
INDEX 219

COLOR ILLUSTRATIONS

(following page 96)

Plympton House from seventeenth-century Massachusetts (Greenfield Village and Henry Ford Museum)

Bedroom with William and Mary and Queen Anne furniture from New England (Winterthur Museum)

Dining room of about 1750 with Queen Anne furniture from New York (Winterthur Museum)

Parlor from a New Hampshire house with New England country Chippendale furniture (Greenfield Village and Henry Ford Museum)

The Chinese Parlor with Chippendale furniture from Philadelphia, Newport, and Charleston (Winterthur Museum)

Room from a Pennsylvania German farmhouse built near Kutztown, Berks County, in 1783 (Winterthur Museum)

Dining room with Federal furniture of the late eighteenth century (Greenfield Village and Henry Ford Museum)

Dining room with New York Federal furniture made about 1810 by Duncan Phyfe (The Metropolitan Museum of Art)

Parlor with New York furniture in the Late Classical style made in 1837 by Duncan Phyfe (The Metropolitan Museum of Art)

Bedroom with painted and decorated country furniture of 1815–1840 (Privately owned)

Victorian parlor in the Rococo Revival style of 1850–1860 (The Metropolitan Museum of Art)

Sitting room in the Renaissance Revival style of the 1870's (The Metropolitan Museum of Art)

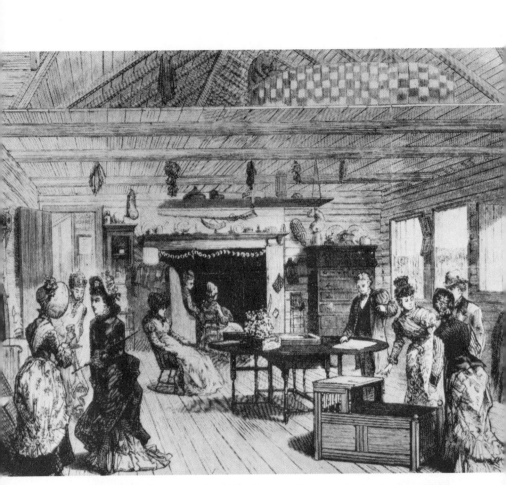

1. Newspaper illustration. The New England Kitchen at the 1876 Philadelphia Centennial Exhibition was furnished with antique furniture from various periods and was pictured in Frank Leslie's *Illustrated Weekly Newspaper*. June 10, 1876. (Privately owned)

THE STORY OF
COLLECTING

People have always cherished and preserved the possessions that belonged to their ancestors. American diaries and inventories of the seventeenth and eighteenth centuries describe with fondness such things as "Grandfather's great oak chair." It was not, however, until the middle of the nineteenth century that scholars and historians began the serious study of American antiques. The noted author and art critic William Dunlap, in his 1834 edition of *A History of the Rise and Progress of the Arts of Design in the United States,* discussed American paintings and, occasionally, the furniture on which the subjects sat for their portraits.

By 1876 this interest in the "things that reflect our nation's past" was great enough for the organizers of the Centennial International Exhibition at Philadelphia to include nostalgic "Colonial"

displays in this event, which commemorated the one hundredth anniversary of the Declaration of Independence.

One exhibit, "A New England Kitchen of 1776," was constructed with a beamed ceiling, leaded casement windows, and a great fireplace. The kitchen was furnished with pieces dating from the seventeenth, eighteenth, and nineteenth centuries.

This immensely popular presentation had far-reaching consequences. The ensuing craze for collecting and decorating in the "Colonial" or "Early American" style caused manufacturers, quick to sense the possibility of big profits, to turn their workmen from the production of French-inspired Victorian pieces to the crafting of modern "antiques" or reproductions.

This national fervor for things antique inspired many to seek authentic examples of antique American furniture. At first only the very earliest pieces were seriously collected. The massive simple forms of the Pilgrim century and the later Queen Anne and Chippendale styles were most sought.

As with everything taste changed, and during the 1920's and 1930's collectors expressed admiration for the more delicate Sheraton and Hepplewhite styles of the late 1700's and early 1800's.

Until the 1960's the machine-made Late Classical and Victorian furniture produced in the last two-thirds of the nineteenth century was not considered worthy of being collected. Again, changing taste and the relatively high cost and scarcity of earlier styles have altered this attitude somewhat. Major museums have conducted extensive investigations of nineteenth-century America and presented exhibitions relating to this period.

For the collector of seventeenth- and eighteenth-century handcrafted pieces, it is difficult to appreciate the current interest in machine-made Victorian pieces. No doubt in another hundred years the plastic blow-up chairs and sofas used by today's avant-garde will be eagerly sought by collectors and museums.

PILGRIM STYLES

Medieval European traditions dominated the taste of New England's inhabitants during the seventeenth century. The settlers of the New World were not attempting to deny their past, but were seeking to establish freedoms unobtainable in their homelands.

Few colonists understood how elementary their lives in America would be—food, shelter, and personal safety were the primary concerns. Survival was difficult for those who had lacked the foresight to prepare to face nature. Many of the earliest settlers in the Massachusetts Bay Colony were forced to "burrow themselves in the Earth for their first shelter under some Hill-side." Their plight was not unique. The Spanish in the South and Southwest had attempted in the 1530's and 1540's to establish permanent

settlements and failed. The 1607 Jamestown, Virginia, project never grew beyond infancy.

In the first few years of each new settlement the pattern repeated itself. Men were unconcerned with furniture or furniture-making until permanent homes had been constructed to replace their temporary shelters, crops had been planted and gathered, and peace had been negotiated with the surrounding Indians.

In New England, a society that measured a man's wealth and social position by the quantity and quality of the furniture, pewter, and silver he possessed, furnishings remained scarce. Writing from Massachusetts in 1634, fourteen years after the founding of the Massachusetts Bay Colony, William Wood expressed a need for "an ingenious Carpenter, a cunning Joyner, a handie Cooper, such a one as can make strong ware for the use of the countrie."

The transition from infant settlement to well-ordered, fully organized town did not always require a great lapse of time, for Edward Johnson, a professional "joiner" (cabinetmaker), in 1642 observed, "The Lord hath been pleased to turn all the wigwams, huts, and hovels the English dwelt in at their first coming, into orderly, fair, and well built houses, well furnished many of them. . . ."

Throughout the entire seventeenth century many colonists ordered furniture from Europe. Mr. Fitzhugh of The Virginia Company wrote to London in 1681 requesting a "feather bed & furniture, curtains & vallens. The furniture, Curtains & Vallens, I would have new, but the bed at second hand, because I am informed new ones are full of dust."

American furniture of the early seventeenth century is called Jacobean, after the Latin word "*Jacobus*," for James I (1566–1625), the English king who reigned during the settling of Jamestown and Plymouth.

Native oak was the wood most used for the construction of the earliest pieces—which were often carved and sometimes decorated with paint and with applied spindles and bosses.

If modest in pretension, American Pilgrim furniture was by

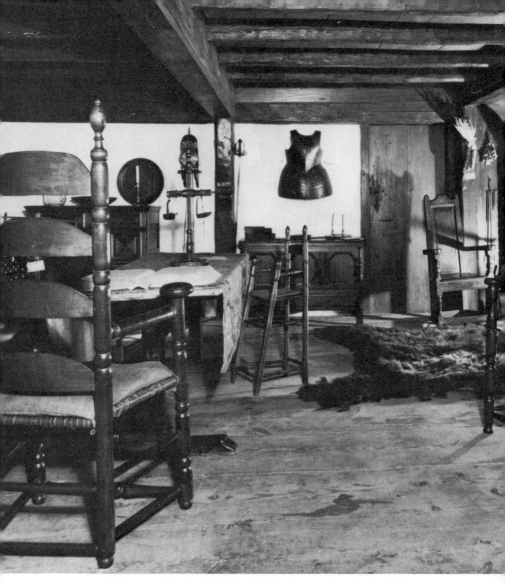

2. Museum installation. This Puritan Keeping Room is constructed with beams and floor boards from a house at Wrentham, Massachusetts, and is furnished with seventeenth-century American pieces, including, in the left foreground, a four-slat-back chair with mushroom terminals on the front posts, a trestle table, a paneled, one-drawer blanket chest with applied spindles at the center rear, and a paneled wainscot chair to the left of the fireplace. (The American Museum, Bath, England)

no means crude. Throughout the entire seventeenth century, its forms closely mirrored fashions in England.

FURNITURE WITH CARVED DECORATION

Pilgrim furniture was constructed and decorated in four ways: joining ("whereby several Pieces of Wood are so fitted . . . they shall seem one intire Piece"), turning, carving, and painting. All four processes were often used in the construction of a single piece.

Decoration carved in a flat, stylized manner was used extensively on the earliest American furniture. Boxes, chests, and chests-of-drawers frequently were embellished with Elizabethan motifs reminiscent of ornamentation found on Italian Renaissance pieces.

Sturdy oak boxes, like that of figure 3, were built to hold the Pilgrims' most prized possession—the Bible. Some carvers preferred geometric motifs, while others chose repeated designs of stylized leafage. It is usual to find dovetailing and handmade nails in these boxes, which were generally constructed of oak with pine tops hinged with cotter pins or staple hinges.

The progression from a box to a chest was a natural one, since early settlers needed a chest to hold their "earthly possessions." The pine example, figure 4, is of six-board construction, where a single board forms the top, the bottom, and each of the four sides. The front of this Pilgrim-style chest is decorated with incised carving and is held in place by nails. The bootjack legs are continuations of the sides.

Next came the lift-top chest containing a storage well and one, two, or three drawers. As with other forms, the earlier examples are made of oak, and often have pine tops. The most elaborate of these are of the stile-and-rail construction, in which decorative panels are framed with uprights (stiles) and horizontals (rails) that are mortised and turned and secured with wooden pegs. The oak panels in figure 5 are carved with tulip and sunflower motifs on a punched ground. Turned maple spindles and

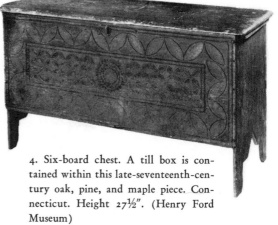

3. Bible box. Oak cleats attached to the pine top serve as hinges. New England. 1680–1700. Width 26¼″. (Henry Ford Museum)

4. Six-board chest. A till box is contained within this late-seventeenth-century oak, pine, and maple piece. Connecticut. Height 27½″. (Henry Ford Museum)

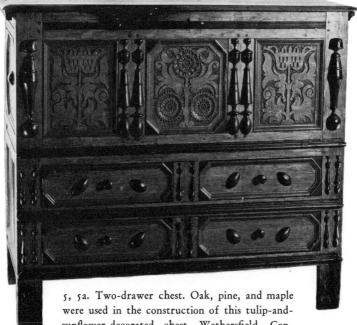

5, 5a. Two-drawer chest. Oak, pine, and maple were used in the construction of this tulip-and-sunflower-decorated chest. Wethersfield, Connecticut. *Circa* 1680. Height 41¼″. (Henry Ford Museum)

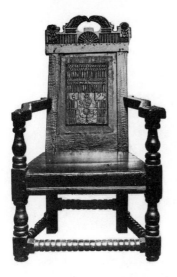

6. Wainscot chair. Robert Rhea, a Scottish carpenter, probably constructed and carved this oak chair for his wife, Janet. Freehold, New Jersey. 1695. Height 42½". (Monmouth County Historical Association)

bosses and applied moldings enliven an otherwise plain front surface. Red paint applied to the background of the panels and the moldings and black-painted spindles enhance the overall effect of this distinctive seventeenth-century piece from the Connecticut River Valley. The drawers, as on most early furniture, are of the side-runner construction; that is, they slide on suspended runners attached to the sides and not on the bottom of the drawer frame as modern drawers do.

The back of the New Jersey Jacobean wainscot chair, figure 6, is richly carved and includes the date "1695" and the initials "R/RI" for Robert and Janet Rhea of Freehold, New Jersey. Wainscot chairs were generally made of oak and derive their name from the Dutch word *"wagonschot,"* a high-grade oak plank, which during the seventeenth century was exported to Continental Europe from America. Large chairs, in their time known as "great chairs," were the privilege of the wealthy. The less affluent satisfied themselves with stools or with much simpler forms.

FURNITURE WITH PAINTED DECORATION

Since the time of the cave dwellers, man has attempted to beautify the place in which he lives by decorating it with paint or paint-

ings. The seventeenth-century American colonists were no exception, for they not only whitewashed their walls, but applied bright paint and decoration to their furniture.

Historians of the earliest colonists have developed the portrait of a drab, deeply religious people suffering through arduous winters. The colonists were religious and the winters were difficult, but our ancestors were certainly not drab in dress or the decoration of their homes. Even the most forbidding personage, William Brewster the Elder, sported a violet-colored coat, green drawers, and a blue suit.

Examples of American furniture of the Pilgrim period that retain their original painted finishes are quite rare. Most of the surviving examples are from Massachusetts, the Connecticut River Valley, and the Hudson River Valley. Research compiled by students of the American decorative arts has recently identified the work of individual decorators or schools of painters from these areas.

Oak and pine were used in the construction of the New England press cupboard inscribed "Hannah Barnard," figure 7. Hannah Barnard was born in Hadley, Massachusetts, on June 8, 1684; she married John Marsh in 1715; and died in 1717. Polychrome and black geometric designs, including hearts and vines, relate the dec-

9. Ornamental design from opening page of The Book of Job in the King James Bible. 1611. The early colonists brought to America copies of the first edition of the King James Bible. The design, incorporating the Red Rose of England, the Fleur-de-lis of France, and the Thistle of Scotland, served as a source of inspiration for Connecticut furniture decorators. (The Henry Francis du Pont Winterthur Museum)

7. Press cupboard. The upper section of this oak-and-pine piece is constructed with two doors that, when opened, reveal a single shelf. Connecticut River Valley. *Circa* 1684. Height 61⅛". (Henry Ford Museum)

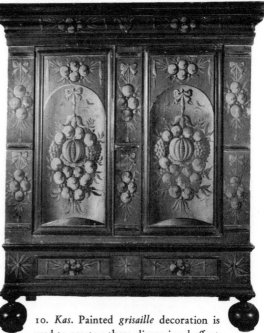

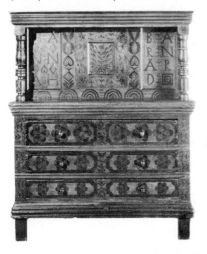

10. *Kas.* Painted *grisaille* decoration is used to create a three-dimensional effect on the front of many "Dutch American" wardrobes. Tulip. Hudson River Valley. 1700–1735. Height 69⅞". (Winterthur Museum)

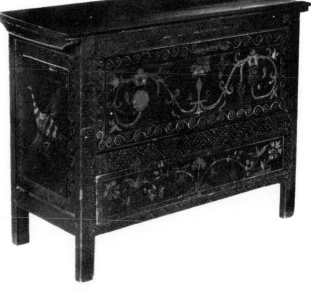

8. Decorated chest. The oak, tulipwood, and chestnut chest-with-drawer is attributed to Charles Gillam. Old Saybrook, Connecticut. *Circa* 1715. Height 34¼". (Henry Ford Museum)

oration on this late-seventeenth-century cupboard to two similar pieces of Connecticut River Valley furniture in the collections of The Henry Francis du Pont Winterthur Museum, Winterthur, Delaware, and the Pocumtuck Valley Memorial Association, Deerfield, Massachusetts.

At the mouth of the Connecticut River, in the Guilford–Old Saybrook area, a large group of painted furniture was fashioned between 1700 and 1725. Chests, chests-of-drawers, cupboards, and even tallboys, or highboys, all painted and decorated with fantastic birds and an emblematic design of the Crowned Tudor Rose and Thistle of Scotland, attest to the work of several decorators instead of a single artist. The seventeenth-century cabinetmaker, carver, and painter Charles Gillam (died 1727) has often been credited with the creation of these pieces; however, it seems certain that no single artisan could leave behind the large number of pieces that have survived.

Very dark green paint is the background color for figure 8, a chest with a single drawer. Other background colors found on furniture from this area are red and black.

The Dutch in New Amsterdam and of the Hudson River Valley, like their northern neighbors, constructed furniture in the same forms that they had known in their homeland. One of the most prized pieces of furniture in this area was the *kas* or wardrobe, figure 10. American versions were frequently painted with a gray-and-white decoration known as *grisaille*. *Trompe l'oeil* designs of pendant fruit approximate the heavily carved continental Dutch examples of a slightly earlier period.

TURNED FURNITURE AND FURNITURE WITH TURNED AND APPLIED DECORATION

Turned furniture was fashioned on a "great wheel" or lathe, figure 11, which was cranked by an apprentice or "turn-wheel"

(a hired man). A rope or belt strung between the crank and the headstock spun the stock at approximately 750 revolutions per minute. The wood, held between lathe centers, was shaped by cutting with a chisel.

Because the numerous turned members in chairs of this period could be crafted easily on a great wheel, many of the earliest seventeenth-century American examples are of this general type.

The Brewster chair, figure 12, is named after a similar example now at Pilgrim Hall, Plymouth, Massachusetts, that once belonged

11. Museum installation. "Great wheel" and lathe in the H. Card Turner and Carver Shop, The Street of Shops. (Henry Ford Museum)

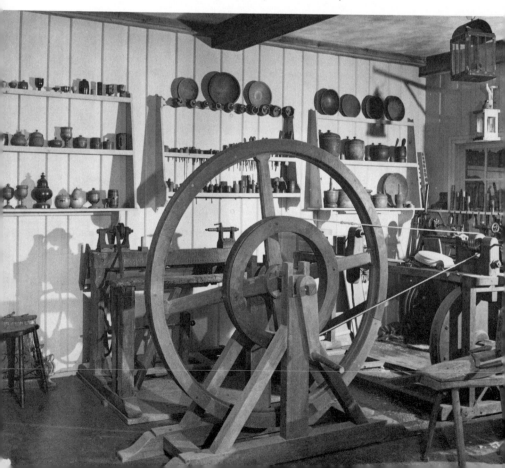

12. Brewster armchair. The two out-side spindles in the lower tier under the seat of this oak chair are missing. These probably were kicked out to pro-vide an easy resting place for weary feet. New England. 1640–1660. Height 46¼". (Henry Ford Museum)

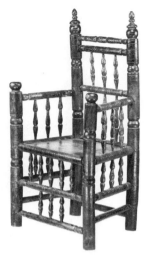

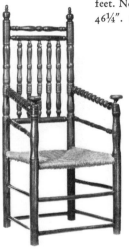

13. Carver armchair. This robustly turned maple and hickory piece has sloping arms, and the front posts are capped by mushroom finials. New Eng-land. 1640–1660. Height 53½". (Henry Ford Museum)

14. Corner chair. Though seating pieces similar to this oak example were popu-lar in England, few documented Amer-ican examples are known. American(?). *Circa* 1690. Height 31½". (Henry Ford Museum)

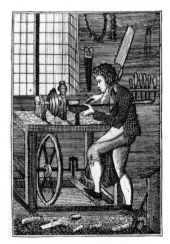

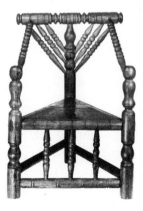

15. *The Turner.* An illustration from the *Book of Trades or Library of Use-ful Arts* published by Jacob Johnson and sold in Richmond, Virginia, and Philadelphia, Pennsylvania, in 1807. (The Library of Congress)

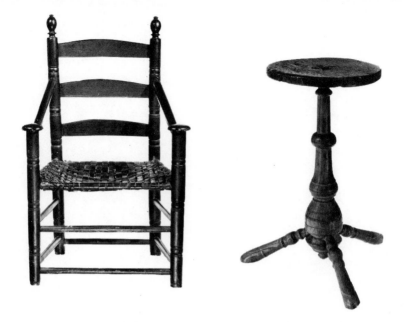

to the Elder William Brewster (1567–1644). Brewster chairs are different from Carver chairs, named after Governor John Carver (died 1621), in that they are constructed with spindles below the arms and seat rails as well as in the back. Carver chairs have spindles only in the back, figure 13.

The turned corner chair with a triangular seat, figure 14, is an unusual variant, though by no means unique.

Chairs were not the only furniture forms to be fashioned on the great wheel. Various parts of larger pieces of furniture came from the woodturner's shop as well. In addition, spinning wheels and flax wheels were often produced for the community.

The front posts capped with mushroom finials, the back posts, the arm supports, and the stretchers on the slat-back armchair, figure 16, would have been produced in a turner's shop. This chair is fitted with a splint seat woven from willow saplings split lengthwise.

Ash and oak were used by the turner and his assistant in creating the legs and central pedestal on the candlestand, figure 17.

The bulbous turned balusters, the split turned spindles, and the turned drop pendants on the press cupboard, figure 18, cer-

16. Far left: Pilgrim slat-back armchair. The posts are turned from maple; the spindles and slats are hickory and ash. New England. *Circa* 1690. Height 41¾".
(Henry Ford Museum)

17. Left: Pilgrim candlestand. This piece is constructed of oak throughout. Connecticut. 1660–1680. Height 24¼". (Henry Ford Museum)

18. Below: Pilgrim press cupboard. Oak was used for the case of this piece; pine for drawer bottoms, sides, and backs; and maple for the split and applied spindles and bulbous turned posts. Massachusetts. *Circa* 1680. Height 61". (Henry Ford Museum)

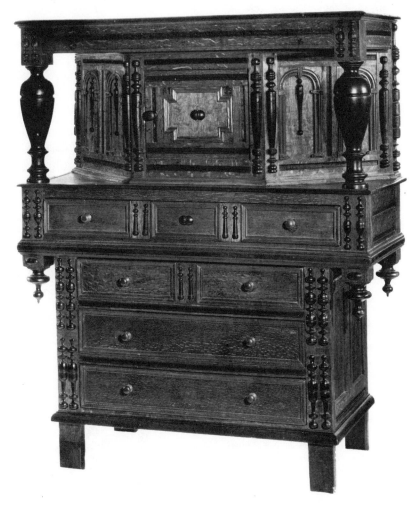

tainly were created with the aid of a great wheel. Turned drop finials are used where the upper section of this distinctive piece overhangs the base. A similar architectural feature is found on New England houses of the period, such as the Parson Capen House, Topsfield, Massachusetts.

During the seventeenth century most cabinetmakers had their own lathes. Toward the end of the century, however, it was not uncommon to "send out" to professional turners for such things as legs and stretchers.

CROMWELLIAN FURNITURE

The designs that inspired American Cromwellian furniture originated in England during the middle years of the seventeenth century. With the failure of Oliver Cromwell's Commonwealth and the restoration of the Stuart monarchy in 1660, Charles II returned to England from exile in France. It was during his reign that the Cromwellian style, based upon bobbin, ball, and ring turnings found favor in the colonies. The immensely popular spiral rope or "twisted" turnings of the English Cromwellian

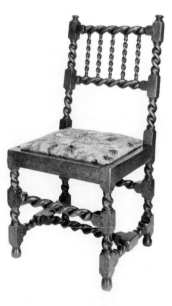

19. Right: Cromwellian rope-turned side chair. Walnut and white oak were used for the construction of this turned piece. Crosswick's Creek, New Jersey. 1699. Height 39¼". (Winterthur Museum)

20. Center: Cromwellian up-and-down stretcher-base table. Very often parts of early American furniture were painted black to simulate exotic woods, such as ebony. This piece is constructed from maple, oak, and pine. Massachusetts. 1680–1700. Width 36½". (Henry Ford Museum)

21. Far right: Cromwellian side chair. Only the front legs and stretchers on this maple and oak chair are turned. New England. 1680–1690. Height 33¼". (Henry Ford Museum)

period were not extensively used by American joiners. When these turnings are found on American furniture, it is generally assumed that the pieces are from New York, New Jersey, or the South.

The side chair with rope-turned stretchers and back, figure 19, by tradition was owned by the Pearson family of New Jersey.

Oak, the wood most often used in the construction of early Pilgrim furniture, was replaced in this period by the more easily worked woods—walnut, maple, and pine.

The breadboard top (consisting of a board or boards with a wooden cleat nailed on each end) on the ball-turned up-and-down stretcher table, figure 20, was constructed from soft pine. The stretchers are painted black to simulate ebony.

The side chair with block-and-ball turned front stretchers, figure 21, is stained dark brown. The leather upholstery on the rectangular back and seat is held in place by nails and was probably a concession to comfort.

The lid on the desk-box-on-frame, figure 22, is also pine. It was customary to finish furniture by painting or staining it since several different woods were frequently used in the construction of a single piece.

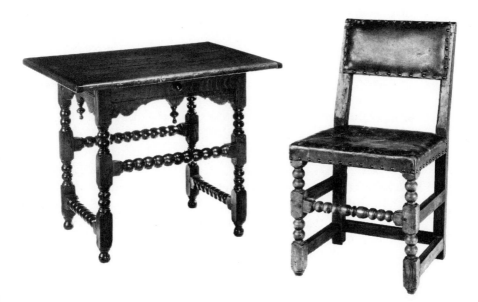

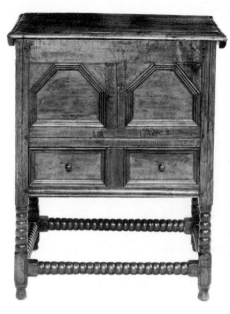

22. Left: Cromwellian desk-box-on-frame. A single, long drawer is made to look like two smaller drawers through the use of applied moldings on this maple, oak, and pine special-purpose piece. Massachusetts. *Circa* 1700. Height 34″. (Henry Ford Museum)

23. Right: William and Mary banister-back armchair. The banisters, or splats, in the back of this maple chair were created from two pieces of wood that were glued together, turned on a great wheel, and then split in half. New England. 1700–1720. Height 48″. (Henry Ford Museum)

WILLIAM AND MARY FURNITURE

When Catherine of Braganza wed Charles II on May 21, 1662, she brought with her the richest dowry Europe had ever known. Included in her large retinue were numerous craftsmen, including furniture-makers who introduced the C-scroll and S-scroll motifs that became popular in the William and Mary period.

The floral design in the pierced crest or top rail of the banister-back armchair, figure 23, is flanked by carved stylized C-scrolls. Ram's-head terminals on the arms and sausage-turned front and side stretchers further embellish this distinctive piece.

Following King James II's exile to France in 1689, the Dutchman, William of Orange, crossed the Channel and, with his English wife, Mary Stuart, accepted the throne of England. Under the leadership of these aggressive rulers, England developed from a secondary power into an important shipping and trading empire rivaling the older, more established mercantile countries.

In the Colonies the well-to-do sought a style of living closely approximating that found in England. Thus evolved new and more elegant furniture forms.

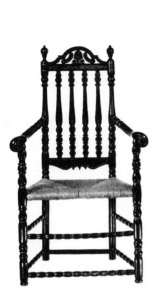

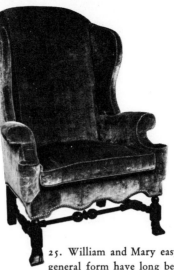

25. William and Mary easy chair. Chairs of this general form have long been associated with the craftsman John Gaines. Maple. Possibly Ipswich, Massachusetts. 1710–1730. Height 48¼". (Bayou Bend Collection, Museum of Fine Arts, Houston)

The caned daybed, or couch, with richly carved crest rails and stretchers, figure 24, and the easy chair, probably made by John Gaines (died 1743) of New Hampshire, figure 25, were obvi-

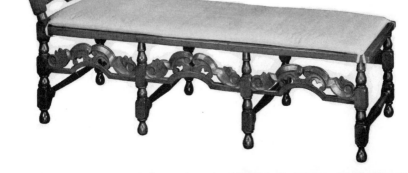

24. William and Mary daybed. American furniture made of beech in this period has long been a subject of controversy among scholars, the consensus saying that pieces made of beech are of English origin. Recent investigation, however, has advanced arguments to refute this claim, now saying there is good reason to believe such pieces were actually made in America. Beech with cane seat and back. New England. Late seventeenth century. Length 59½". (The Metropolitan Museum of Art)

ous concessions to comfort. The legs of the easy chair terminate in carved "Spanish feet," a form especially popular during this period. The medial stretcher under the seat is ring-and-vase turned. Such turnings continued to be used on furniture throughout the eighteenth century.

Walnut was the wood most favored by America's furniture-makers in this period. The caned side chair, figure 26, is painted black to simulate ebony.

Veneer and inlay first appeared on American furniture at the close of the seventeenth century. Using techniques introduced into England by the Dutch and the Flemish, American craftsmen created many beautiful pieces of furniture in the William and Mary style. Following the English preference for walnut, they selected burl and oftentimes veneered it in a herringbone pattern.

The slant-top desk with molded base and large ball feet, figure 27, was crafted in such a manner. The burl panel on the slant-top was further embellished with an inlaid eight-pointed star, sometimes called a mariner's star. Brass escutcheons with teardrop pulls are frequently found on the drawers of case furniture of this period.

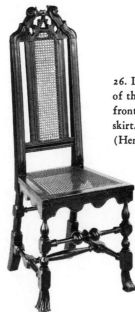

26. Left: William and Mary side chair. The seat of this walnut and maple chair is finished on the front and two sides with a molded, scalloped skirt. New England. 1720–1730. Height 47⅛". (Henry Ford Museum)

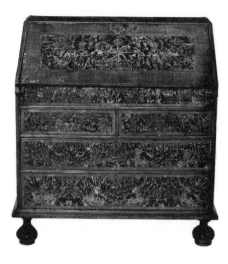

27. William and Mary slant-top desk. This maple and pine case piece was veneered with walnut and walnut burl and rests on "turnip" feet. Massachusetts. *Circa* 1700. Width 35⅝". (Henry Ford Museum)

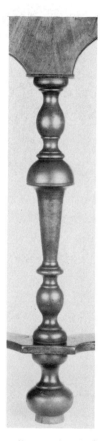

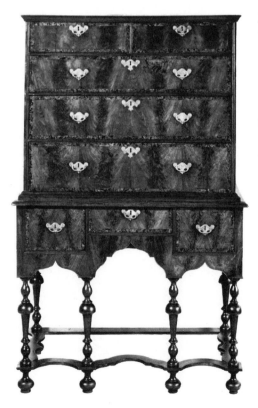

28, 28a. William and Mary high chest-of-drawers. The sides of this piece are constructed from maple and the front is veneered with walnut and walnut burl. New England. 1700–1720. Height 61⅞". (Henry Ford Museum)

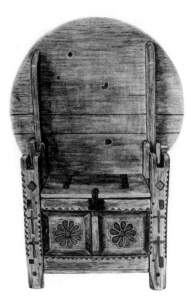

29. Left: Chair-table. When the Spanish brought the native American Indians under their control, they taught them the virtues of Christianity and encouraged them to make simple pine furniture and decorate it with the symbol of Christianity —the cross. Southwestern United States. Eighteenth or early nineteenth century. Height 25″. (Index of American Design)

30. Below: Trestle table. Since maple is a durable wood, the craftsman who constructed this table used it for the base. The pine top is made from two boards that run the entire length of the piece. New England. Early eighteenth century. Length 167¾″. (Henry Ford Museum)

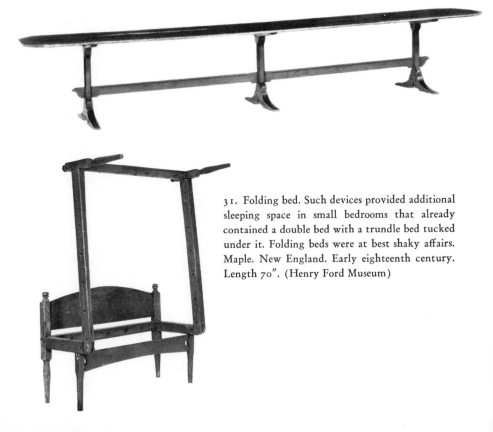

31. Folding bed. Such devices provided additional sleeping space in small bedrooms that already contained a double bed with a trundle bed tucked under it. Folding beds were at best shaky affairs. Maple. New England. Early eighteenth century. Length 70″. (Henry Ford Museum)

Veneering was a difficult and expensive task. Sometimes American furniture-makers would veneer only the face or front as with the high chest of drawers, or highboy, figure 28. This impressive case piece was once owned by Mary Ball Washington (1708–1789), George Washington's mother. Because of this important historical association, it was displayed at the Chicago World's Fair in 1893. Its inclusion in such an exhibition indicates the early interest in antique American furniture.

Figure 28a, a detail of the leg from this highboy, illustrates a "capped trumpet" turning. Trumpet turnings were first introduced into America around 1700. They are found on highboys and on dressing tables or lowboys, which were sometimes constructed en suite.

SPACE SAVERS

The concept of dual-function furniture appears to have first evolved during the close of the Middle Ages in Continental Europe. Space-saving devices were especially popular with early colonists, who, many times, were forced to live, eat, and sleep within a single room.

Carved and painted Spanish-Indian motifs embellish the front of the southwestern chair-table, figure 29. Its New England counterpart, the trestle table on shoe feet, figure 30, is constructed in a manner that enables it to be "put up and taken down" quickly.

Folding beds similar to the pine and maple example, figure 31, provided much-needed space during the daytime. This eighteenth-century example would have been strung with rope in a crisscross pattern to serve as support for a mattress stuffed with cornhusks or milkweed.

Toward the end of the seventeenth century, tuckaways, figure 32, provided additional table space. The base of this example

is constructed from maple; the top is made from a single piece of pine.

As the William and Mary period flourished in America, the gateleg table, figure 33, provided dining facilities for "polite society." These handsome tables are called gatelegs because the supports for the leaves are in the form of a swinging gate. Several examples with Spanish feet are known; however, those with ball feet are encountered more often.

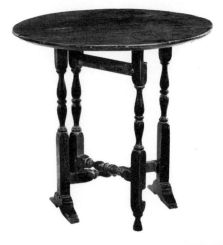

32. Left: Tuckaway table. The pine top on this maple shoe-footed space saver could be tipped upright so that the piece would fit snugly against the wall. Connecticut. Seventeenth century. Height 26¼" open. (Henry Ford Museum)

33. Below: Gate-leg table. Especially large examples of the form were constructed with two swinging gates to support each drop leaf. Mahogany was used for the construction of this piece. New England. 1695–1720. Width 77¾" open. (Henry Ford Museum)

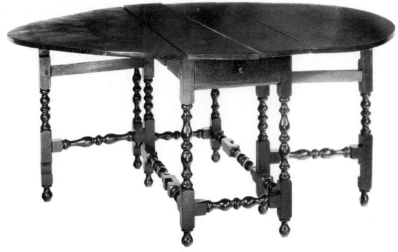

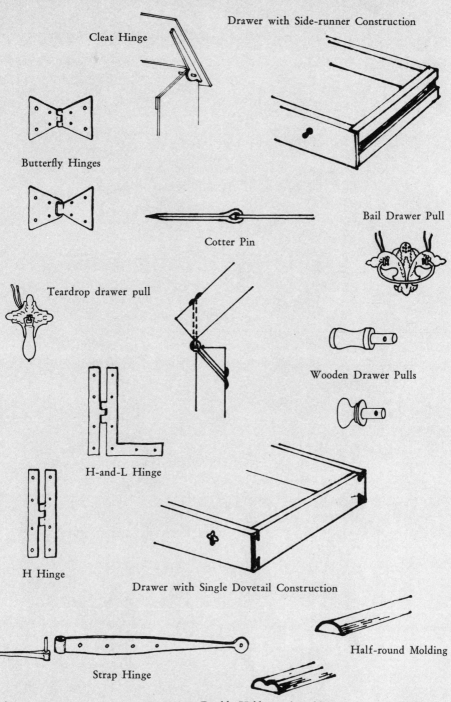

Cleat Hinge

Drawer with Side-runner Construction

Butterfly Hinges

Cotter Pin

Bail Drawer Pull

Teardrop drawer pull

Wooden Drawer Pulls

H-and-L Hinge

H Hinge

Drawer with Single Dovetail Construction

Half-round Molding

Strap Hinge

Double Half-round Molding

THE QUEEN ANNE
STYLE

The American Queen Anne period, 1720–1755, is often referred to by students of the American decorative arts as "The Age of Regionalism." Furniture-makers used distinctive methods of construction that varied greatly from region to region. Therefore, the geographical origin of a piece is usually quite easily determined. The main furniture centers were Boston, Newport, New York, and Philadelphia.

Many new design elements were introduced into the American furniture-maker's craft during this period. Several of them were borrowed from the French Huguenot Daniel Marot (1663–1752). Marot, a religious refugee, sought freedom in Holland. From there, around 1700, he journeyed to England, where he entered the service of William III. Marot's engraved designs included

34. Museum installation. New England furniture of the Queen Anne period was used to furnish the Exeter, New Hampshire, Secretary Pearson House now at Greenfield Village, Dearborn, Michigan. So-called "Indian shutters" slide out of the wall to protect the inhabitants from harsh New England winters. (Henry Ford Museum)

chairs with cabriole legs, curvilinear backs, and central splats, which were oftentimes pierced and carved. Executed by court craftsmen, they inspired the general acceptance of the Queen Anne style. Anne, second daughter of James II, succeeded to the English throne in 1702. In terms of furniture design, her twelve-year reign was significant, for it was during this period that the influences of the "foreign excesses" of the preceding years were domesticated and totally nationalized into a cohesive style.

The Orient contributed several design motifs. The outline of the vaselike solid splats in the backs of Queen Anne chairs can be compared with the profile of Oriental porcelains imported into the English market by the East India Company. The claw-and-ball foot, used on some Queen Anne chairs and so typical of the succeeding Chippendale style, is thought to have been copied from Chinese ivory carvings of a dragon's claw clutching a pearl. Following English fashion, American craftsmen japanned furniture in imitation of Oriental lacquer work. Such examples of "chinoiserie" became the "rage" among well-to-do Colonials in the Queen Anne period.

In the opening years of the eighteenth century, comfort became a major consideration in American homes. The first rude dwellings were replaced with more secure and permanent houses. Upholstery appeared as an important part of furniture design, and the "easy chaire" was a popular household addition. Contemporary inventories and account books attest to the wide variety of fabrics that were imported especially for use by the upholsterer. The daybed, or couch, first introduced in the William and Mary period, continued in fashion.

MASSACHUSETTS FURNITURE

Cabinetmakers in the cosmopolitan city of Boston were as strongly influenced by English fashions as were those in other Colonial

35. Queen Anne tile-top mixing table. The frame of this diminutive maple table is painted black. Boston. 1720–1730. Height 26⅜″. (Henry Ford Museum)

cities. Inherent New England restraint, however, manifested itself in their furniture designs.

Massachusetts relied heavily upon commerce to support its economy. Therefore, it is not surprising that the population was fascinated by tales of the sea, especially those associated with the mysterious Orient, and the gigantic profits to be realized from trade ventures there.

Particularly popular with New Englanders was Delft, a tin-glazed earthenware made in Holland and England to resemble Chinese porcelain. Twenty blue-and-white Delft tiles, decorated with biblical scenes from the Old and New Testaments, are set into the rectangular top of the mixing table, figure 35. Few mixing tables with tile tops are known; those with slate or marble inserts are less rare. The four very slim cabriole legs terminate in pad feet with small "cushions."

During the last years of the seventeenth century, wealthy Americans, following the English and Dutch precedent, favored richly veneered furniture. Walnut burl was used extensively in Massachusetts and faces the front of the highboy, figure 36. The sides and front, beneath the veneer, and the legs are constructed from maple.

The earliest Queen Anne highboys have flat tops. They con-

trast sharply with later examples, figure 37, which generally have bonnet tops and elaborate finials. The impressive height of the later highboy (almost one-third taller than the earlier piece, figure 36) is accentuated by the twisted flame finials. The cabinetmaker used walnut to veneer both the front and the sides of his maple piece. All of the drawers are banded with a herringbone veneer border. A concave shell design is carved on the center drawers at top and bottom.

CONNECTICUT FURNITURE

The old cliché among collectors that "anything odd and made of cherry is from Connecticut" is certainly inaccurate. However,

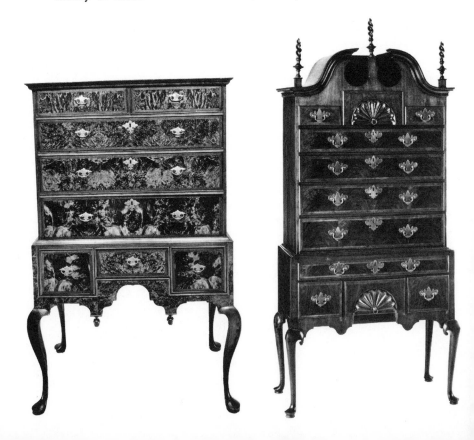

Connecticut craftsmen during the eighteenth century, having a supply of this warm-hued wood close at hand, used it extensively as a substitute for imported mahogany.

The unique cherry secretary-desk-and-bookcase-on-frame, figure 38, bridges the gap between the seventeenth century and the Queen Anne style. The carved leafage with punched ground is reminiscent of carving found on seventeenth-century chests and on numerous doorways throughout the Connecticut River Valley. Pad feet and arched (tombstone) panels are typical of the Queen Anne period.

The dressing table, or lowboy, figure 39, also constructed of cherry wood, was made en suite with a highboy. Both have quatrefoil carvings with a small brass knob on the front of an otherwise plain central drawer. On the other drawers, butterfly

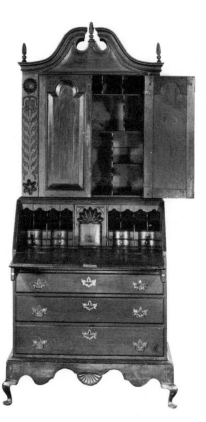

36. Far left: Queen Anne highboy. Maple with burl veneer. The secondary woods used in the construction of the drawers are pine and ash. New England. 1720–1730. Height 60½". (Henry Ford Museum)

37. Left: Queen Anne highboy. The brass "willow" escutcheons for the drawer pulls on this case piece form an interesting contrast with the brass "butterfly" escutcheons on figure 36. Walnut and maple. Massachusetts. *Circa* 1750. Height 91¼". (Henry Ford Museum)

38. Right: Queen Anne secretary-desk-and-bookcase-on-frame. Short, stubby cabriole legs with pad feet are frequently called "bandy" legs. Cherry. Probably Hartford, Connecticut, area. 1725–1750. Height 87¼". (Henry Ford Museum)

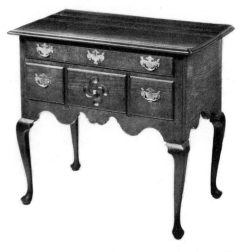

39. Above: Queen Anne lowboy or dressing table. Swastika carvings, much like that on the lower center drawer, are common in Connecticut; however, they occasionally appear on Philadelphia furniture also. Cherry. Connecticut. 1740–1750. Width 35″. (Henry Ford Museum)

40. Left: Queen Anne side chair. The vase shape of the splat is similar in form to Oriental porcelain imported during the early eighteenth century. Attributed to a member of the Southmayd family, Middletown, Connecticut. Maple. *Circa* 1756. Height 42⅞″. (Henry Ford Museum)

escutcheons with bail handles are typical of the period. The swelling cabriole legs interlock in design with the richly valanced skirt and sides and terminate in cushioned-pad feet.

The "spoon-back" side chair, figure 40, was probably crafted by a member of the Southmayd family of Middletown, Connecticut. Inscribed on the seat frame is "No. 3 June 17th 1756 Elizabeth Lothrop." Miss Lothrop lived in nearby Norwich, Connecticut. The seat is upholstered in an embroidered fabric worked in a diamond pattern of green, rose, and yellow. The front legs are cabriole and terminate in pad feet. Square and canted rear legs are united by a rectangular stretcher. As with many New Eng-

land chairs, the front and back legs are tied by block-and-turned stretchers, which are themselves united by a medial vase-and-ring-turned stretcher.

Modern collectors vie for such exquisitely proportioned "country pieces." Beautiful and strong, they resist warping and, to the delight of today's housewife, take a fine polish.

RHODE ISLAND FURNITURE

The cabinetmaking activities of the Quaker Townsend-Goddard dynasty began during the Queen Anne period at Newport, Rhode Island, with the work of Job Townsend (1699–1765) and John Goddard (1723–1785). However, much of their greatest furniture, distinguished by blocked fronts and shell carving, was crafted in the Chippendale style.

Newport's strategic geographical location and deep natural harbor provided the local furniture-makers with a worldwide market for the products that they fashioned from native walnut and imported mahogany.

The slipper chair, figure 41, was probably made for Chris-

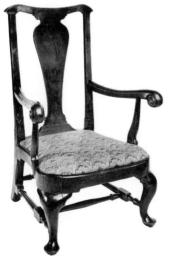

41. Queen Anne slipper chair. Carved blocks at the knees of most Queen Anne chairs are nailed into place. Walnut. Probably Newport, Rhode Island. 1740–1750. Height 35½". (Joseph K. Ott)

topher Champlin (1707–1766) of Charleston, Rhode Island. Usu-
ally constructed without arms, slipper chairs have especially low
seats, thus making it easy for a person to put on his shoes. Like
most Rhode Island chairs, this walnut example has turned stretch-
ers under the upholstered slip-seat. The front rail or skirt, the two
side rails, and the back rail all mortise into the legs.

John Goddard, son-in-law of Job Townsend, is believed to
have made the walnut side chair, figure 42. The shaped splat is
centered by a carved shell at the top rail. The slip seat is balloon
shaped. Cabriole front legs terminate in pad feet, and the rear legs
are round above the stretcher and square below.

Job Townsend probably made the mahogany dressing table,
or lowboy, figure 43, in his Easton's Point, Newport, shop. The
skirt is decorated with a carved concave shell in the center and the
graceful cabriole legs terminate in slipper feet. Large willow brasses
are used on the drawers of this distinctive piece.

Chestnut grew locally in abundance. Because of its great
strength, it was used as a secondary wood on most Rhode Island
furniture.

The closed-bonnet top of the mahogany highboy, figure 44,
is centered by a carved, stylized urn-and-flame finial. This device
and, of course, the concave carved shell in the skirt are almost
always associated with the Townsend-Goddard school. Unlike
this example, many Rhode Island case pieces have claw-and-ball
feet in the front and pad feet in the rear.

NEW YORK FURNITURE

The Dutch Colonial period of New York ended when the
English, under the leadership of the Duke of York, deposed the
fabulous peg-legged Peter Stuyvesant and the Dutch West India
Company in 1664.

Despite the polyglot nature of the population, Dutch tradi-
tions continued to dominate the daily life of the colony. The

42. Queen Anne side chair. The original linen underlining remains intact on the slip-seat of this chair. Walnut. Newport. 1740–1760. Height 40⅞". (Henry Ford Museum)

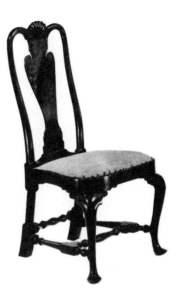

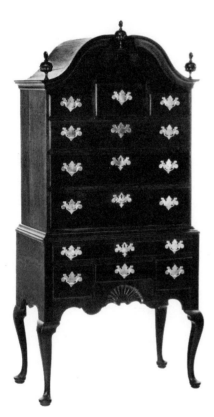

44. Queen Anne highboy. Chestnut was used for the inside of the drawers of this case piece. Mahogany. Newport. 1750–1760. Height 83". (Henry Ford Museum)

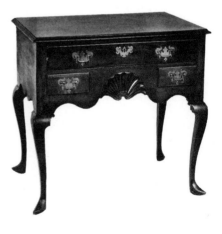

43. Queen Anne dressing table. Rhode Island Queen Anne furniture is constructed with cabriole legs terminating in either pad, cushioned-pad, snake, or claw-and-ball feet. Mahogany. Newport. 1740–1760. Width 33¼". (Henry Ford Museum)

Swedish naturalist Peter Kalm made the following observation about the city of Albany in 1749: ". . . They speak Dutch . . . their manners are likewise Dutch; their dress, however, is like that of the English." Mrs. Anne Grant, a contemporary author, noted, "Valuable furniture . . . was the favorite luxury of these people. . . ."

The geographical location of New York perhaps explains the varied techniques of construction that were used by local cabinet-makers. The New England tradition of uniting the four legs of a chair with stretchers is encountered in figure 45. Other times, however, seating furniture follows the custom of Philadelphia, where chairs were generally constructed without such supporting devices, figure 46. Bold projecting knees on sharp cabriole legs terminating in pad or claw-and-ball feet are almost universal on New York examples. In New York City walnut was favored for the most expensive furniture. Up the Hudson, maple, hickory, and ash were used in the construction of less sophisticated pieces, figure 47.

The drop-leaf table with oval leaves, figure 48, is constructed with eight legs, four of which swing to support the top when it is raised. The legs, slightly cabriole, are short and squat and terminate in the heavy, pointed, clublike feet popular in the New York–New Jersey area. White oak, poplar, and pine are the secondary woods used for the construction of the single drawer at each end.

New York furniture also has elements that show the influence of design motifs imported from the Orient. The bold outline of a Chinese vase can be seen in the lower portion of the splat of figure 46, and the upper part of the splat resembles a Chinese ginger jar.

PHILADELPHIA FURNITURE

Philadelphia furniture of the Queen Anne period is more like contemporary English examples than that from any of the other colonies. The similarities are so strong in both form and construc-

45. Right: Queen Anne side chair. The slip-seat of this chair is stuffed with marsh grass. Since the coil spring was not devised until the mid-nineteenth century, seating comfort as we know it today was virtually nonexistent. Walnut. New York. 1740–1760. Height 40¾". (Henry Ford Museum)

46. Left: Queen Anne side chair. Delicate floral carvings flank the center relief-carved shell on the top rail of this transitional chair. Walnut. New York. 1740–1750. Height 38¾". (Henry Ford Museum)

47. Queen Anne armchair. Modified William and Mary trumpet turnings often appear on the front legs of New York "Dutch" chairs. Simple country chairs with rush seats are almost impossible to date accurately since they were made throughout the entire eighteenth and much of the nineteenth centuries. Maple, hickory, ash. New York. *Circa* 1735. Height 43⅝". (Henry Ford Museum)

48. Queen Anne drop-leaf table. Imported mahogany was used for the construction of this monumental piece. New York. 1730–1740. Length 69¼". (Henry Ford Museum)

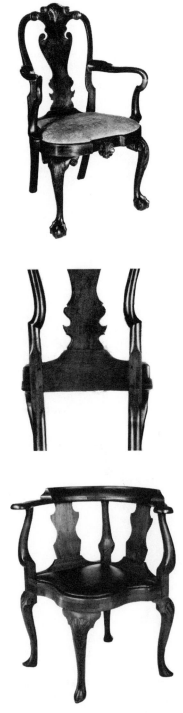

49. Upper left: Queen Anne armchair. Sometimes very elaborate chairs from both New York and Philadelphia are constructed with a solid splat veneered on the front side. The splat of this piece is hard pine and is faced with branch walnut. Walnut. Philadelphia. 1740–1750. Height 42⅜". (Winterthur Museum)

50. Center left: Detail from a Philadelphia side chair. Almost without exception, the side rails on Philadelphia chairs extend through the rear legs and are secured with pegs. Mahogany. Philadelphia. 1740–1750. Height 41". (The Metropolitan Museum of Art)

51. Lower left: Queen Anne corner chair. The frame of the slip seat is constructed of hard pine and covered with leather. Walnut. Philadelphia. 1740–1750. Width 27". (Winterthur Museum)

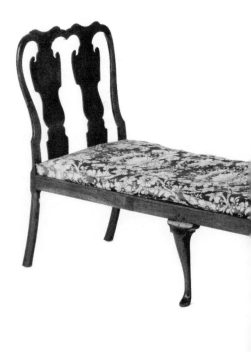

tion that even today experts disagree on the origin of many pieces. The loop arms on the walnut chair, figure 49, speak strongly for an English attribution, and yet the contours and ornament are easily recognizable as Philadelphian in origin. Claw-and-ball feet and balloon-shaped seats appear earlier in this area than in the other furniture centers.

The techniques used in the construction of chairs are much like those employed by English furniture-makers. The side rails extend through the rear legs and are pegged in place, figure 50. The front legs dowel into the underside of the seat rail. This contrasts sharply with the New England practice of mortising the front rail into the front legs.

The corner or roundabout chair first appeared in the William and Mary style. The form, probably most popular in the Queen Anne period, continued to be made throughout the eighteenth

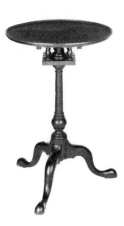

53. Queen Anne candlestand. John Paschall, a "Practioner in Physick late of Darby," in 1799 counted among his many possessions a "small pine table, a walnut table, a small dº, a small work chest." This entry indicates that even though a single wood might be popular within a given period, it was by no means used exclusively. Mahogany. Philadelphia. *Circa* 1745. Diameter 18⅝". (Henry Ford Museum)

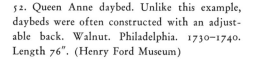

52. Queen Anne daybed. Unlike this example, daybeds were often constructed with an adjustable back. Walnut. Philadelphia. 1730–1740. Length 76". (Henry Ford Museum)

century. The short slipper feet with carved tongue overlays and the inverted cabriole arm supports on figure 51 are features typical of Philadelphia construction.

Famous for his fine furniture, the Quaker cabinetmaker, William Savery is credited with crafting the walnut double-chairback daybed, figure 52. The splats are spoon-shaped in a conscious effort to achieve comfort. The valanced, scrolled top rail is carved in a style similar to that of labeled chairs by Savery. Chamfered or shaped rear legs differ from the four others that are cabriole and terminate in slipper feet. As on all such early pieces, rope springs strung on pegs support the stuffed pad. Savery's long career began in 1742 and terminated some forty-five years later. It is not surprising, therefore, that furniture constructed in his shop "at the Sign of the Chair, a little below the Market, in Second Street, Philadelphia" displays a combination of design elements from several succeeding styles.

The small, round dish-top on the mahogany candlestand, figure 53, is supported by a birdcage device that enables it to be swiveled and tilted. The pedestal is turned with a ring and flattened-ball design typical of Philadelphia craftsmanship. The cabriole legs stand on padded feet. Diminutive tables such as this are rare.

SOUTHERN FURNITURE

Wealthy southern colonists, isolated by rural plantation life, were not content with furniture of domestic origin. From the first, they satisfied a longing for their English homes by ordering furnishings from London: "From England, the Virginians take every article for Convenience or ornament which they use, their own manufactures not being worth mentioning." Despite this preference for imported furniture, at least thirteen cabinetmakers lived and worked in Williamsburg, Virginia, during the eighteenth century. Local products competed not only with foreign imports, but with

furniture ordered from the other colonies. In 1769, 4 tables, 10 desks, and 347 chairs, among various other pieces, were landed at Burwell's Ferry and sold in the nearby capital, Williamsburg.

Much southern furniture is similar stylistically to that of Philadelphia. The walnut drop-leaf table, figure 54, probably from Virginia, has a paneled trifid foot that was commonly used by furniture-makers in Philadelphia. Oak was used for the construction of the frame and gate; yellow pine for the drawer linings.

The trifid foot appears again on the walnut highboy, figure 55. Case pieces of this type occur from southern New Jersey to eastern Virginia. This piece is framed with tulipwood, or poplar, which was also used for the backboards and drawer linings.

The walnut breakfast table with one gate leg, figure 56, is also probably from Virginia. Such pieces are commonly called "handkerchief tables" because the triangular top, when opened, forms a square much like the shape of a handkerchief. Similar English forms are known. This is not surprising since most southern Colonials built their homes "exactly similar to the old manor houses of England . . . in a style which approaches nearer to that of English country gentlemen than what is met with anywhere else on the (American) continent."

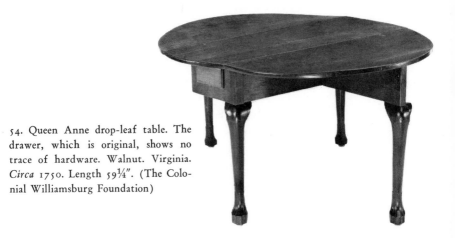

54. Queen Anne drop-leaf table. The drawer, which is original, shows no trace of hardware. Walnut. Virginia. *Circa* 1750. Length 59¼". (The Colonial Williamsburg Foundation)

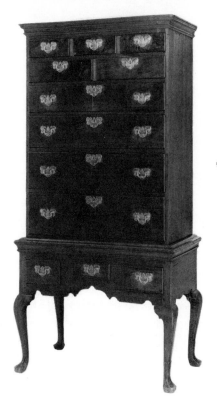

55. Left: Queen Anne highboy. In the South, tulipwood was the favorite lining for walnut and mahogany furniture throughout the eighteenth and nineteenth centuries. Walnut. Virginia. *Circa* 1750. Height 83½". (The Colonial Williamsburg Foundation)

56. Above: Queen Anne breakfast table. The turned legs are straight and tapered and terminate in a delicate cushioned-pad foot. Walnut. Virginia. 1740–1750. Height 27¾". (Henry Ford Museum)

JAPANNED FURNITURE

During the seventeenth century lacquer furniture imported from the Orient was eagerly collected in Europe. To satisfy the demand for such colorful furniture, the Englishmen John Stalker and George Parker in their 1688 publication, *A Treatise of Japaning and Varnishing,* contrived a means of imitating Eastern lacquer by using a plaster-and-glue mixture, today called gesso, to create fanciful chinoiserie designs in relief. These designs were then covered with paint or gold leaf and varnished.

In Stalker and Parker's book twenty-four plates of patterns

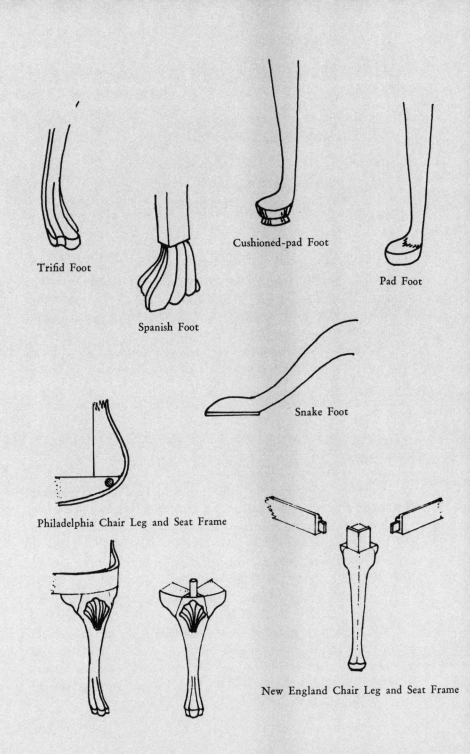

Trifid Foot

Spanish Foot

Cushioned-pad Foot

Pad Foot

Snake Foot

Philadelphia Chair Leg and Seat Frame

New England Chair Leg and Seat Frame

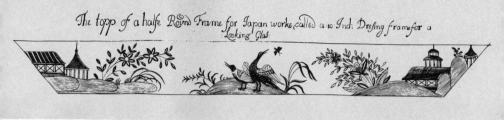

The topp of a halfe Round Frame for Japan worke, called a 10 Inch Dresing frame for a Looking Glas

57. Suggestions for Oriental designs intended as guides for craftsmen who japanned furniture. Published by John Stalker and George Parker in *A Treatise of Japaning and Varnishing*. (London, 1688.) (The New York Public Library)

and drawings supplemented the recipes for preparing the formulas. They felt that their designs, figure 57, were better than the originals since "we have helpt them a little in their proportions, where they were lame or defective, and made them more pleasant yet altogether as Antick."

A Boston advertisement of 1714 proclaimed ". . . Japan Work of all sorts done and sold, and Looking Glass shop in Queen St. near the Town House." "Looking Glasses—frames plain, Japan'd or flowered" were offered by Gerardus Duyckinck of New York City in 1736.

Stalker and Parker's publication was familiar to American craftsmen and in 1789 it was included in the catalogue of The Library Company of Philadelphia.

First appearing in the William and Mary period, American japanned furniture was popular throughout the Queen Anne period. One of the most impressive examples, the shell-carved highboy, figure 59, was made by John Pimm (died 1773) of Boston in his Fleet Street Shop for Commodore Joshua Loring between 1740 and 1752. Pimm's establishment, operating in 1736, probably competed with Thomas Johnson, who in 1732 engraved his own trade card "Japanner At the Golden Lyon in Ann Street Boston."

Although typical of the Queen Anne style, the tall case clock, figure 60, was made by Gawen Brown of Boston in 1766. The case retains the original japanned "tortoise shell" ground decoration. The chinoiserie figures are gilt with painted details. Stylistic

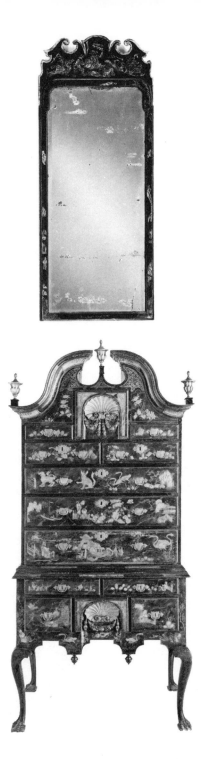

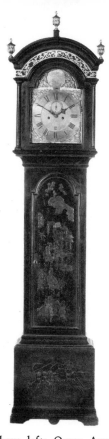

58. Above left: Queen Anne looking glass. The frame was constructed from American red pine and covered with gesso, gilt, and black paint. Probably New York. 1730–1740. Height 43½". (The Colonial Williamsburg Foundation)

59. Below left: Queen Anne high chest-of-drawers. This maple and pine piece was made for Commodore Joshua Loring, who was at Boston in 1716. As the King's Agent, he was a Loyalist and for personal safety was forced into exile in 1775. Boston. 1740–1750. Height 86". (Winterthur Museum)

60. Above: Queen Anne tall case clock. Pine. Boston. 1766. Height 86½". (Henry Ford Museum)

features on this clock, associated with the Queen Anne period, are the arched dial, the domed top over the arched cornice, and the tombstone-shaped door.

UPHOLSTERED FURNITURE

John Smibert in his 1731 painting of Colonel Francis Brinley, figure 61, shows him in his Roxbury, Massachusetts, residence, Dachet House, sitting in a Queen Anne armchair with upholstered back and seat. Upholstered furniture became very popular during the Queen Anne period, especially in Boston, the town seen through the open window in Brinley's portrait.

The open armchair, figure 62, is similar in form to that shown in the Brinley portrait. In this example, the back has a bow-shaped crest, the serpentine arms terminate in a curl, the arm supports are also serpentine, and the front legs are cabriole with a cush-

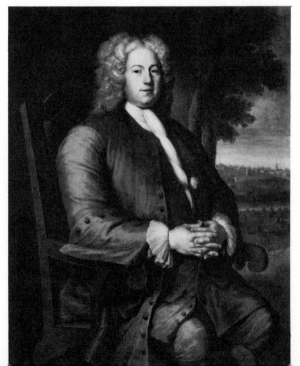

61. Portrait of Colonel Francis Brinley (1690–1765). Painted by John Smibert (1688–1751). Oil on canvas. American. 1731. Height 50″, width 39¼″. (The Metropolitan Museum of Art)

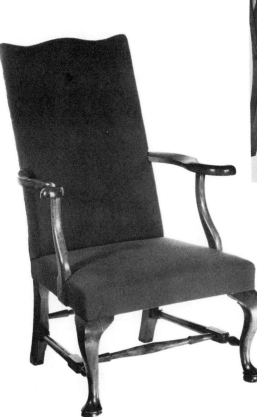

62, 62a. Queen Anne open arm-chair. Furniture created in the Queen Anne style is totally different in design from what had been fashioned previously. Sinuous curves in the form of cabriole legs and reverse cabriole arm supports indicate the phasing out of the architectural approach to furniture-making and the ultimate triumph of the curved line. Walnut. Massachusetts. 1730–1750. Height 41″. (Henry Ford Museum)

ioned-pad foot. Figure 62a illustrates how the back leg is attached with both wooden pegs and metal screws.

The wing chair or "easy chaire," figure 63, is typical of New England construction. The cabriole front legs and the block-and-spindle-turned H-stretchers are walnut; the rear legs maple. The arms on most upholstered northern chairs and sofas of this period scroll outward in a cone-shaped manner.

Eighteenth-century plum-colored moreen was used to upholster the New York "stuffed-back" open armchair, figure 64. The high back and sloping arms are unusual features in such diminutive

63. Queen Anne easy chair. Crewels worked in a Tree of Life design were used to upholster this chair. Walnut and maple. New England. 1720–1740. Height 45½". (Henry Ford Museum)

chairs. Rather plain knees, unadorned by carved decoration, are often encountered in furniture from this region.

The upholstered settee, figure 65, was made around 1735 for Stenton, the rural Philadelphia home of James Logan (1674–1751), secretary to William Penn. Even though easy chairs were popular after the early 1700's, upholstered American settees are rare. The walnut front legs are cabriole and have carved shells on the knees. They terminate in padded trifid feet. The scrolled outline of the tall back is repeated by the C-scrolled arms.

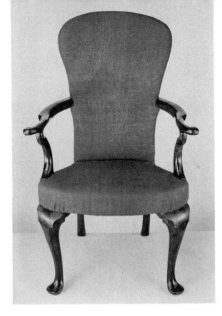

64. Left: Queen Anne armchair. The shape of the high back on this chair is much like the shape of a woman's bodice of the period. Walnut. New York. 1735–1750. Width 23½". (Winterthur Museum)

65. Below: Queen Anne upholstered settee. C-scroll arms are found on most upholstered Philadelphia pieces of the Queen Anne and early Chippendale period. Walnut. Philadelphia. *Circa* 1735. Length 58½". (The Metropolitan Museum of Art)

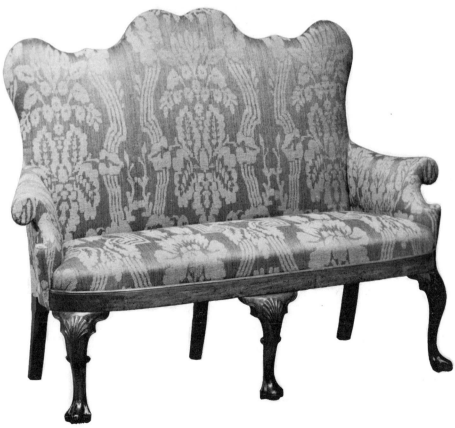

THE CHIPPENDALE
STYLE

The English cabinetmaker Thomas Chippendale (1718–1779), in the 1754 edition of his furniture design book called *The Gentleman and Cabinet-Maker's Director*, illustrated furniture in the Chinese, the Gothic, and the "Modern" or French tastes. His Modern designs were based upon the Rococo, or rock-and-shell, motifs favored in France.

Chippendale's undulating decorative designs were immensely popular in both England and America—where this new and fashionable style supplanted the Queen Anne style and flourished in the period 1755–1780 in the metropolitan centers of Boston, Newport, New York, and Philadelphia, where Colonial craftsmen freely copied and adapted its various elements.

Regional schools of cabinetmakers, all working within the

Chippendale style, developed during the mid eighteenth century. Guides to recognizing the origin of a specific example are the carvings on the cabriole legs and feet of claw-and-ball pieces and the pierced splats and top rails of chairs.

The claw-and-ball design is thought to have been introduced into English furniture-making during the late seventeenth century. Oriental carvings incorporating this motif were imported and avidly collected. Its introduction into American furniture-making first appeared in Philadelphia during the Queen Anne period. Especially beautiful are the walnut transitional chairs with solid spoon-shaped splats of the early Queen Anne style and the robust claw-and-ball foot of the succeeding Chippendale style.

On Philadelphia chairs the ball of the foot is held firmly within the claw. On New England versions, one of the talons turns back in a sharp diagonal and rests lightly on top of the ball instead of grasping it firmly. In New York, the shape of the claw-and-ball is very square; in fact, so square one can almost feel the block of wood it was carved from. In Newport and neighboring cities of Rhode Island, the claw is extended and relaxed over an

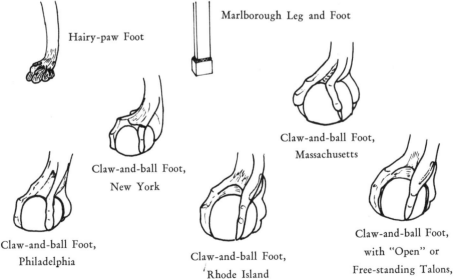

Hairy-paw Foot

Marlborough Leg and Foot

Claw-and-ball Foot, New York

Claw-and-ball Foot, Massachusetts

Claw-and-ball Foot, Philadelphia

Claw-and-ball Foot, Rhode Island

Claw-and-ball Foot, with "Open" or Free-standing Talons, Rhode Island

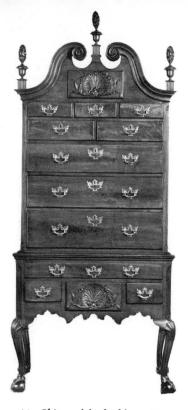

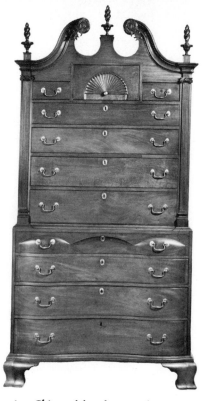

66. Chippendale highboy. Mahogany was the favorite wood of Philadelphia Rococo cabinetmakers. 1760–1780. Height 97″. (Henry Ford Museum)

67. Chippendale chest-on-chest. Attributed to Benjamin Frothingham. Mahogany. Massachusetts. 1760–1780. Height 88″. (Henry Ford Museum)

oval or egg-shaped ball. An exception to this is the pierced or open talon sometimes used in Newport by John Goddard and others. Pieces constructed with this distinctive feature are rare and highly prized by collectors and museums.

A method for identifying the origin of a case piece—highboy (or high chest-of-drawers), secretary-desk, bookcase, etc.—is to become familiar with the pediments.

Philadelphia highboys, for instance, are topped by pediments that are decorated with ornately carved Rococo motifs, figure 66.

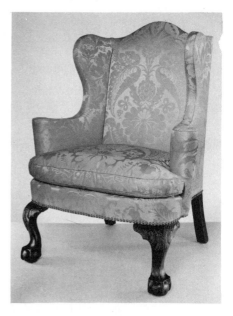

68. Chippendale easy chair. Elaborate carving extends over the knees of this chair. Mahogany. New York. 1760–1775. Height 36⅛″. (Winterthur Museum)

69. Chippendale dressing table or lowboy. Walnut, pine, and poplar. Philadelphia. 1755–1790. Height 31″. (Yale University Art Gallery)

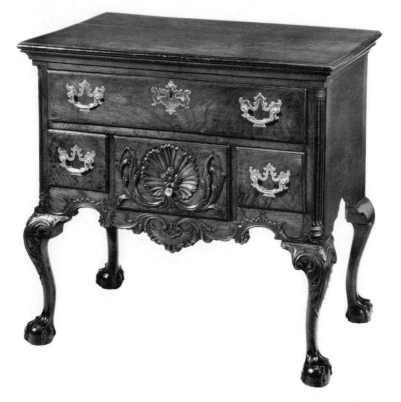

Massachusetts furniture of this same period is perhaps stylistically more similar to Philadelphia examples than those found in any of the other colonies. The chest-on-chest, figure 67, suggests a simplified version of Philadelphia forms.

The Queen Anne style lasted longest in conservative New England. Massachusetts craftsmen throughout the Chippendale period continued to create case pieces with bonnet or dome tops. The scrolls on such pieces are occasionally left plain. More common, however, is the use of a rosette. Urn-and-flame finials remained

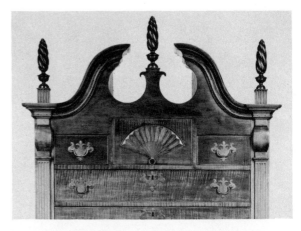

70. Detail of a pediment from a chest-on-chest. The fan and shell motifs which appear on Queen Anne and Chippendale case pieces usually are adaptations of those general designs. The carving on the center drawer in this pediment is a rare literal interpretation of a fan. Curly maple. Massachusetts. 1770–1785. Height 86″. (Winterthur Museum)

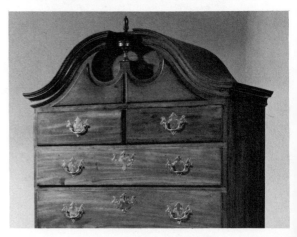

71. Detail of a pediment from a highboy. Closed bonnet-top pediments generally indicate a Rhode Island origin. Mahogany. *Circa* 1750. Height 82″. (Yale University Art Gallery)

popular.

Rhode Island case pieces, including some clocks, terminate with closed-bonnet top pediments that are further embellished with handsome finials of the urn-and-flame type with fluted carving on the urns. Block-front pieces were especially popular with Newport cabinetmakers and are usually attributed to the Townsend-Goddard cabinetmaking shops.

Southern Chippendale furniture design was strongly influenced by imported English pieces.

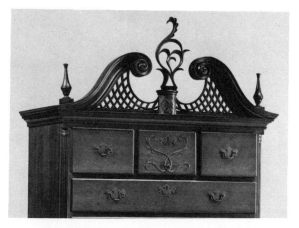

72. Detail of a seahorse finial from a highboy made by Eliphalet Chapin. Cherry. East Windsor, Connecticut. 1755–1805. Height 81″. (Wadsworth Atheneum)

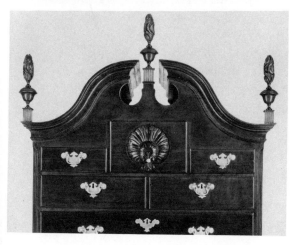

73. Detail of a pediment from a highboy. The carved sunburst with stiff streamers on the front of the drawer in the upper part of this case piece is identical with that on the lower drawer. This duplication of carved embellishment often occurs on highboys. Walnut. Probably Maryland. 1760–1775. Height 106″. (Winterthur Museum)

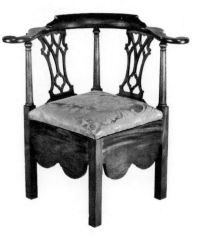

75. Chippendale roundabout commode chair. Martha Washington is known to have had such pieces at Mount Vernon. Mahogany. Massachusetts. 1755–1775. Height 30¾". (Henry Ford Museum)

MASSACHUSETTS FURNITURE

New Englanders clung tenaciously to inherited tastes and traditions. This predilection for the familiar was strongly manifested in the furniture ordered from cabinetmakers. The imposing tall back of the upholstered armchair, figure 74, resembles in form the "chayre back stools" of the late seventeenth century. The New England custom of uniting the four legs of a chair with stretchers continued. Although the Queen Anne style had been phased out by 1760 in the other Colonial centers of cabinetmaking, the only indication that New England craftsmen were aware of the Chippendale fashion was the use of Rococo carving on the knee of a leg or the introduction of a claw-and-ball foot.

The deep skirt on the roundabout chair, figure 75, was designed to conceal a chamber pot, thus making this a commode chair. The slip seat can be removed for easy access. Such chairs were used in bedrooms in the days before modern plumbing. The legs on this piece are plain and accent the openness of the Gothic lattice-like splats.

The "two doz. strong, neet and plain but fashionable Table chairs" mentioned by George Washington in his 1783 letter to Bushrod Washington are thought to have been Philadelphia "pret-

76. Chippendale side chair. The front legs of this chair are square and molded. The rear legs are square and canted. Mahogany. Massachusetts. 1750–1780. Height 37". (Henry Ford Museum)

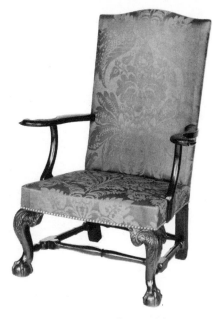

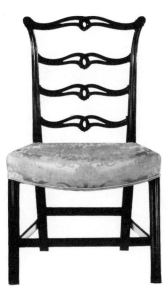

74. Chippendale armchair. Elaborate birdlike carvings serve as the terminals for the arms on several New England armchairs. Mahogany. Massachusetts. 1750–1770. Height 42¾". (Henry Ford Museum)

zel-back" chairs, much like the Massachusetts example, figure 76. The concave seat of this chair is an unusual feature. It contrasts in a very pleasing way with the pierced, bow-shaped top rail and splats.

Pretzel-backs were popular throughout cosmopolitan America, even though neither Chippendale nor Robert Manwaring (another English furniture designer) illustrated this type of chair. The Revere-Little family of Boston owned similar chairs with upholstered seats. The Philadelphia financier Stephen Girard probably purchased from the local cabinetmaker, Daniel Trotter, pretzel-backs with pierced splats centered by a spray of flowers. Even southern examples are known. The Brice House in Annapolis, Maryland, was furnished with chairs in this style.

The bombé chest-of-drawers, figure 77, is often referred to as being "kettle-shaped." The form was seldom made in England, but appears frequently on the Continent. American examples are uncommon and usually originated in Massachusetts, where desks and secretary-desks using the bombé form were also crafted.

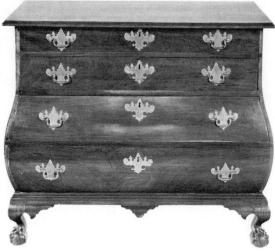

77. Chippendale chest of drawers. American bombé-shaped pieces are usually from New England. Mahogany. Massachusetts. 1760–1780. Width 38½". (Henry Ford Museum)

BLOCK-FRONT FURNITURE

Job Townsend (1699–1765), with his son-in-law, John Goddard (1723–1785), developed block-front and shell-carved Chippendale furniture during the mid eighteenth century in Newport, Rhode Island. This style of cabinetmaking is possibly the most original of any made in Colonial America. Examples of this cabinetwork are greatly prized by private collectors and museums.

The front of the desk-and-bookcase, figure 78, is blocked and carved in a convex-concave-convex pattern. The closed-bonnet top with raised paneling on the pediment, the fluted urn finials, and the stop-fluted inset quarter columns are familiar features on pieces from the Townsend-Goddard furniture shops of Newport.

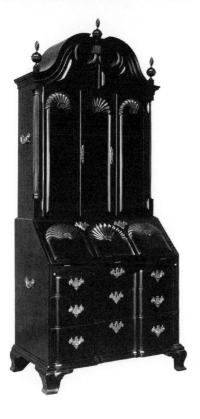

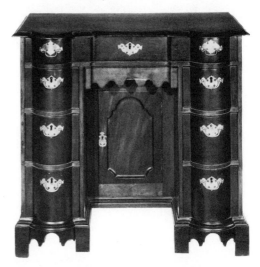

78. Left: Chippendale desk-and-book-case. Mahogany. Rhode Island. 1760–1775. Height 99½″. (The Metropolitan Museum of Art)

79. Below: Chippendale block-front kneehole desk. Mahogany. New York. 1760–1780. Height 31¾″. (Henry Ford Museum)

Block-front furniture, however, was not limited to Rhode Island. The top drawer of the New York desk, figure 79, is blocked and runs the full width of the piece. The scalloped apron over the kneehole opening is also a drawer. Flanking this section are three graduated, blocked drawers with willow brasses and bail handles. The piece stands on six bracket feet, a form that became common-place in the Chippendale period.

The shape of the molded top on the three-drawer chest, figure 80, does not conform to that of the blocked front. The short front feet are cabriole and terminate in a claw-and-ball foot. As is customary on such Connecticut pieces, the back legs are shaped brackets. The upper drawer has a center concave shell flanked by convex shells and the two lower drawers are blocked to match the

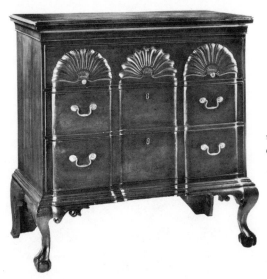

80. Chippendale block-front three-drawer chest. Cherry. Connecticut. 1770–1790. Height 36¾″. (Henry Ford Museum)

one above. Although the Connecticut craftsmen who created this and a small related group of case pieces still remain unidentified, they appear to have been located in New London County.

The front and base of the mahogany desk, figure 81, are blocked. Less ambitious than his contemporaries, the Massachusetts

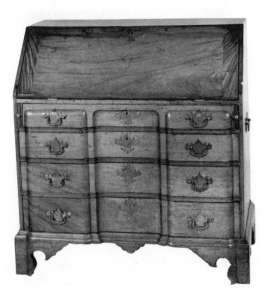

81. Chippendale block-front desk. Mahogany. Massachusetts. 1760–1780. Height 47″. (Henry Ford Museum)

cabinetmaker who made this piece chose to omit the carved shells often associated with blocked furniture.

Most often, blocking is accomplished by the shaping of a single plank of wood, sometimes as thick as six or seven inches. Other times, the blocks are merely applied, thus saving the cabinetmaker time and effort.

RHODE ISLAND FURNITURE

Rhode Island walnut and mahogany furniture, constructed with carved stop-fluting (see sketch) as an integral part of its design, is often associated with the numerous shops maintained by the Townsends and Goddards. Chestnut, plentiful in the area, was the customary secondary wood. The cross-hatching that extends from the top rail onto the upper portion of the splat is a common motif on their Chippendale side chairs with Marlborough legs, figure 82. Variants of this device are also found on pieces from nearby Connecticut.

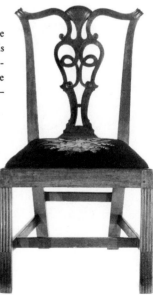

82. Chippendale side chair. Attributed to the Townsend-Goddard school. The front legs of this chair are stop-fluted. This occurs when the concave fluting is alternated with convex fluting (see sketch below). Mahogany. Rhode Island. 1760–1780. Height 37″. (Henry Ford Museum)

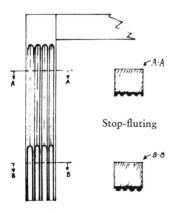

Stop-fluting

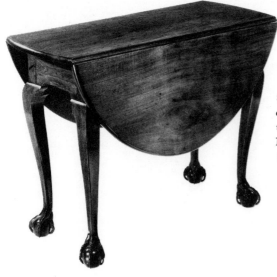

83. Chippendale table. Furniture with open-talon claw-and-ball feet appears to have been made only in Rhode Island. Mahogany. 1750–1765. Length 45½″. (Henry Ford Museum)

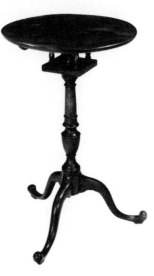

84. Chippendale candlestand. The feet on this diminutive piece consist of up-turned scrolls called whorls. The open-work section with four small turned supports under the top is called a bird-cage, and it enables the top to be both turned and tilted. Mahogany. Rhode Island. 1750–1770. Diameter 18⅝″. (Henry Ford Museum)

The open talons on the claw-and-ball-footed table, figure 83, are rare. Such meticulous attention to detail is not surprising, for Rhode Island craftsmen created furniture that in some ways is probably more sculptural than that from any other region.

Even more unusual than an open-talon, claw-and-ball foot is the use of a "French foot" on the candlestand, figure 84. The round top of this distinctive piece is slightly dished and rests on a birdcage. The turned, extended-vase section of the pedestal is typical of Rhode Island craftsmanship. Benjamin Randolph, the Philadelphia cabinetmaker, used similar but much more elaborate whorl feet on one of his famous "Sample" chairs.

Because of its favorable geographical location and deep harbor, Newport's cabinetmakers found it profitable to consign "venture" furniture to sea captains for sale in distant ports. Records show that Thomas Goddard sold numerous pieces for export. The city's prosperity was abruptly halted by the onset of the American Revolution; shortly after the Revolution, however, cabinetmakers joined in cooperative shipments and the exporting of furniture increased sharply.

CONNECTICUT FURNITURE

Connecticut Chippendale is perhaps the furniture style most easily recognized by the uninitiated. As a novice collector once said, "If it's cherry, and funny looking, it's from Connecticut." Though

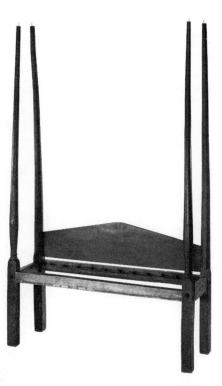

85. Chippendale bedstead. This is believed to have belonged originally to Simeon North of Middletown. The head posts are "pencil post" in form; the foot posts were turned on a lathe. Maple. Probably Middletown, Connecticut. 1795–1815. Height 88″. (The Connecticut Historical Society)

87. Chippendale looking glass. Made by Kneeland and Adams, Cabinet- and Chair-Makers, Hartford, Connecticut. This piece was probably owned by Thomas Bagg (1749–1837) of West Springfield, Massachusetts. Mahogany veneer, pine, and whitewood. 1792–1795. Height 30⅝". (The Connecticut Historical Society)

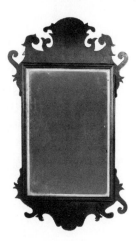

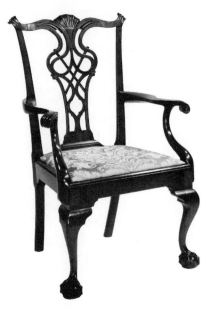

86. Chippendale armchair. Possibly by Eliphalet Chapin. Chapin spent several years working in Philadelphia. Upon returning to his native state, he used the Philadelphia construction technique of tenoning the seat rails through the back posts. Cherry and pine. East Windsor, Connecticut. 1755–1805. Height 40". (The Connecticut Historical Society)

88. Chippendale desk. Attributed to Samuel Loomis. The blocking of the drawers is extended to the top where it is surmounted by a convex-concave-convex pattern of stylized shells. Tapered and twisted columns flank the four drawers. Mahogany. Colchester, Connecticut. *Circa* 1780. H. 47". (Henry Ford Museum)

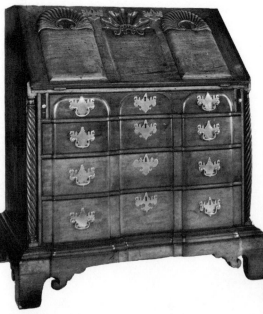

not, of course, an accurate statement, much of the furniture from this New England state was made from cherry wood. Plentiful stands of cherry provided local craftsmen with a strong, easily worked material that could be stained in imitation of the more costly imported mahogany.

The design of Connecticut furniture is indeed often unconventional. The special character of these charming pieces is easily explained by the fact that the craftsmen borrowed decorative elements and construction techniques from other areas, and rearranged them to suit local taste.

Perhaps the most famous of all eighteenth-century Connecticut cabinetmakers is Eliphalet Chapin (1741–1807), who is believed to have fled Connecticut for Philadelphia to avoid a "marriage of necessity." Returning to the East Windsor, Hartford County, area in 1771, he created furniture that shows evidence of his training in both Connecticut and Philadelphia. Working largely with cherry, he and his second cousin, Aaron, created truly individual, yet beautiful, pieces. Though twelve years his senior, Aaron entered Eliphalet's shop as an apprentice in 1774. In 1783 Aaron left East Windsor, and his advertisement in the *Connecticut Courant* of December 9 informed the Hartford public that his shop, opposite Mr. Samuel Burr's, "now carries on the Cabinet and Chair making business, in as great variety perhaps as is done in any shop in the State." Furniture was offered in both "Mahogany and Cherry Tree."

NEW YORK FURNITURE

Throughout the entire eighteenth century, Dutch-styled furniture satisfied rural New Yorkers. In the major urban centers on the Hudson River—Albany in the North and New York City in the South—this was not the case, however, for here gifted craftsmen, fully aware of the Chippendale style, produced superb examples of furniture using Rococo design concepts.

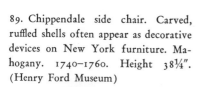

91. Chippendale gaming table. The fifth leg swings out to support the top leaf when it is opened for use. The heavy gadrooning on the skirt and fine carving on the knees and legs are typical features. Mahogany. New York. 1765–1785. Height 26¾". (Museum of the City of New York)

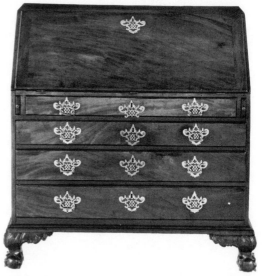

89. Chippendale side chair. Carved, ruffled shells often appear as decorative devices on New York furniture. Mahogany. 1740–1760. Height 38¼". (Henry Ford Museum)

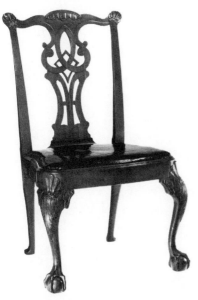

90. Chippendale desk. A square compartment within this case piece contains four drawers marked, "medals," "gold coins," "silver coins," and "brafs and bafe mettal coins." Mahogany. New York. 1760–1780. Width 45". (Henry Ford Museum)

"Tassel-back" and "kite-back" were the two most popular forms of chair design in New York. The mahogany example, figure 89, has a diamond or kite splat and is very similar to pieces made at the shop of Gilbert Ash (active 1748–1763). The top rail is decorated with shell-and-leafage carved ears. The slip seat is balloon shaped. Rare in American cabinetmaking is the use of a carved, ruffled shell overlapping the seat rail. A handful of Philadelphia pieces are known with this device; however, it is more frequently found on New York furniture.

The slant-top mahogany desk, figure 90, is attributed to Samuel Prince, who was described in 1785 as "a conspicuous character in his way and esteemed one of the best workmen in this city." The massive ogee bracket and the compressed claw-and-ball feet are identical to illustrations that he used in his advertisements. This piece was once owned by President Ulysses S. Grant and a braid from his uniform frames a mirrored panel within the writing compartment.

Heavy gadrooning, typical of New York cabinetmaking, borders the skirt of the Chippendale gaming table, figure 91. The linear, acanthus carving at the knee of the cabriole leg and the massive, square claw-and-ball foot are indicative of the splendid abilities of New York furniture-makers.

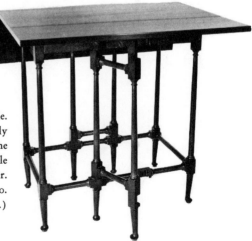

92. Chippendale "spider" gate-leg table. These diminutive pieces were usually fashioned from mahogany since the hardness of the wood made it possible for the turnings to be extremely slender. Mahogany and oak. New York. 1760. Height 29″. (Shelbourne Museum, Inc.)

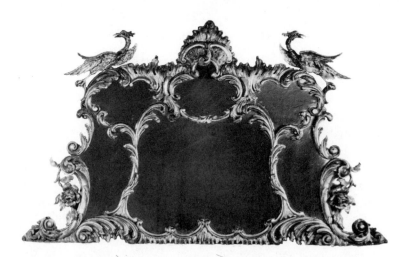

93. Chippendale chimney piece. Though many of Thomas Chippendale's illustrations in the *Director* were asymmetrical in concept, American craftsmen generally created symmetrically balanced furniture in this style. Pine. Possibly Philadelphia. 1760–1780. Length 52". (David Stockwell)

The price of a piece of furniture related directly to the amount of carving the client required. Benjamin Lehman asked one price for "claw feet," more for "shells on the Knees and Front Rail," and even more for "Leaves on the Knees." A cabinetmaker seldom did his own carving. He either employed carvers at his shop or, as with upholstery, sent work out to a specialist.

The mahogany and walnut New York "spider" gateleg table, figure 92, is a very rare form in American furniture. The slender turned legs terminate with small cushion pads. A few other examples, all with a New York history, are known.

PHILADELPHIA FURNITURE

The 1769 catalogue of The Library Company of Philadelphia lists Thomas Chippendale's *Director* of 1762 (Third Edition) in its collection. Thomas Affleck, responsible for making the Independence

Hall armchair, figure 102, personally owned a copy of "Shippendale's Design Book." Maker of some of Philadelphia's most elaborate furniture, Benjamin Randolph was also influenced by Chippendale, as can be seen by the motifs he chose to decorate his trade card. The unidentified Philadelphia artisan who carved the chimney piece, figure 93, relied extensively upon his familiarity with the *Director* for guidance.

Director Plates XII through XVI offer numerous variations that were intended as ornamentation for chair stiles. Some of those suggestions were incorporated into the carving on the side chair, figure 94, one of a pair undoubtedly by the same unidentified carver who created the famed Lambert family chairs now in the Winterthur collection.

94. Chippendale side chair. The shell that centers the front skirt on many Philadelphia chairs is frequently carved and applied. Mahogany. Philadelphia. 1760–1780. Height 41½″. (Henry Ford Museum)

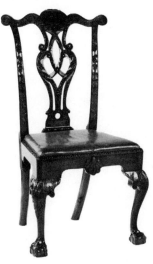

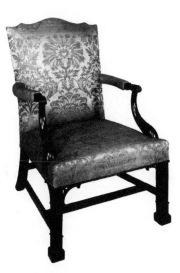

95. Chippendale armchair. Carved by Thomas Affleck. The Marlborough legs of this distinctive open armchair end with blocked feet that have paneled insets of husks and strapwork carved in relief. This form was called a "French chair" by Thomas Chippendale. Mahogany. Philadelphia. *Circa* 1770. Height 42¾″. (The Colonial Williamsburg Foundation)

Chippendale's real contribution was not the creation of new designs; he grafted decorative elements of the French Rococo onto contemporary English furniture forms.

The carving on the lower center drawer in Philadelphia highboys is almost always similar in design to that on the pediment. When combined with quarter round columns at the sides, the entire front of the piece is visually enclosed in a single decorative frame.

Some of America's greatest pieces of furniture were made in the Chippendale style by Philadelphia cabinetmakers.

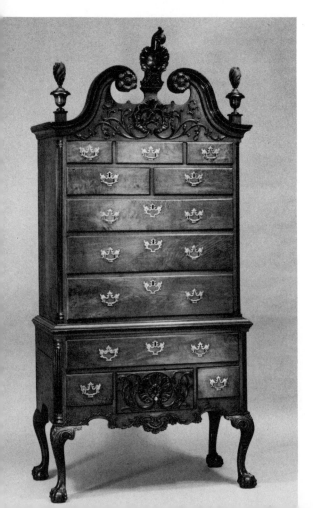

96. Chippendale highboy. High-style American Chippendale furniture is made of mahogany. Occasionally, very sophisticated pieces are made of walnut. Walnut, pine, and poplar. Philadelphia. 1755–1790. Height 107½". (Yale University Art Gallery)

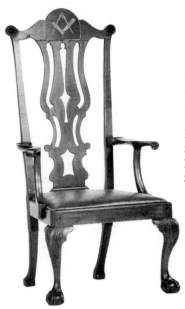

97. Chippendale armchair. The square and compass, symbols of the Masonic Order, are inlaid in the top rail of this chair. Mahogany and ash. Charleston, South Carolina. *Circa* 1770. Height 56″. (Museum of Early Southern Decorative Arts)

SOUTHERN FURNITURE

The southern migration of craftsmen during the last half of the eighteenth century from Philadelphia into Maryland and Virginia was a natural one. The fact that these artisans were working in a different geographical area did not compel them to alter their construction techniques. Therefore, it is not surprising to discover distinct Philadelphia features on some southern furniture.

The Chippendale armchair, figure 97, was used in a Masonic lodge in Charleston, South Carolina, and the top rail is inlaid with a compass and square, symbols of the Masonic Order. The curious carved floral rosettes on the ears of the top rail are repeated at the center of the knuckles on the arms.

Philadelphia furniture design is not the only "outside" influence evident in southern furniture. The pierced fretwork design of the skirt on the card table from Charleston, figure 98, is almost identical to illustrations in eighteenth-century English pattern books. Brackets in the form of a C-scroll visually tie the leg to the skirt and lend an air of lightness to the entire piece.

After the Revolutionary War, settlers poured into Virginia. Furniture-makers produced pieces of sound craftsmanship that stylistically reverted to the forms popular in earlier periods. Using mahogany and the native woods, cherry and tulipwood, they fashioned some truly remarkable examples of furniture, figure 99. The small cabriole legs of this corner cupboard are shell-carved at the knee and terminate in claw-and-ball feet. The doors of the lower cupboard section are constructed with raised or "fielded" panels and are attached by H-hinges. The upper portion of the cupboard has a glass-paneled door enclosing shaped shelves. Elaborate dentil moldings and punched decoration add an air of elegance to this unusual piece, which is topped by carved bud-and-flower finials.

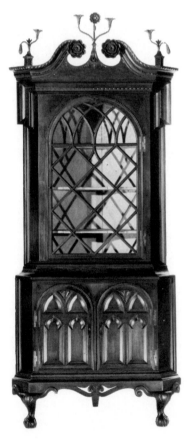

99. Chippendale corner cupboard. Southern cabinetmakers sometimes worked in a style long outmoded in the more sophisticated urban centers of the North. Cherry, pine, and poplar. Tidewater Virginia. *Circa* 1800. Height 114″. (Henry Ford Museum)

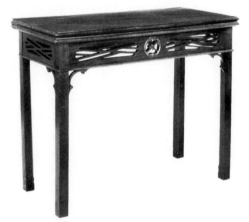

98. Chippendale card table. As with most examples of this form, one of the rear legs swings outward, providing a support for the top when it is opened. Mahogany. Charleston. 1760–1780. Width 36⅛″. (Henry Ford Museum)

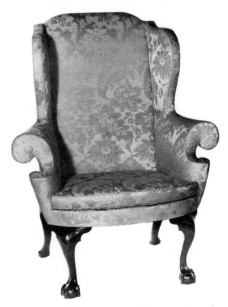

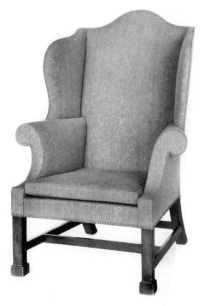

101. Chippendale easy chair. Most Marlborough-legged easy chairs, even though they were constructed in Philadelphia, were originally made with rectangular-shaped stretchers. Mahogany. Philadelphia. 1765–1785. Height 48″. (Henry Ford Museum)

100. Chippendale easy chair. Attributed to Benjamin Randolph. This robust seating piece with C-scrolled upholstered arms descended in the Randolph family. Mahogany. Philadelphia. 1760–1775. Height 46½″. (Henry Ford Museum)

UPHOLSTERED FURNITURE

Upholstered Chippendale furniture of the mid eighteenth century offered an elegance that had been previously unavailable.

In addition to making furniture, Thomas Chippendale worked as a decorator and upholsterer. In 1772 he upholstered the sofas and armchairs and draped the windows in the drawing room of the famous English actor David Garrick's new house with green silk damask. At the same time he provided green serge slipcovers for the seating pieces. At other times he is known to have used striped or checked linen or cotton for slipcovers.

Advertising in the *Pennsylvania Packet* of Philadelphia on September 5, 1774, Charles Allen, lately from London and Paris,

offered the local inhabitants ". . . all sorts of field, festoon, and canopy beds drapery, window curtains, stuffs sofas, settees, couches, French elbow, easy, corner and back-stool chairs" from the shop of Mr. George Dowig at the sign of the Crown & Jewels in Front Street. Mr. Allen also "puts up all sorts of paper hangings, and makes Venetian blinds for windows."

Contemporary records indicate that Philadelphia furniture-makers occasionally upholstered chairs and sofas in their own shops; more often, they "sent them out" for completion. Benjamin Randolph is credited with making the easy chair, figure 100, which was constructed without stretchers in the Philadelphia manner. Marlborough legs, with a block or plinth foot, figure 101, were popular in the Philadelphia region.

Payment was rendered to Thomas Affleck in 1794 for carving the "Speaker's Chair," figure 102, for use in Congress Hall. The

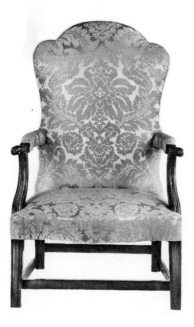
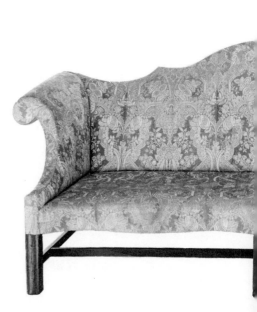

bead-and-reel carving on the legs and arms is typical of Affleck's work.

The serpentine-back sofa, figure 103, is referred to as a "camel back." Since metal springs did not exist at that time, quantities of linen stuffing or other material, such as feathers, were used under the "canvas" covering beneath the elegant, expensive outer fabric.

COUNTRY FURNITURE

Many collectors today treasure the country furniture of the eighteenth century, which in form resembles the more sophisticated pieces created in urban cabinetmaking establishments. Often linen stuffing or other material, such as feathers, were used under the "canvas" covering beneath the elegant, expensive outer fabric.

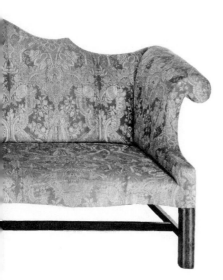

102. Far left: Chippendale "Speaker's Chair." Carved by Thomas Affleck. Affleck, a Royalist, was forced to leave Philadelphia during the Revolution. He returned and resumed a most successful business, which included a commission for furniture for Congress Hall. Mahogany. Philadelphia. *Circa* 1794. Height 51″. (Henry Ford Museum)

103. Left: Chippendale sofa. Camel-back sofas were usually constructed with a very deep seat. This example has a serpentine-curved front seat rail that would make it especially comfortable for short people. Mahogany. Philadelphia. 1765–1780. Length 83″. (Winterthur Museum)

the furniture made in isolated rural areas displays superb crafts-manship. Major John Dunlap (1746–1792) and his related clan of cabinetmakers in New Hampshire fashioned highly individual pieces.

The three-sectioned chest-on-chest-on-frame, figure 104, was found in Bedford, New Hampshire, and was unquestionably made by the "Major." Like most early Dunlap furniture, it is constructed from maple. The painted and grained finish and the wooden drawer pulls were added in the nineteenth century. This piece was orig-inally stained a reddish brown.

Painted decoration is also much in evidence on the New Eng-land side chair, figure 105. Like many country chairs, the front legs are Marlborough and molded at the outer edge and the splat is pierced.

Probably one of the most important needlework documents in America is the mortality picture, figure 106, worked by Miss Prudence Punderson (1758–1784). Miss Punderson, later Mrs. Timothy Rossiter of Preston, Connecticut, depicts herself first as an infant in a cradle, later as a mature woman working at her

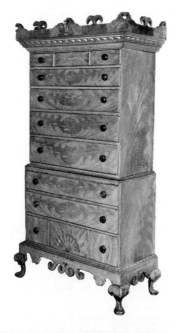

104. Chippendale chest-on-chest-on-frame. Attributed to Major John Dun-lap. Account books indicate that the Major did not prepare his own lumber, but purchased it from local sawmills. Maple with nineteenth-century painted graining. Bedford, New Hampshire. 1720–1750. Height 77½". (Privately owned)

105. Right: Chippendale country side chair. Painted decoration in gold in the form of pendant grapes and grape leaves and floral motifs enlivens the surface of this charming country piece. Maple and pine. New England. 1760–1780. Height 37¼". (Stewart E. Gregory)

106. Below: Needlework picture. Worked by Miss Prudence Punderson. The checkered floor covering in this needlework is of unusual interest. Miss Punderson created a unique set of twelve needlework pictures of Christ's Disciples, one of which shows St. James the Less sitting in a country Queen Anne chair with Spanish feet. Connecticut. Late eighteenth century. 12½" x 16½". (The Connecticut Historical Society)

needlework, and finally in death, symbolized by the casket on the table and the covered looking glass or mirror directly behind it. The mirror, the table where she works, and the inkstand, as well as the picture and numerous other examples of her handiwork, are all part of the collections at The Connecticut Historical Society in Hartford. All this furniture is typical of the work of country cabinetmakers of the period. This needlework is of special interest, for it documents the window hangings used by our Colonial ancestors.

Country cabinetmakers, working in isolated rural communities away from the shipping ports and contact with foreign influences, used furniture designs that were long outmoded in cosmopolitan seacoast cities. This cultural isolation lasted sometimes as long as fifty or seventy-five years. It is not surprising, therefore, that scholars today can many times recognize a piece of furniture crafted in the Queen Anne style as being the work of a late eighteenth-century cabinetmaker and date it accordingly.

As networks of new roads and canals were built, communication and transportation became more feasible. Under such circumstances, country cabinetmakers became more quickly aware of city fashions and incorporated elements of new styles into their products, thus shortening the city-country cultural lag.

The chest-on-chest, figure 107, unquestionably from the shop of Elijah Booth of Southbury, Connecticut, retains many of the elements of the Queen Anne style. The profile of the shaped skirt, the use of the broken pediment and the incorporation of the fan design on the center top drawer all hark back to an earlier period. Since Booth was not born until 1748, it seems unlikely that he would have made this sophisticated piece prior to 1770, long after the Chippendale style was flourishing in nearby Boston.

The New Hampshire country chairs, figures 108 and 109, both show a direct relationship to city furniture. Molded front legs and back rails, as on figure 109, are frequently encountered on Philadelphia pieces of a slightly earlier date. Serpentine slats, like those of figure 108, were used by city cabinetmakers in both Boston and Philadelphia.

108. Chippendale side chair. Mahogany. New Hampshire. 1780. H. 38½". (Henry Ford Museum)

109. Chippendale side chair. Maple. New Hampshire. 1775–1800. H. 41". (Winterthur Museum)

107. Chippendale chest-on-chest. Attributed to Elijah Booth (1745–1823). Cherry. Southbury, Connecticut. 1775–1795. Dimensions unavailable. (Mr. and Mrs. David Pottinger)

110. Chippendale candlestand. Cherry with ash inlay. Connecticut. *Circa* 1780. H. 25¾". (Henry Ford Museum)

George Washington, "Father of His Country," increased the popularity of the Masonic Order through his membership. Throughout the last half of the eighteenth and the entire nineteenth century, symbols and signs of this fraternal society were incorporated into furniture design. The handsome candlestand, figure 110, with its square and compass, was quite possibly made for use in a Masonic lodge room.

Southern country furniture appears to be less sophisticated than its northern counterpart. The yellow pine corner cupboard, figure 111, was found in Williamsburg, Virginia. The upper half is fitted with glazed doors, each with six panes separated by molded mullions.

PENNSYLVANIA GERMAN FURNITURE

The first German settlers in Pennsylvania built rude log cabins for shelter. The construction of these dwellings, with their squared

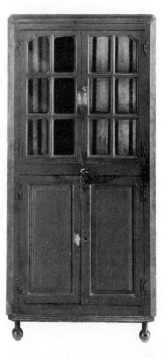

111. Chippendale corner cupboard. Yellow pine. Found in Williamsburg, Virginia. 1730–1760. H. 76½". (The Colonial Williamsburg Foundation)

112. Plank chair. The back is pierced with a stylized heart design and decorated with a carved leaping stag. Walnut and ash. Pennsylvania. 1770. Height 31¼". (Winterthur Museum)

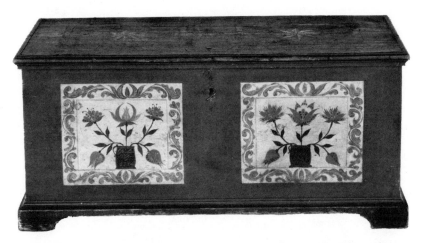

113. Blanket chest. Painted by Christian Seltzer (1749–1831). The left panel on the front of the chest is centered by a black vase on which Seltzer scratched his name and the date "1784." Pine. Jonestown, Dauphin County, Pennsylvania. Length 52⅛". (Henry Ford Museum)

logs and notched corners, was reminiscent of building techniques in northern Europe.

Perhaps because so many homes were lost during the French and Indian wars, German colonists altered their construction techniques and built spacious fieldstone farmhouses "large as pallaces." These were complemented with good-sized barns to house their herds of fat cattle.

Though fashioned during the second half of the eighteenth century, the designs of most of the best Pennsylvania German furniture are not directly related to the Chippendale style. In form, the furniture preserves the traditions of German and Swiss pieces of the seventeenth and early eighteenth centuries. It is often brightly painted with tulips, hearts, pomegranates, pairs of birds, vases of flowers, heraldic unicorns, figures of horsemen, geometric stars, and even representations of Adam and Eve with the tempting serpent draped about a heavily laden tree. At other times, wax inlay decoration enlivens the surfaces.

The Germans in America established themselves in rural farming communities where outside influences were almost nonexistent. Mennonites, Moravians, Dunkers, Amish, and Lutherans produced furniture forms that remained unchanged over a long period of time.

114. Schrank. The upper section of this painted and decorated piece has two cupboard doors that are held in place by rat-tail hinges. The lower section contains five drawers painted and grained to simulate marble. Pine. Lancaster County, Pennsylvania. *Circa* 1790. Height 88½". (Henry Ford Museum)

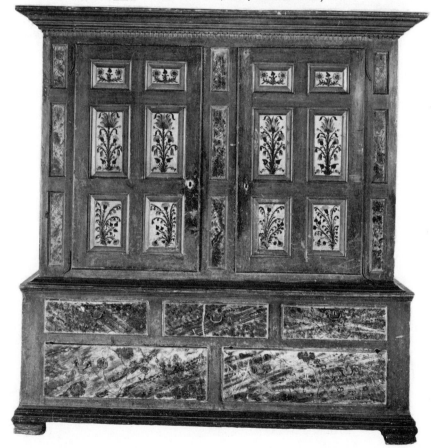

THE WINDSOR STYLE

The Windsor chair originated in England in the Gothic era. By the early eighteenth century its use was well established, and in 1730 "John Brown of St. Paul's Churchyard," London, offered "All sorts of Windsor Garden Chairs, of all sizes painted green or in the wood."

American colonists in Philadelphia appear to have adopted the form earliest. By 1760 it appeared throughout the colonies, where until about 1870 it remained the most popular form of seating furniture in America.

Windsor chairmakers were specialists; however, they sometimes also advertised spinning wheels. This combination of merchandise is not surprising, since both require carefully turned parts.

In England the Windsor never achieved the respectability

that other forms of seating furniture enjoyed. In fact, Thomas Chippendale, in his *Director,* ignored its existence.

Windsor chair legs were joined to the seat in two ways. The most frequent method was to drill a hole through the seat, insert the leg from the bottom, and drive a wedge into the top of the leg, thus forcing it open. The leg was secured with a peg. The other method was the "blind fox" joint. A hole was drilled from the bottom of the seat upward approximately two-thirds of the way through. A wedge was inserted into the top of the leg and the leg placed in the hole and driven upward. As before, the wedge forced the top of the leg open, thus securing it in place.

America's political struggle as a young republic could almost be told in terms of the Windsor chair. Thomas Jefferson is known to have labored over the Declaration of Independence while sitting in a swivel, writing-arm Windsor. In Independence Hall Benjamin Franklin and his compatriots sat in Philadelphia bow-back chairs made by Francis Trumble at the time they were signing the great document. George Washington, desiring to furnish Mount Vernon

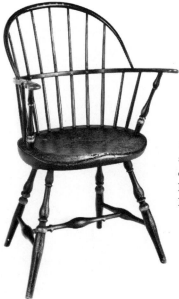

115. Left: Bow-back Windsor armchair. Chairs similar to this were originally used in Independence Hall, Philadelphia. Pine and maple. New England. 1775–1800. Height 36¼". (Henry Ford Museum)

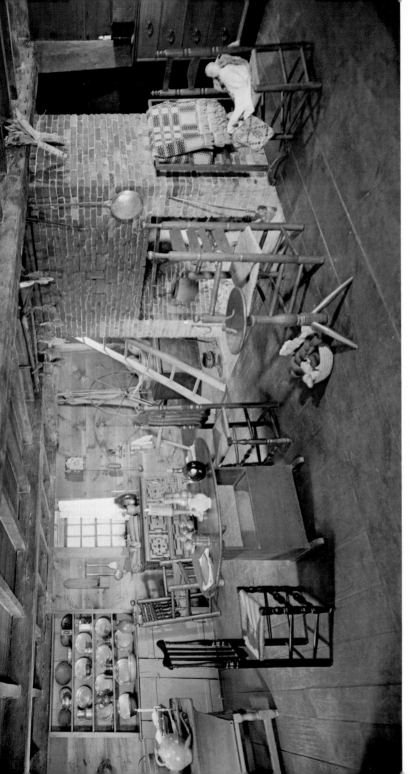

Plympton House is a seventeenth-century one-room dwelling originally owned by Thomas Plympton of South Sudbury, Massachusetts. Plympton was a founder of the Sudbury Plantation in 1638. The free-standing fireplace was built to provide heat on all four sides. The seventeenth- and early eighteenth-century furniture includes a Brewster chair, slat-back and banister-back chairs, and a chair-table. (Greenfield Village and Henry Ford Museum)

This bedroom setting comfortably combines William and Mary pieces of 1700–1720 (the superb painted and decorated high chest of drawers at left and the chest at the foot of the bed, both from Connecticut) with a New England Queen Anne easy chair in its original flamestitch upholstery and an armchair, both originating in New England and dating from 1720–1745. The bed is a country Chippendale piece from the late eighteenth century. (Winterthur Museum)

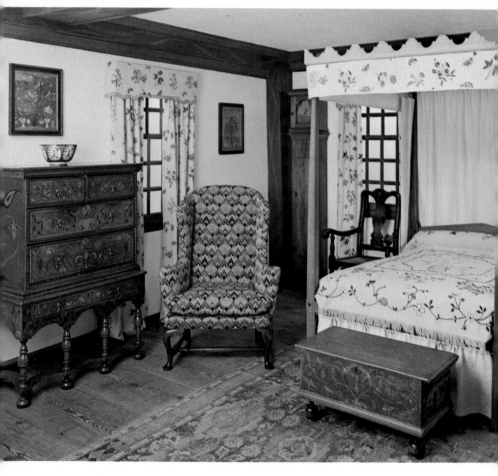

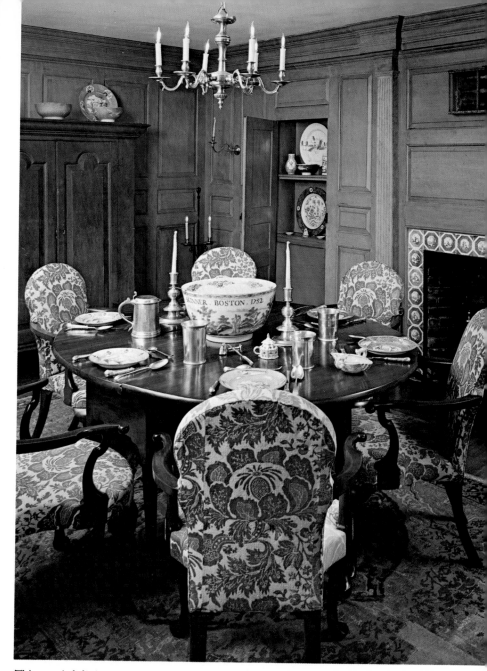

This paneled dining room is from an East Derry, New Hampshire, house of about 1750. The New York furniture in the contemporary Queen Anne style includes a rare set of armchairs, dining table, and a *kas* from Dutchess County, New York. The room is brightened with English delft plates, bowls, and fireplace tiles in purple, blue, and white. (Winterthur Museum)

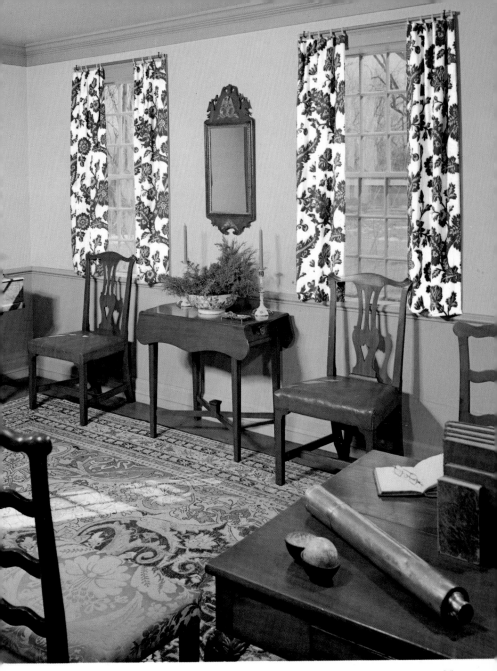

The "Best Parlor" from the simplified Georgian house built in 1750 at Exeter, New Hampshire, by John Giddings, a prosperous merchant and shipbuilder, contains furniture in the New England country Chippendale style of the late eighteenth century. After 1790, the house was owned by Joseph Pearson, New Hampshire's first Secretary of State. (Greenfield Village and Henry Ford Museum)

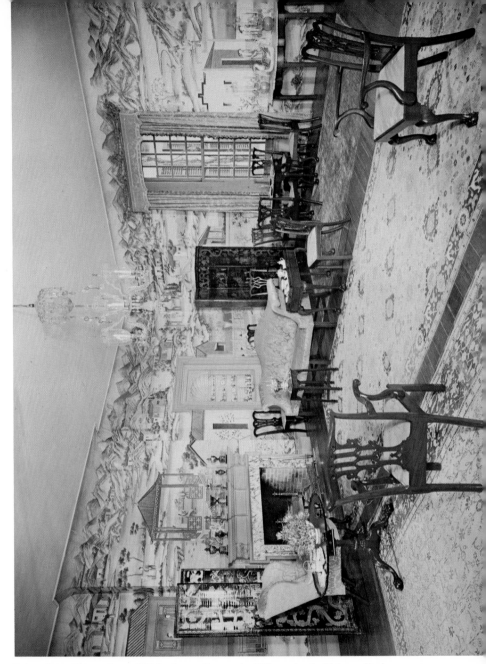

Painted in China about 1770, the wallpaper in Winterthur's Chinese Parlor creates a fashionably exotic background for the splendid Chippendale furniture, dating from 1760–1780, which originated in the great cabinet shops of Philadelphia, Newport, and Charleston. The lacquer screens were brought from China before 1800 for Elias Hasket Derby of Salem, Massachusetts. (Winterthur Museum)

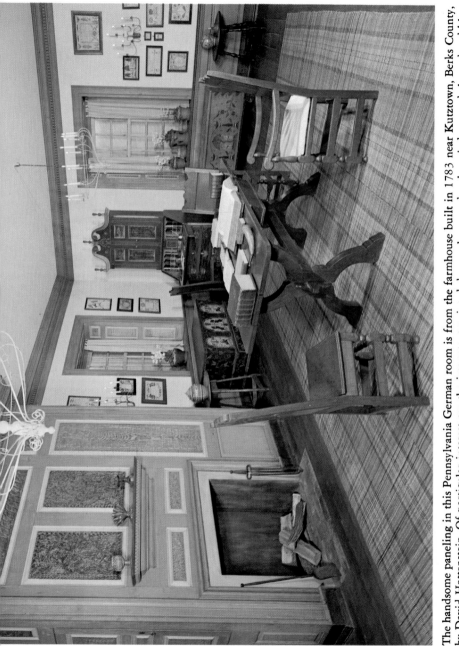

The handsome paneling in this Pennsylvania German room is from the farmhouse built in 1783 near Kutztown, Berks County, by David Hottenstein. Of particular interest are the important painted dower chests under the windows and the red-and-blue painted desk-and-bookcase, a rural version of the Chippendale style. Pennsylvania German *frakturs* enliven the walls. (Winterthur Museum)

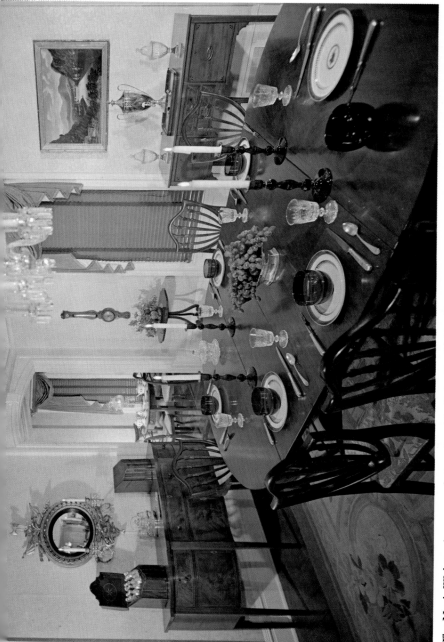

The Noah Webster house was designed and built by David Hoadley in 1822 at New Haven, Connecticut. The dining room, with its mahogany Hepplewhite table set for dessert, is furnished with Federal pieces dating from 1790–1800. The gilded girandole mirror over the sideboard at left is crowned with axes and flags. Thomas Chambers' painting *A View Near Anthony's Nose, Hudson Highlands, New York* hangs at the right. (Greenfield Village and Henry Ford Museum)

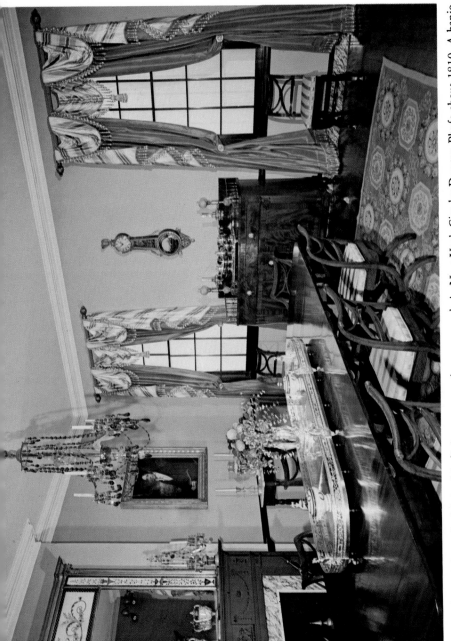

The Federal chairs and table in this dining-room setting were made in New York City by Duncan Phyfe about 1810. A banjo clock hangs above the sideboard between the windows. The curtains are fashioned after a Parisian design. (The Metropolitan Museum of Art)

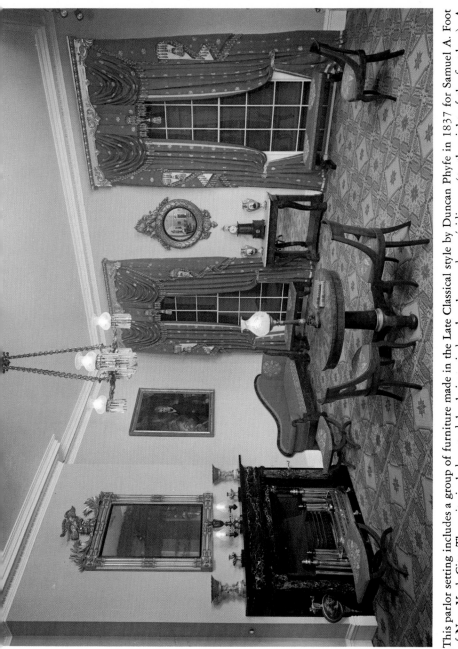

This parlor setting includes a group of furniture made in the Late Classical style by Duncan Phyfe in 1837 for Samuel A. Foot of New York City. The suite includes gondola chairs, window benches, and a méridienne (to the right of the fireplace). A lighthouse clock stands on the pier table between the windows. (The Metropolitan Museum of Art)

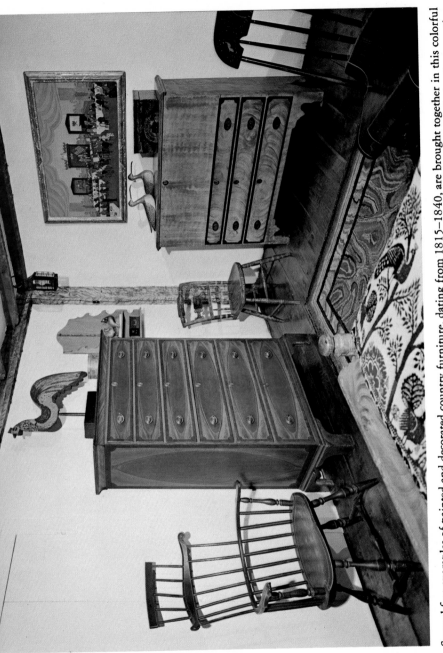

Several fine examples of painted and decorated country furniture, dating from 1815–1840, are brought together in this colorful bedroom. The tall chest of drawers has been elegantly painted to resemble mahogany and satinwood. The painting is an auction scene of the 1920's by Wood Gaylor. (Privately owned)

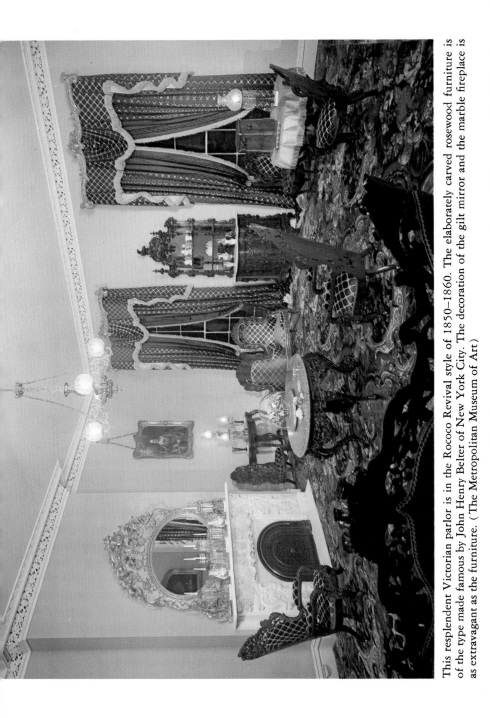

This resplendent Victorian parlor is in the Rococo Revival style of 1850–1860. The elaborately carved rosewood furniture is of the type made famous by John Henry Belter of New York City. The decoration of the gilt mirror and the marble fireplace is as extravagant as the furniture. (The Metropolitan Museum of Art)

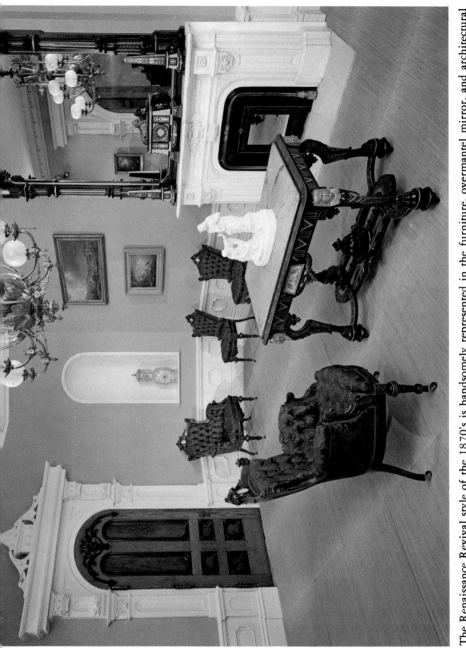

The Renaissance Revival style of the 1870's is handsomely represented in the furniture, overmantel mirror, and architectural elements in this sitting room from the forty-room mansion built by Jedediah Wilcox at Meriden, Connecticut. Mother-of-pearl cameos decorate the crests of the chairs and the mirror. (The Metropolitan Museum of Art)

116. Below: Windsor settee. Though large benches are frequently encountered, this two-chair-back settee is a rare form. Andrew Gautier of Prince Street advertised in the *New York Gazette* in 1765, ". . . High back's, Low back's and sack back chairs and settees, or double seated fit for Piazza or Gardens. . . ." Maple, hickory, and pine. Rhode Island. 1750–1800. Length 37″. (Henry Ford Museum)

117. Right: Comb-back, writing-arm Windsor. This dramatic form is fitted with a drawer and candle slide under the writing arm. It was originally owned by Reverend Learned of Westminster, Connecticut. Maple, pine, and oak. Connecticut. 1770–1800. Height 46¼″. (Henry Ford Museum)

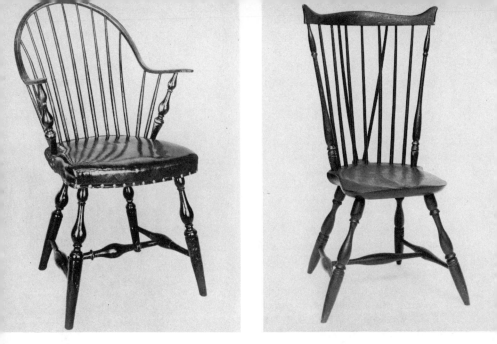

118. Left: Upholstered Windsor armchair. This piece not only bears the paper label of John DeWitt, "Windsor chair maker at No. 47, Near Coenties Slip, New York," but also boasts the printed label of "William W. Galatian, Upholsterer and Paper Hanger No. 10 Wall-Street, New York." DeWitt made Windsors for New York's Federal Hall, too. Pine, maple, and hickory. New York. 1797. Dimension unavailable. (Joe Kindig III)

119. Right: Fan-back Windsor side chair. The eighteenth- and early nineteenth-century inventories of Rhode Island houses indicate an abundance of "green chairs." This example retains its original paint. Pine, maple, hickory. Rhode Island. Late eighteenth century. Height 39¾". (Joseph K. Ott)

"Blind fox" joint

120. Opposite left: Bow-back Windsor side chair. Newspaper advertisements from the eighteenth century sometimes refer to this form as a loop-back or balloon-back chair. Pine, maple, and hickory. New England. *Circa* 1800. Height 36". (Henry Ford Museum)

121. Opposite right: Low-back Windsor arm-chair. This form appears to have been most popular between 1740 and 1785. In Philadelphia the blunt arrow-splayed legs are usually braced by a recessed stretcher with bulbous turnings. Pine and maple. Probably Pennsylvania. *Circa* 1765. Height 28½". (Winterthur Museum)

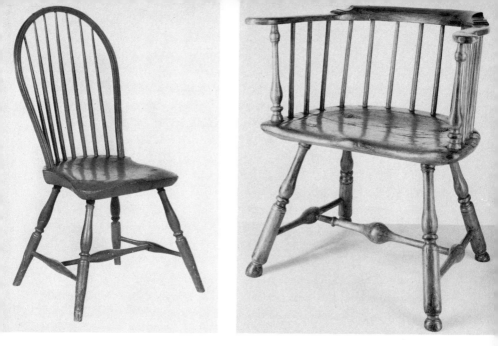

in a "uniformly handsom and genteel" manner, used "yellow bottom Windsor chairs" in the Little Parlor. Mrs. Washington worked yellow-and-brown shell-patterned cushions for these pieces, using a tent stitch on canvas. The inventory of Monticello, made after Jefferson's death, included in the large entrance hall "28 black painted chairs," known to be Windsors.

Windsors were almost always painted. Various hues of green, red, brown, blue, and black paint disguised the fact that several different woods had been used in the construction of a single chair —pine for seats; maple, hickory, oak, and ash for legs, spindles, stretchers, and top rails.

"Bamboo"-turned Windsor chairs, settees, benches, and other forms made their appearance during the early years of the nineteenth century. This particular type of Windsor furniture was popular until the 1840's and was made in almost every city and town in America. Often called rod-backs, or as Thomas Jefferson referred to them, "stick chairs," these pieces owe their design origins to Thomas Sheraton, who illustrated in his *Cabinet-Maker and Upholsterer's Drawing Book*, 1791–1794, chairs with rectan-

gular backs and turned spindles, arms, arm supports, and legs, which he called "Fancy Chairs."

Simply designed Windsor furniture was by no means relegated to the homes of the poor. George Washington owned a Windsor "riding chair"—an open carriage with a rod-back Windsor chair attached. Thomas Jefferson on July 19, 1800, in a letter to his Richmond business agent, George Jefferson, notes that "Mr. Barnes has made some mistake about the stick chairs he received and paid for half a dozen for me. They were painted of a very dark colour, & were in this style." His message was accompanied by a drawing of a five-spindle rod-back chair. Rod-back Windsor chair legs were turned upon a lathe. The same craftsman who created these pieces might well fashion a high or low stool, a table base, or even a cradle on rockers, figure 122.

123, 123a. Birdcage Windsor side chair. Made by Samuel Gragg. Increased comfort is achieved by the gentle backward flaring of the spindles and back rails on this, one of a pair of chairs. It was branded with a hammerlike metal mallet on the bottom of the seat. Other Gragg pieces bearing printed paper labels are known. Pine and maple. Boston. *Circa* 1810. Height 37″. (Gary Davenport)

122. Windsor cradle. The bottom is fashioned from a single pine board and has been deeply shaped. Pine and maple. New England. *Circa* 1800. Length 40¾". (Henry Ford Museum)

124. Birdcage Windsor settee. This ten-legged bench might have been used either on a porch or in a public meeting hall. Maple and pine. New England. *Circa* 1815. Length 83". (Henry Ford Museum)

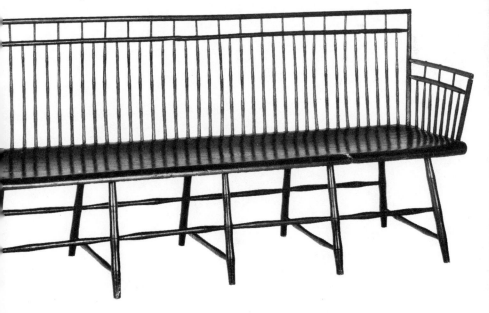

THE FEDERAL STYLE

The first phase of the Classical Revival movement in America was inspired by English styles. The decoration on the furniture designed by the Englishman Robert Adam (1728–1792) during and after the 1760's incorporated the Greek key, guilloche, and cameo-like medallions. By stringing small husks into tapering festoons, this distinguished designer and architect created a new kind of plaster relief decoration for ceilings and walls. Though many of Adam's designs had their origins in ancient Greece and Rome, he managed to use them in a new way when his firm created homes and furnishings for the English elite.

The Adam style was adapted for wide public use in George

125. Museum installation. This room setting contains numerous pieces of New England Hepplewhite furniture, including a shield-back chair with urn and drapery (right), which was probably carved by Samuel McIntire. (Henry Ford Museum)

Hepplewhite's *The Cabinet-Maker and Upholsterer's Guide* of 1788, thought to have been published posthumously by his wife Alice, and in Thomas Sheraton's *The Cabinet-Maker and Upholsterer's Drawing Book* of 1791–1794.

Hepplewhite (died 1786) illustrated chairs with straight, tapering legs, square in section, and with shield backs. His suggestions for decoration included drapery, swags, urns, medallions, sheaves of wheat, and Prince-of-Wales feathers, often inlaid. American furniture of this style dates roughly 1790 to 1810.

Thomas Sheraton (1751–1806), in contrast, favored the square line. The legs on Sheraton furniture are often turned and reeded. Chair backs are trellis-like and many times are centered with a superimposed panel in the form of a draped urn. American Sheraton furniture was crafted between 1795 and 1810.

During the ten years immediately following the printing of Hepplewhite's *Guide* and Sheraton's *Drawing Book*, American furniture was frequently modeled on the illustrations in those publications. In the work of Duncan Phyfe (1768–1854), a New York cabinetmaker, one can easily establish his familiarity with both Hepplewhite's and Sheraton's designs.

Another American craftsman who borrowed extensively from Hepplewhite's *Guide* was Samuel McIntire (1757–1811) of Salem, Massachusetts. McIntire carved chairs for cabinetmakers that are identical to some illustrated in the *Guide*.

Hepplewhite and Sheraton characteristics are often intermingled in the furniture created by American artisans during this first phase of the Classical period. Regional schools of cabinetmaking continued to exist, and in Boston, Salem, Portsmouth, New York, Philadelphia, and Baltimore distinct differences were evident.

NEW ENGLAND FURNITURE

The inlaid pilasters that flank the cupboard doors of the Sheraton sideboard, figure 126, and the turned and reeded legs are features

126. Right: Federal sideboard. Attributed to John and Thomas Seymour. The brass knobs are stamped with a floral design. Mahogany with bird's-eye maple inlay. Boston. 1800–1810. Width 53¼". (Henry Ford Museum)

127. Above: Federal work table. Possibly made by John and/or Thomas Seymour. Mahogany with veneered panels of figured birch. Boston. 1800–1810. Height 29¾". (Winterthur Museum)

128. Right: Federal card table. Carving attributed to Samuel McIntire. The spade feet are painted black to simulate ebony. Mahogany. Salem, Massachusetts. 1790–1810. Height 29½". (Henry Ford Museum)

associated with the Boston cabinetmaking establishment of John (1738–1818) and Thomas (1771–1848) Seymour.

The fabric bag on the mahogany and figured-birch Massachusetts work table, figure 127, is attached to the lower drawer, and is intended for the storage of sewing or other needlework. The border of shaded lunettes on the top of this exquisite piece and the handsomely veneered panels are also characteristic of Seymour craftsmanship.

Samuel McIntire, the famous Salem, Massachusetts, architect and craftsman, is credited with the elaborate carving on the semicircular Hepplewhite card table, figure 128. Typical of his work are the rosette-carved edge, the carved bowknot, and the carved pendant grapes and leaves on all four legs.

Most Hepplewhite furniture is constructed with slender tapering legs and spade feet. The chair, figure 129, is elaborately carved with a sheaf of wheat on the top rail and an urn and swags on the back. This piece is believed to have been carved by McIntire for Salem's merchant prince, Elias Hasket Derby. Much of McIntire's greatest work was commissioned by this distinguished patron.

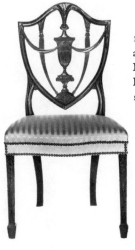

129. Federal side chair. Carving attributed to Samuel McIntire. Mahogany. Salem. 1790–1800. Height 38⅜". (Henry Ford Museum)

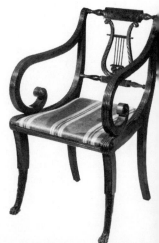

131. Federal armchair. From the shop of Duncan Phyfe. Mahogany. New York City. *Circa* 1815. Height 33". (Henry Ford Museum)

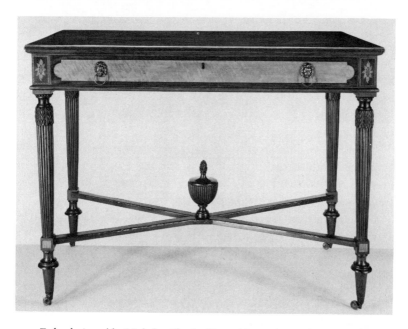

130. Federal pier table. Made by Charles-Honoré Lannuier. Mahogany with satinwood and rosewood. New York City. 1805–1810. Width 49″. (Winterthur Museum)

NEW YORK FURNITURE

Today, New York Federal pieces are perhaps the most prized of all Early Classical furniture. Public interest in the late eighteenth-century excavations in Greece and Rome inspired French cabinetmakers to copy or adapt the furniture forms being discovered. Paris replaced London as the international center of taste, and France, the political ally of the newly formed American nation, became its style dictator.

Charles-Honoré Lannuier (1779–1819), a French émigré cabinetmaker, advertised in the July 1803 *New-York Evening Post* "all kinds of Furniture, Beds, Chairs &c in the newest and latest French fashion." Lannuier noted that he had brought ". . . gilt and brass frames, borders of ornaments, and handsome safe locks, as well as new patterns." The labeled pier table, figure 130, is an early example of his New York cabinetmaking efforts, and its

design reflects elements of the declining Sheraton style—the legs are turned and reeded and carved above the reeding. Furniture of this period was sometimes constructed with metal casters attached to the feet.

Lannuier's most ambitious competition was provided by the fashionable cabinetmaking shop owned and operated by the Scottish immigrant Duncan Phyfe. Today, Phyfe's name is almost synonymous with the Federal style. This is not surprising since the furniture from his firm represents all phases of the Classical movement —Hepplewhite, Sheraton, Empire, and Victorian, and in some instances incorporates elements from all of them. The reeding on the armchair, figure 131, is indicative of the Sheraton style. The use of the lyre splat at the back and the hairy legs and "dog-paw" feet are typical of the Empire period. Phyfe's woodworking vocabulary was extensively used by other New York furniture-makers.

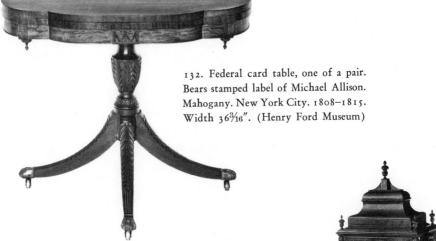

132. Federal card table, one of a pair. Bears stamped label of Michael Allison. Mahogany. New York City. 1808–1815. Width 36¾₆". (Henry Ford Museum)

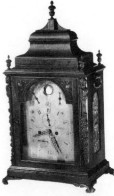

133. Federal shelf clock. Case made by Slover and Kortright, New York City; movement by Andrew Billings, Poughkeepsie, New York. Mahogany with satinwood inlay and brass trim. Dated 1795. Height 24¾". (Henry Ford Museum)

If the mahogany pedestal-base card table, figure 132, was not labeled with the stamp of Michael Allison (active 1800–1845), it might well be attributed to Phyfe's shop on stylistic grounds. The carved bowknot-and-drapery in the central panel and the water-leaf carving and reeding on the "saber" legs were embellishments used by both Phyfe and Lannuier.

Cabinetmakers like those mentioned above were successful businessmen and members of polite society. Mr. Phyfe, upon his death in 1854, left an estate of nearly half a million dollars. His furniture was obviously expensive, for in January 1816 he billed Charles N. Bancker of Philadelphia for $800.00, less a 3 percent discount for cash, for "12 Mahogany chairs, a Sofa, a Piere table, a Pair of card tables plus $19.00 for packing."

A clockmaker generally obtained his cases from a furniture-maker. The bracket clock, figure 133, is inlaid with satinwood and further embellished with brass trim. A brass plate with an oval insert is inscribed, "Made by Andw Billings for C. D. Colden, 1795."

PHILADELPHIA FURNITURE

It is not surprising that some of the handsomest Federal furniture made in America should have come from the cabinetmakers' shops of Philadelphia, for that city was, until the late 1790's, "the most beautiful and best built city in the nation, and also the wealthiest, though not the most ostentatious."

It would have indeed amazed Thomas Sheraton, a man of very limited means, to know of the great influence his *Drawing Book* would exert on early Federal cabinetmaking, especially in Philadelphia.

Samuel Walton (working 1763–1777), the cabinet- and chairmaker, in his warehouse on Spruce Street offered ". . . all kinds of household furniture, of the newest and most elegant patterns, which have been lately imported from Europe." George

134. Left: Federal side chair. Maple and ash. Philadelphia. 1796. Height 38". (The Metropolitan Museum of Art)

135. Right: Federal armchair. Attributed to the shop of Ephraim Haines. Mahogany. Philadelphia. *Circa* 1800. Height 34⅝". (Henry Ford Museum)

Washington's favorite cabinetmaker, John Aitken (working by 1775), commented on "the completest and newest taste now prevailing in this city." The fashion-conscious Elias Hasket Derby of Salem ordered in 1796, through Joseph Anthony and Company of Philadelphia, a group of twenty-four painted oval-back chairs, figure 134. Three design variants exist in this distinctive set intended to grace the home of "the richest man in the nation." The quality of the polychrome decoration—delicately painted bowknots, ostrich plumes, peacock feathers, and floral motifs on a plain-painted background—remains unsurpassed on American furniture. Sheraton had discussed the practice of painting and gilding furniture and expressed regret that the wonderful effect that could be achieved by using these techniques of decoration could not be successfully suggested by the engraved drawings in his book.

Craftsmen like Henry Connelly (1770–1826) and Ephraim Haines (1775–c. 1811), the cabinetmaker who had in 1806 made for Stephen Girard, the great Philadelphia banker, "12 chairs one sofa 2 pier tables and 4 stools" from imported ebony, preferred to work with fine-grained mahogany. When constructing chairs, they also appear to have favored the Sheraton-style back, which was rectangular in shape and had a crossbar just above the seat,

136. Federal Pembroke table. Stylized floral designs in oval panels flank the drawer. Mahogany with satinwood inlay. Philadelphia. *Circa* 1800. Length 32¼". (Henry Ford Museum)

figure 135. Perhaps neither man actually owned Sheraton's *Drawing Book,* but a plate from it published in the *Philadelphia Journeyman Cabinet and Chairmakers' Book of Prices,* 1795, helped publicize the style. It also stated that "Day Men . . . work from six to six o'clock, the Employer to find Candles."

Hepplewhite, in *The Cabinet-Maker and Upholsterer's Guide,* 1788, recommended finishing chairs "with paint or japanned work . . ."; however, ". . . chairs in general are made of mahogany." These were usually embellished with inlay or carving. Delicate line inlay decorates the front of the drawer, the legs, and the unusually shaped leaves of the Hepplewhite Pembroke table, figure 136.

FURNITURE FROM BALTIMORE AND THE SOUTH

Baltimore emerged as a major center of cabinetmaking during the early Federal period. At this time profits realized from exports

enabled newly rich citizens to build elegant homes and to furnish them with sumptuous furniture.

Much of the furniture was elaborately inlaid with contrasting ovals and circles, pendant bellflowers, and string banding. Materials for these elegant inlays were imported on clipper ships—mahogany, satinwood, and tulipwood from the West Indies, and rare veneers from the Far East and Africa.

In the South, furniture design very closely resembled the English "fancy" pieces with painted landscapes and gilt decoration. Many times elaborate reverse paintings on glass, known as *eglomisé* decoration, were also included.

Hepplewhite in 1788 recommended the finishing of furniture in this manner: ". . . A new and very elegant fashion has arisen within these few years, of finishing them [chairs] with painted or japanned work, which gives a rich and splendid appearance to the minuter parts of the ornaments. . . . Japanned chairs should have cane bottoms, with linen or cotton cases over cushions to accord with the general hue of the chair."

In *The Cabinet Dictionary*, Sheraton advised that "Varnish colours" were distinctly different from "common oil painting" and should be used exclusively when working with "fancy furniture." "Fancy Sheraton" pieces in America were made and sold by the same craftsmen who advertised Windsor chairs; their use, however, was usually confined to the "better" rooms of the house.

Plate 38 of Sheraton's *The Cabinet Dictionary* illustrated a "Sister's Cylinder Bookcase." It probably inspired the creation of the mahogany desk-and-bookcase, figure 137, crafted in Baltimore, or possibly Philadelphia, about 1811. Inlaid satinwood ovals, bandings, and drawer fronts, and the mirrored and painted glass panels, as well as the inscription on the bottom of one of the drawers, "M Oliver Married the 5 of October 1811 Baltimore" speak strongly for a Baltimore attribution. Margaret Oliver, daughter of the Baltimore millionaire merchant Robert Oliver, married Roswell Lyman Colt.

The oval sewing table, figure 138, was constructed with a

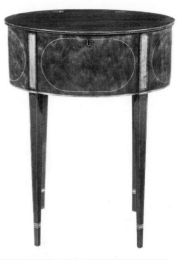

137. Below: Federal cylinder desk-and-bookcase. Mahogany and satinwood with painted glass panels. Baltimore. *Circa* 1811. Height 91″. (The Metropolitan Museum of Art)

138. Right: Federal sewing table. Mahogany with satinwood and ebony inlay. Baltimore. *Circa* 1800. Height 29⅝″. (Henry Ford Museum)

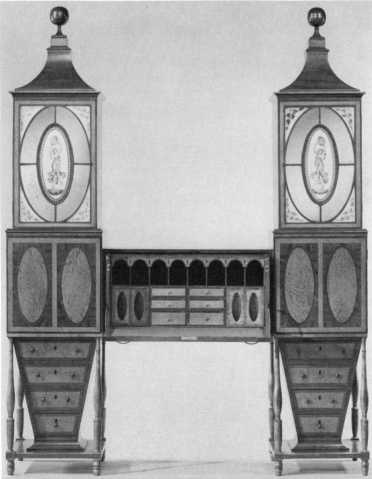

139. Federal side chair. The center splat of this oval-back piece is inlaid with a pendant bellflower which is identical to that found on documented Maryland pieces. Mahogany with satinwood inlay. Philadelphia or Baltimore. *Circa* 1795. Height 36¼". (Henry Ford Museum)

140. Federal settee. This piece and two matching side chairs are attributed to the shop of Thomas Renshaw. The painted decoration was probably executed by John Barnhart. Maple, hickory, and walnut. Baltimore. *Circa* 1815. Length 70¼". (Henry Ford Museum)

hinged lid edged by a narrow band of satinwood inlay. Both ebony and satinwood veneers were used to create the inlay and cuffs on the slender tapering Hepplewhite legs of this Baltimore piece.

Joseph B. Barry, one of Philadelphia's most popular cabinet-makers during the early 1800's, maintained a branch in Baltimore for over two years. The molded legs on the oval-back chair, figure 139, might indicate a Philadelphia origin, since few Baltimore pieces with this design are known.

In 1810 some 50 Maryland cabinetmakers produced furniture valued at $237,043.00. During that same year Virginia listed 507 dozen chairs at $9,125.00. On this basis, the $237,043.00 from Maryland represents a very large production indeed.

Although painted furniture was produced in many centers of cabinetmaking, Baltimore pieces remain unequaled. Advertisements in local newspapers by John and Hugh Findlay indicate that between 1799 and 1833 they worked at South Frederick Street and North Gay Street. Perhaps their stiffest competitors were Thomas Renshaw and John Barnhart. Renshaw actually made the furniture and Barnhart, the "Ornamenter," decorated it. The four-chair-back settee, figure 140, attributed to these artisans, is painted

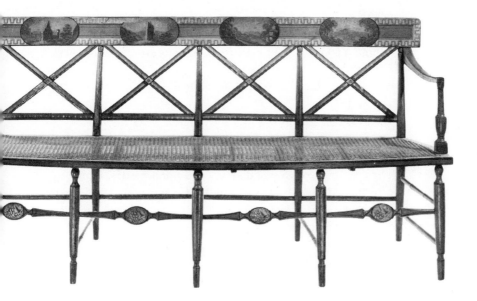

in sepia, brown, yellow, and black; the landscapes, painted in ovals, interrupt the "Greek key" motif that surrounds the top rail and seat frame.

Southern side tables, sideboards, and hunt boards are especially tall. The elegance of the painted, marble-top Baltimore example, figure 141, contrasts with the simplicity of the pine example with brass drawer pulls, figure 142. It is probably from a rural crafts-

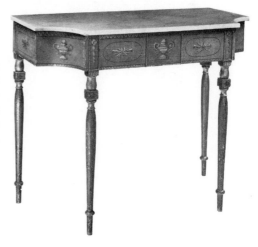

141. Federal side table. This serving table is fitted with a shaped marble top and is decorated with gilt-painted Classical motifs, including urns and two horns tied with a ribbon. Pine. Baltimore. *Circa* 1800. Width 44¼". (Henry Ford Museum)

man's shop. Yellow pine was used throughout for the construction of this Hepplewhite-style piece.

The walnut chest with pine interior, figure 143, was made by Godfrey Wilkin of Hardy County, Virginia. The putty inlay relates information about the owner, "March 1 Jacob Wilkin His Chest A.D. 1801." Seven small side-by-side drawers are revealed when the front, which is hinged at the bottom, is opened.

The card table with inlaid satinwood floral motifs, figure 144, was constructed in Charleston, South Carolina. As with much furniture from this region, the surface of the inlay is engraved. The basket of flowers and broad floral scrolls on the skirt and legs are unusual in their naturalism. Few documented pieces of Charleston furniture have been discovered. Most of those that are known, however, are embellished with a skillfully inlaid eagle enclosed in an oval medallion.

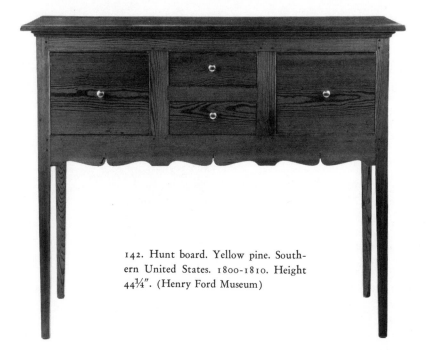

142. Hunt board. Yellow pine. Southern United States. 1800-1810. Height 44¼". (Henry Ford Museum)

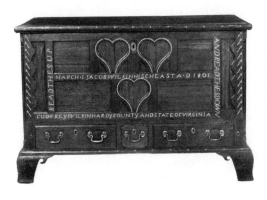

143. Chest. Rural craftsmen very often used forms that had become outmoded in sophisticated centers of cabinetmaking. Though this piece is in the Chippendale style, it is dated 1801. Walnut, pine, with putty inlay. Hardy County, Virginia. Length 54¾". (Henry Ford Museum)

144. Federal card table. Charleston cabinetmakers frequently defined the design of their inlay by actually engraving upon the surface of the wood. This technique was used to enhance the linear quality of the basket and floral tendrils on this piece. Mahogany inlaid with satinwood. Charleston. *Circa* 1800. H. 29½". (Henry Ford Museum)

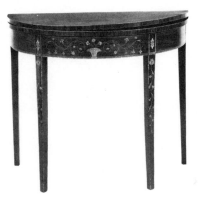

UPHOLSTERED FURNITURE

The upholstering of furniture during the Federal period was almost always executed by trade specialists. Some of these professionals would finish carriage seats and casket interiors as well.

The nineteenth-century upholstering tools, figure 145, are German; however, identical American examples are known.

Thomas Sheraton in *The Cabinet Dictionary* (1803) wrote of the ancient Greek manner of eating: "The table was placed in the middle, round which stood three beds covered with cloth or tapestry. . . . Upon these the guests lay inclining the superior part of their bodies upon their left arms, the lower part being stretched out at full length, or a little bent." Duncan Phyfe had no such extravagant banquet in mind when he made the Récamier sofa, figure 146. Constructed in the new "Greek" style, the

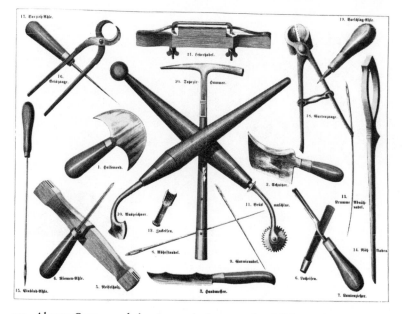

145. Above: German upholstering tools from a colored lithograph. Early nineteenth century. (Henry Ford Museum)

146. Below: Federal Récamier sofa. From the shop of Duncan Phyfe. Mahogany. New York City. *Circa* 1810. Length 85½″. (Henry Ford Museum)

reeded frame is ornately decorated with carved swags, bows, and tassels. The legs curve outward and terminate in brass animal-paw feet that are finished with casters. By 1815 sofas of this form were advertised by country and city cabinetmakers alike and were almost always fitted with a round bolster.

Most "Martha Washington" chairs were made in New Eng-

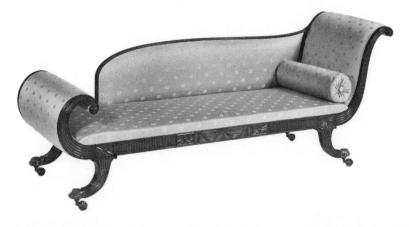

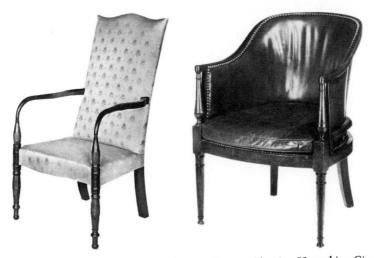

147. Left: Federal open armchair. Mahogany. Portsmouth, New Hampshire. *Circa* 1800. Height 46″. (Henry Ford Museum)

148. Right: Federal armchair. Made by George Bright. Mahogany. Boston. 1797. Height 31¼″. (Henry Ford Museum)

land. The mahogany Sheraton example, from Portsmouth, New Hampshire, figure 147, has a turned and carved front leg that becomes the arm support. During the eighteenth century such pieces were frequently called "lolling chairs"; however, the paper label of Joseph Short (1771–1818), Newburyport, Massachusetts, states that he "also makes Martha Washington chairs." Hepplewhite variants with square tapering legs and open arms are more frequently encountered in antique shops today.

The Old Boston State House, designed by Charles Bulfinch, was furnished with mahogany chairs, figure 148, made by George Bright in 1797. These were originally upholstered in brown leather with a separate loose cushion. The rather unusual form of the chair was inspired by the gondola-like French *fauteuil de bureau*.

Leather upholstery appears to have been extremely popular in the late eighteenth and early nineteenth centuries. George Washington in 1790 purchased from Thomas Burling, "cabinetmaker, 36 Beekman Street," New York, for £7 an "Uncomn Chr," which had a brass-nailed, leather-upholstered back and seat.

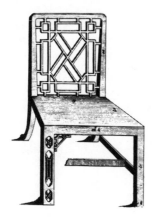

149. Design for a Chinese chair from *The Gentleman and Cabinet-Maker's Director*, third edition, 1762, by Thomas Chippendale. Plate 26. (Privately owned)

THE CHINESE INFLUENCE

Americans were just as obsessed with things Oriental during the early years of the Republic as they had been in the William and Mary and Queen Anne periods. This was not without precedent, for in the seventeenth century japanned boxes and furniture, and Chinese porcelains had been especially popular.

Acknowledging the keen mid-eighteenth-century English interest in Eastern-inspired furnishings, Thomas Chippendale in his *Director* of 1754 included designs for Chinese chairs, figure 149. Some of his Oriental motifs were incorporated into American furniture.

By the early nineteenth century the clipper-ship trade with the East produced vast fortunes for New England's merchant princes. American imports were not confined to pieces of furniture —lacquered trays, paintings, porcelain, pottery, wallpaper, ivory carvings, and even children's toys were purchased in Canton, the only Chinese port open to foreign trade until the Opium War of 1839–1842. Goods were sold in *hongs*, factories or warehouses that lay between the walled city and the Canton River.

In 1795 Andreas Everardus Van Braam Houckgeest, retired director of the Dutch East India Company in Canton, emigrated to America. He furnished his new home on the banks of the Dela-

ware River with one of the largest known collections of Oriental objects. Contemporary accounts indicate that "the furniture, ornaments, everything at Mr. Van Braam's reminds us of China. It was even impossible to avoid fancying ourselves in China, while surrounded at once by living Chinese, and by representations of their manners, their usages, their monuments, and their arts."

George Washington, while on a trip to New York, purchased from Samuel Dunlap, "store keeper, 13 Queen St.," a dressing glass for £8. It closely resembles the Oriental cypress example, figure 150, with lacquer and gilt decoration. This piece, however, has birds and floral motifs painted on the face of the mirror.

150. Toilet mirror. Cypress. China. Late eighteenth or early nineteenth century. Height 32⅝″. (Henry Ford Museum)

152. Federal candlestand. This tilt-top table is painted with chinoiserie figures. Maple and pine. United States. 1800–1825. Height 28½″. (Henry Ford Museum)

151. Watercolor painting of Chinese craftsmen fashioning furniture for the Western market. China. 1813. Height 11¾", width 15". (Ginsburg & Levy, Inc.)

The Chinese workmen in the painting of an Oriental furniture workshop, figure 151, are making Western-style furniture for export. Caned couches and settees, much like those being worked on, are still found in the coastal homes of New England, where returning captains brought them as gifts for their families.

Though similar in form to tables shown in the workshop painting, the candlestand, figure 152, is of American origin. This maple piece is painted dark brown and embellished with chinoiserie paintings in gold, red, and blue-green.

THE EMPIRE STYLE

The source of inspiration for American cabinetmaking shifted during the close of the eighteenth century from London to Paris, and consequently the second phase of the Classical movement in America more closely follows French Empire prototypes than English examples.

French cabinetmakers of the period were familiar with the furniture used by the Greeks and Romans from vase paintings and grave monuments being excavated at ancient sites. They borrowed the Greek *klismos* shape with the incurved saber leg and the curule chair with a cross-base support. Gifted carvers reused the *monopodia*—a design in which an animal leg is surmounted by an animal head—and winged caryatids, griffins, mermaids, and animal forms became familiar features of Empire furniture.

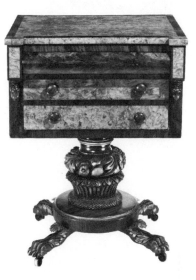

153. Left: Empire girandole mirror. The round, marblelike balls that appear on looking glasses and mirrors of this period are often counted and mistakenly thought to be an indication of the number of states in the Union when the piece was made. Pine and gesso with gold leaf. United States. 1800–1820. Height 39". (Henry Ford Museum)

154. Right: Empire work table. Made by J. Lasselles. Mahogany and bird's-eye maple veneer. New York. *Circa* 1820. Height 29⅜". (Henry Ford Museum)

During this period New York City emerged as the center of American high-style cabinetmaking, with Philadelphia and Boston close behind. French immigrants brought with them their decorative devices—metal inlay and ormolu mounts in the form of wreaths, trophies, swans, and medallions. The use of Egyptian motifs—the dog-paw foot and lyre splats and supports—was widespread. These new developments dominated urban furniture design.

Charles-Honoré Lannuier's admirable ability to combine the Directoire, the Consulate, and the Early Empire styles was perhaps unequaled by his contemporaries. The Empire card table, figure 155, made of mahogany with gilding further embellished with ormolu mounts and wire inlay, is one of a pair from the Van Rensselaer manor house near Albany, New York. These distinctive pieces were made for Stephen Van Rensselaer IV and his wife, Harriet Elizabeth Bayard, about 1817. In 1839, when the manor house became theirs, they took the pieces to their new home. The winged supports and lion's-paw feet are typical of Empire design. The ormolu mounts were probably made in Paris, where Lannuier's brother was an *ébeniste* (cabinetmaker).

During the Empire period exotic marbles, slate, and other beautiful stones were finely cut and inlaid into the tops of tables

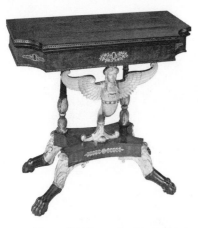

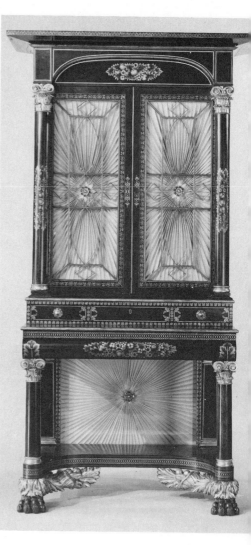

155. Above: Empire card table. Labeled by Charles-Honoré Lannuier. Mahogany with gilding. New York. *Circa* 1817. Height 29¾". (Albany Institute of History and Art)

156. Below: Empire pedestal table. Made by Antoine Gabriel Quervelle. Mahogany with marble top. Philadelphia. *Circa* 1830. Height 29⁹⁄₁₆". (The Metropolitan Museum of Art)

157. Right: Empire secretary. Possibly made by Joseph Meeks & Sons. Ebonized mahogany with gilt and brass. New York. *Circa* 1825. Height 101". (The Metropolitan Museum of Art)

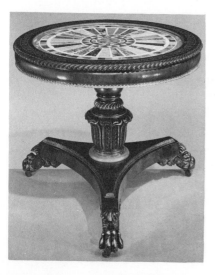

and other forms. The circular pedestal table, figure 156, is from the Philadelphia shop of Antoine Gabriel Quervelle, a Paris-born cabinetmaker who worked in Philadelphia from 1817 through 1856. His cabinet and sofa manufactory was on South Second Street, a few doors below Dock Street. This example very closely relates to other tables that he made for the East Room of the White House in 1829 during Andrew Jackson's administration.

New York furniture of the Empire style was bold, vigorous, and impressive. The secretary, figure 157, possibly made by Joseph Meeks & Sons, is made of mahogany painted black to simulate ebony and is certainly one of the most dramatic examples of formal American decorated furniture with gilt stenciling.

Young ladies of the "best" American families were encouraged to pursue such artistic endeavors as painting and music. In fact, music rooms were designed especially to house instruments made during the early years of the nineteenth century. The elaborately carved piano stool, figure 158, was fitted with a corkscrew mecha-

158. Below: Empire piano stool. Mahogany. Possibly New York. *Circa* 1829. Height 19″. (Henry Ford Museum)

159. Right: Empire upright piano. Made by Jonas Chickering. Crotch mahogany veneer on pine case. Boston. *Circa* 1830. Width 46″. (Henry Ford Museum)

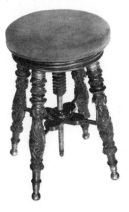

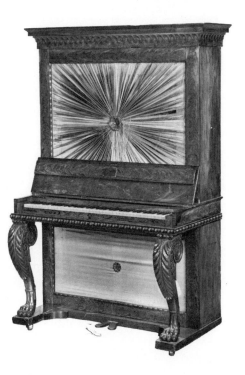

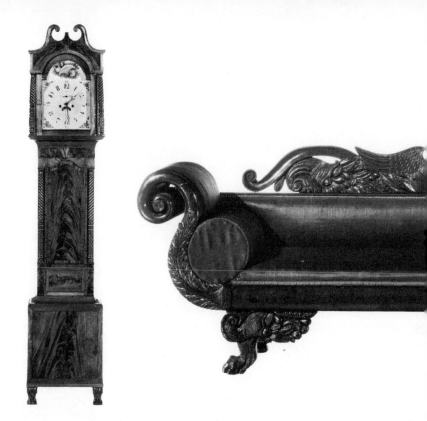

nism that made it easily adjustable. Figure 159 is an innovation, for it is the first upright Chickering piano, and, though Empire in form, elements of the infant Gothic Revival are evident in the pointed arch molding that surrounds the top of the case.

Makers of tall-case clocks in the Empire period incorporated such popular motifs as the rope-turned and pineapple-carved columns on figure 160. The carved paw feet are an interesting adaptation of an Egyptian form. The elegantly carved and richly veneered Empire sofa, figure 161, is a masterpiece of the Empire style. Cornucopias serve as wings for the hairy-paw feet. The back is formed of two cornucopias flanking an eagle that grasps a shield and a pair of arrows. Seldom is the design of Late Empire furniture so successful. This style was phased out during the 1840's when handcrafted furniture, no longer profitable to make, was replaced by bandsawed, heavily veneered, pillar-and-scroll pieces.

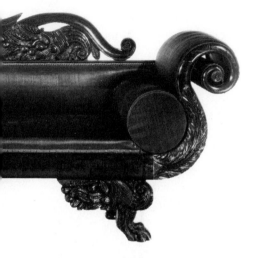

160. Far left: Empire tall-case clock. This timepiece once belonged to Stephen Foster. Mahogany. American. *Circa* 1830. Height 97″. (Henry Ford Museum)

161. Left: Empire sofa. Mahogany and mahogany veneer on pine frame. Massachusetts. *Circa* 1830. Length 96¾″. (Henry Ford Museum)

PILLAR-AND-SCROLL FURNITURE

American furniture of the Late Classical period, *circa* 1830–1850, was inspired by French designs developed during the Restoration. At this time the power machine, which for many years had influenced the manufacture of furniture, became the style dictator. Furniture forms were adapted so that manufacturers could use machines freely in the construction of even their most expensive pieces.

The revered New York establishment of Duncan Phyfe was not above manufacturing furniture in the new French style. Figure 162, a parlor suite ordered in 1837 by the New York attorney Samuel A. Foot for his home at 678 Broadway, is, by family tradition, from Phyfe's shop. The pieces are upholstered in a copy of the original fabric—crimson linen and wool woven with gold medallions.

One of Phyfe's most aggressive competitors was another New York firm, Joseph Meeks & Sons. In an 1833 broadside printed by Endicott & Swett, the Meeks plant boasted forty-one examples of furniture and two sets of draperies. These illustrated pieces, figure 163, indicate the full acceptance of the new pillar-and-scroll style —massive, flat, undecorated surfaces and C-scroll and S-scroll supports dominate the designs.

An 1840 Baltimore publication by John Hall, *The Cabinet*

162. Suite of parlor furniture. By tradition ordered from Duncan Phyfe. Mahogany. New York. 1837. Length of méridienne 72″. (The Metropolitan Museum of Art)

163. Advertisement for the firm of Joseph Meeks & Sons showing pillar-and-scroll furniture. Lithograph by Endicott & Swett. New York City. 1833. (The Metropolitan Museum of Art)

Maker's Assistant, illustrated in 198 plates and accompanying text the principles of the pillar-and-scroll style: "As far as possible, the style of the United States is blended with European taste, and a graceful outline and simplicity of parts are depicted in all the objects. . . . Throughout the whole of the designs in this work, particular attention has been bestowed in an economical arrangement to save labor; which being an important point, is presumed will render the collection exceedingly useful to the cabinet-maker. John Hall, Architect."

164. Ogee mirror. Mahogany veneer over pine. Massachusetts. 1840–1860. Height 24″. (Privately owned)

165. Illustration of three footstools from *The Cabinet Maker's Assistant* published by John Hall, Architect, Baltimore. 1840. (Henry Ford Museum)

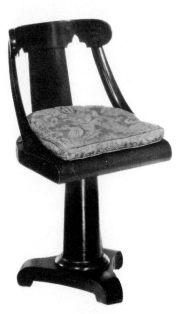

166. Pillar-and-scroll piano stool. Mahogany and mahogany veneer over pine. American. 1840–1860. Height 29¼″. (Henry Ford Museum)

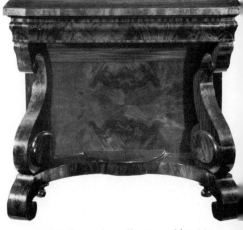

167. Pillar-and-scroll pier table. Mahogany veneer on pine. American. 1830–1850. Width 43″. (Henry Ford Museum)

168. Painting of the Adams family by an unknown American artist. The family is gathered about a Pillar-and-Scroll center table. Oil on canvas. 1850–1860. 27¾" x 41¾". (The Colonial Williamsburg Foundation)

Unlike most popular styles, Late Classical furniture continued to be made even though other fashions flourished. Throughout the remainder of the nineteenth and through the first quarter of the twentieth century, simple bandsaw-cut furniture continued to be constructed.

On the earliest pieces the veneers are usually thicker and their grains more carefully matched than on later examples. Rosewood and mahogany were especially popular and were most generally used over pine carcasses.

THE EARLY VICTORIAN
STYLES

GOTHIC REVIVAL FURNITURE

Andrew Jackson Downing (1815–1852), in his 1850 publication, *The Architecture of Country Houses,* devoted a great deal of space to the Gothic, a style he much favored and promoted.

In America, Gothic furniture never achieved the general popularity that other revival styles enjoyed. The motifs associated with this movement were, however, incorporated as decorative devices into the designs of furniture throughout the last two-thirds of the nineteenth century. Pointed arches, cusps, crockets, trefoils, and pierced tracery were used on even the mass-produced furniture of the 1890's from Grand Rapids, Michigan.

These rather cumbersome efforts contrasted sharply with the

HARTFORD. COTTAGE OF WM. H. DRAKE. 1845.

169. Architectural drawing for the cottage of William H. Drake, Hartford, Connecticut. By A. J. Davis. American. 1845. (The Metropolitan Museum of Art)

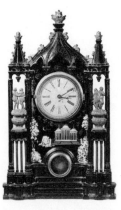

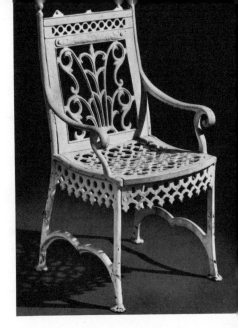

170. Victorian clock in the Gothic style. The pediment of this unusual piece is decorated with Gothic crockets. Cast iron. American. 1850. Height 21⅝″. (Henry Ford Museum)

work of the New York-based architect Alexander Jackson Davis, whose architectural exhibits at the New York Crystal Palace in 1853 won both diplomas and medals, and consequently Davis received commissions throughout the United States.

The relative simplicity of the "cottage of Wm. H. Drake. 1845," constructed by Davis in Hartford, Connecticut, contrasts sharply with the "Gothic Villa" called Lyndhurst, which he built on the Hudson in Tarrytown, New York, for New York City's Mayor, General William Paulding. This magnificent dwelling retains much of the original furniture designed by Davis, and in its completeness is perhaps a unique example of Gothicism created for "those who love shadow, and the sentiment of antiquity and repose."

Though contemporary critics of the style observed that Gothic pieces were "instruments of torture," few nineteenth-century libraries were complete without pointed-arch-and-steeple clocks and cusp-and-crocket-decorated bookcases.

William Paulding's Lyndhurst was purchased in 1864 by the New York City merchant George Merritt. In 1865 Merritt commissioned A. J. Davis, the original designer, to enlarge the structure. Davis's express intent of striking the eye "by the picturesque

171. Victorian armchair in the Gothic style. Trefoil motifs serve as drop finials on the skirt of this outdoor piece. Cast iron. American. *Circa* 1870. Height 34⅜". (Henry Ford Museum)

172. Victorian table in the Gothic style. Designed by A. J. Davis. Oak. American. *Circa* 1841. Length 38". (Lyndhurst, National Trust for Historic Preservation)

173. Photograph of the dining room at Lyndhurst. This dining wing was added to the house in 1865. (Lyndhurst, National Trust for Historic Preservation)

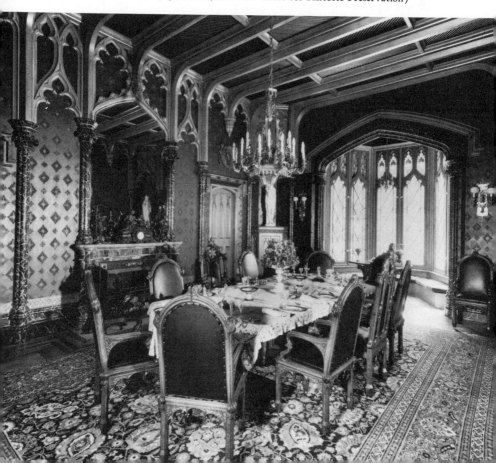

outline of towers, turrets, gables, and pinnacles; and with the pleasing variety afforded by the windows decorated with mullions and tracery" was followed. At the time of this expansion, new furniture was designed for the interior, which was almost doubled in size.

The dining room, figure 173, perhaps one of the most cohesive displays of Gothicism in America, remains unaltered today. The plastered walls were painted with a stenciled floral pattern and covered by a raspberry-red glaze. Woodwork was grained and marbelized. Oak and mahogany were used in the construction of the leather-upholstered seating pieces. The radiator covers, of cast iron, attest to the Victorian interest in advanced technological achievements of the day.

The nineteenth-century Gothic Revival was not always a popular movement. Charles L. Eastlake, an English architect and designer, noted in 1878 (in the fourth edition of *Hints on House-hold Taste*) that ". . . there are not a few people to whom the very mention of Gothic furniture is very naturally associated with everything that is incommodious and pedantic."

Despite adverse attitudes, Gothic motifs permeated nine-teenth-century design. These motifs were especially popular with the manufacturers of iron furniture. Gothic garden seats, clocks, folding chairs, school desks, railroad train seats, theatre seats, and even hospital beds were mass-produced in iron foundries.

Architectural use of Gothic designs was not exclusively the prerogative of the wealthy. Just as today, plans for the construction of inexpensive houses were offered to America's prospective home-builders in contemporary periodicals. *Godey's Lady's Book* several times featured "Model Cottages," once even a new "Tudor version." The pieces selected to furnish such modest homes were generally machine-made. Favored woods were mahogany, rose-wood, and walnut. Lyndhurst's handcrafted pieces, for which Davis billed Paulding $50.00 in September of 1841 for "Fifty designs for furniture, & various services," were mostly of oak.

174. Victorian side chair in the Gothic style. This chair retains the original black horsehair upholstery in an impressed floral design. Mahogany. American. 1830–1850. Height 38". (Sunnyside, Sleepy Hollow Restorations)

175. Victorian washstand in the Gothic style. Mahogany veneer on pine. American. 1840–1860. Height 33". (Henry Ford Museum)

176. "Model Cottage" published in *Godey's Lady's Book*. Gothic motifs permeate this modestly priced home. (Shelburne Museum, Inc.)

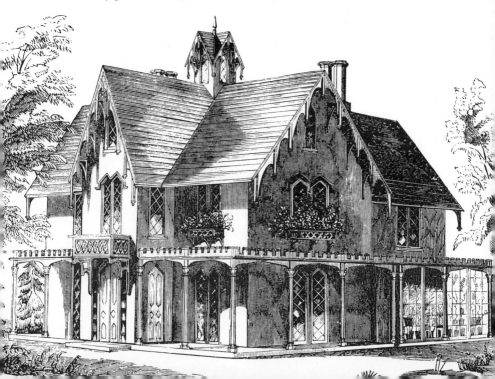

Davis highly recommended the firm of Burns and Trainque, who made "the most correct Gothic furniture . . . executed in this country."

John Jelliff of Newark, New Jersey, made beautiful hand-crafted furniture in walnut and rosewood between 1835 and 1890 in the Gothic, Rococo, Louis XVI, and Renaissance Revival styles. Like most artisans working in the nineteenth century, he finally succumbed to the Industrial Revolution because, he said, the "evils of mass production . . . cause much inferior furniture to flood even the finest stores."

Though exuberantly Gothic pieces were made, most American Gothic furniture is only so by virtue of the application of small details and motifs and is conservative in nature. Washington Irving selected for his dining room at Sunnyside on the Hudson mahogany side chairs, figure 174, that have three pointed arches incorporated into what might otherwise be mistaken for a Sheraton chair. The original black horsehair upholstery is impressed with a floral design.

The simple washstand, figure 175, with a serpentine-shaped drawer, towel racks at the side, and cupboard below, is constructed of pine and enriched with mahogany veneer. The paneled doors on this bedroom piece are the predominant Gothic design feature.

ROCOCO REVIVAL FURNITURE

During the essentially revivalistic nineteenth century, the general popularity of one style did not negate the acceptance of another. The "battle of styles" often produced extraordinary inconsistencies, which explains how a chair from a suite of parlor furniture might be made in the Gothic style, a table from the same suite in the Elizabethan style, and another chair in the Rococo style.

The Rococo or "Modern" movement of the 1850's and 1860's owed an apparent debt to French designs of the eighteenth century, which American craftsmen modified and synthesized with

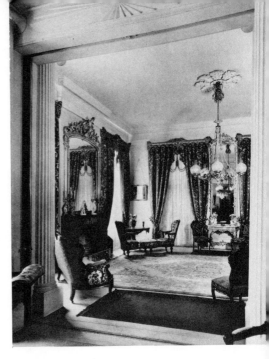

177. Room interior. The parlor of the Greek Revival home built in 1845 for Judge Edward Turner's daughter in Natchez, Mississippi, is furnished with Rococo Revival furniture. (Mrs. George M. D. Kelly)

current technical achievements. The richly carved, elaborately ornamented, undulating lines of Rococo furniture were achieved by the use of a new process of lamination developed first by John Henry Belter of New York City. In 1856 he applied for a patent to protect his process of laminating thin sheets of wood and, through the use of heat, molding them into the desired shape. Until his death in 1863, Belter's factory, which employed several hundred workmen during its zenith, furnished well-to-do customers with huge, lavishly carved, beautifully designed rosewood and walnut suites of furniture.

Belter's patents were almost immediately infringed upon. Charles A. Baudouine, a New York City competitor, circumvented Belter's patent by making chairs with a center seam in the back. Rococo furniture was never inexpensive. Baudouine could "get 1200 a sett."

During this period new centers of cabinetmaking emerged. The Cincinnati Chamber of Commerce boasted in 1848 "every

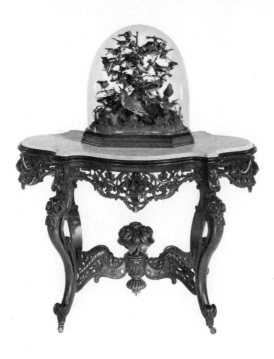

178. Left: Victorian center table in the Rococo Revival style. Made by the firm of John Henry Belter, New York City. This "turtle-top" table is from a suite of parlor furniture used in Abraham Lincoln's Springfield, Illinois, home. Laminated rosewood and marble. 1850–1860. Height 30¾". (Henry Ford Museum)

179. Below: Victorian settee in the Rococo Revival style. Made by the firm of John Henry Belter, New York City. Like most Belter furniture, this piece is ornamented with pierced carving. Laminated rosewood. 1850–1860. Length 60". (Smithsonian Institution)

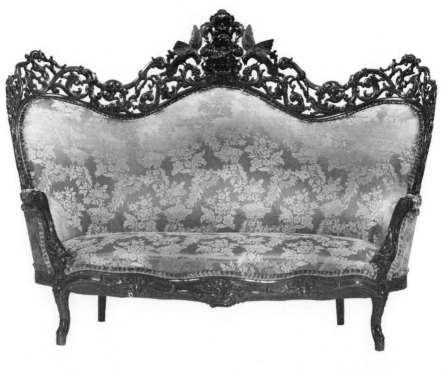

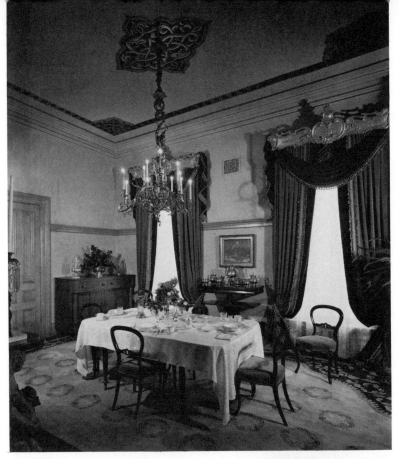

181. Museum installation. The dining room ceiling of the Morris–Butler house, built in 1862 at Indianapolis, Indiana, is painted with "Oriental motifs." (Historic Landmarks, Indianapolis, Indiana)

180. Victorian rocking chair in the simplified Rococo style. The serpentine seat frame and cabriole front legs on this slipper rocking chair are common characteristics of the late nineteenth-century Rococo style. Walnut. American. 1860–1880. Height 32½". (Henry Ford Museum)

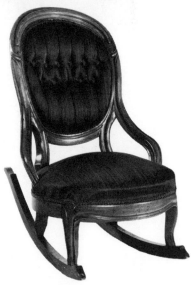

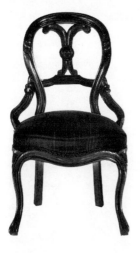

182. Left: Victorian demi-arm chair in the simplified Rococo style. Most seating forms of this variety are upholstered in horsehair. Walnut. American. 1860–1880. Height 35″. (Henry Ford Museum)

183. Below: Victorian settee in the simplified Rococo style. Walnut and mahogany "finger-roll" settees were made throughout the entire second half of the nineteenth century. Mahogany. American. 1860–1880. Length 62″. (Henry Ford Museum)

description of furniture . . . were made in some of their [city's] extensive steam establishments."

François Seignouret and Prudent Mallard also followed French prototypes closely in their furniture productions at New Orleans.

Eastern furniture manufacturers, like Belter in New York City, incorporated the curving lines and cabriole legs of the

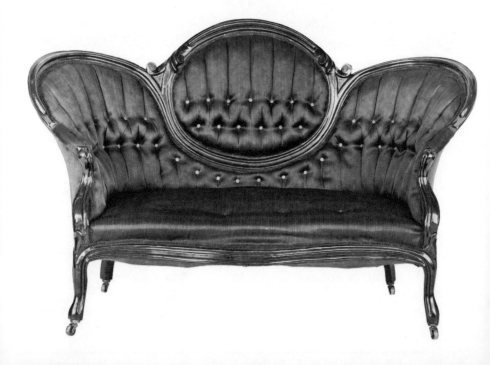

eighteenth-century French Louis XV style into their mid-nine-teenth-century pieces. The high-style Rococo Revival movement lasted only a brief span of some twenty years in America's urban centers. In a much modified and less ambitious form, the style prevailed throughout the nineteenth century in more rural areas.

Emma C. Brewin, a dealer in furniture, carpets, and oilcloths in her Burlington, New Jersey, High Street store, offered in 1888 among her "Housekeeping Articles of all kinds, at Philadelphia Prices," a "3-piece parlor suit consisting of a settee, a gents chair, and a ladies chair" in this simplified form. Merchants in 1897 in Detroit, Michigan, considered such modest pieces "the finest made."

EGYPTIAN REVIVAL FURNITURE

Though Egyptian motifs occasionally appeared on late-eighteenth-century furniture, it was not until after Napoleon's Egyptian campaign (1798–1802) that their use became widespread. *Voyage dans la Basse et Haute Egypte,* written by Baron Vivant-Denon, staff archaeologist for Napoleon, and published in 1802, supplied French as well as American furniture-makers with new design concepts. Egyptian ornamental forms include the winged figure, the sphinx, the animal foreleg, the hairy-paw foot, and numerous combinations of animal and human figures, all superimposed on furniture constructed with more or less cubical lines.

The Egyptian Revival movement in nineteenth-century America was never as dynamic or dramatic as its counterparts, the Gothic Revival, the Rococo Revival, or the Renaissance Revival. In fact, the most popular application of the style was architectural. Countless reproductions of Egyptian temples, imposing in design and size, were destined to serve as public buildings.

Household Furniture and Interior Decoration, published in 1807 by Thomas Hope (1769–1831), an Englishman, illustrated many furniture forms and several interiors in the Egyptian style, figure 184. Hope, an amateur architect of great wealth, spent sev-

eral years in Egypt collecting antique art. Upon his return to England, he designed furniture for his home in Surrey and for his elegant London house, which would complement his art collection.

Though never immensely popular in America, the Egyptian

184. Above: Illustration from *Household Furniture and Interior Decoration* written by Thomas Hope. London. 1807. Plate 8 illustrates how ancient motifs could be adapted for use on modern furniture forms. (Henry Ford Museum)

186. Right: Silhouette of the Cheeseman family by August Edouart (1789–1861). The Cheeseman family and their guests are shown in a parlor, grouped about a fireplace that is flanked by Egyptian caryatids. New York City. 1840. Height 18¾", length 34½" (The New-York Historical Society)

185. 185a. Victorian settee in the Egyptian Revival style. Jay Gould, the American financier, purchased this neo-Egyptian settee and matching chairs for use in Lyndhurst. Rosewood with ebonized wood and inlay. American. 1875–1885. Length 48″. (Lyndhurst, National Trust for Historic Preservation)

Revival movement was an insistent nineteenth-century expression of interest in the artifacts of the ancient world. Loathed and condemned by many Victorian critics, examples of the style are, nevertheless, eagerly sought by today's collectors.

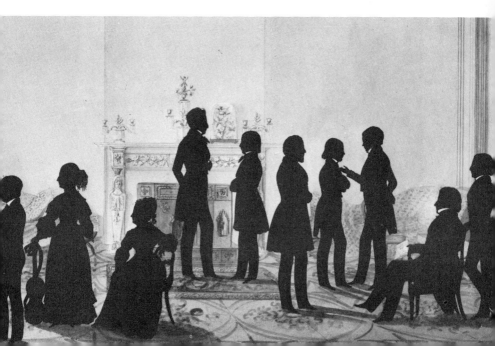

187. Left: Victorian curtain tieback in the Renaissance Revival Style. Thought to have been made by Leon Marcotte. This piece was especially designed to match a bedroom suite, figure 189. Satinwood and rosewood. New York City. 1860–1870. Height 7″. (Theodore Roosevelt Birthplace)

188. Right: Victorian chairs in the Renaissance Revival style. Panels of applied veneer are often found on Renaissance Revival furniture. Burl walnut veneer and walnut. American. 1860–1880. Height of large chair 44¾″. (Henry Ford Museum)

RENAISSANCE REVIVAL FURNITURE

"The world has seen so many mutations of style of furniture that it is almost impossible to construct a new character without combining a number of those in use before," cried out one nineteenth-century architect. The Renaissance Revival movement was popular between 1850 and 1875, and as diverse as it was—"Pompeian"-turned legs, carved and applied ornament in Renaissance designs, and the use of incised lines that were often gilded in decorative patterns—it somehow did produce a cohesive style that today is immediately identifiable.

One of New York's most successful makers of fine furniture in this style was the French émigré Leon Marcotte, whose elegant pieces exhibited "the highest degree of refinement and luxury." The satinwood and rosewood window tieback, figure 187, and the bed, figure 189, were by family tradition made by him for the New York City home of the parents of Theodore Roosevelt.

During the second half of the nineteenth century Americans surged westward, and Grand Rapids, Michigan, emerged as a major center of furniture manufacturing. The Berkey & Gay

189. Victorian bed in the Renaissance Revival style. The broken pediment on the headboard of this piece matches other forms in the bedroom suite. Thought to have been made by Leon Marcotte. Satinwood and rosewood. New York City. 1860–1870. Length 68". (Theodore Roosevelt Birthplace)

Furniture Company in that western "metropolis" exhibited an elaborate Renaissance, jasper-topped and walnut-veneered bedroom suite at the Philadelphia Centennial in 1876. It excited much favorable comment. Such furniture was not without its critics, however, for an 1877 issue of *The American Architect and Building News* expressed the desire that "such an array of vulgarity in design as emanated from the thriving city of Grand Rapids will never again bring disgrace upon the American name at an international exhibition."

Generally speaking, finely crafted pieces in this style originating in the major cities of the eastern seaboard inspired simplified machine-made adaptations in midwestern cities.

190. Victorian chest and dressing mirror in the Renaissance Revival style. Countless pieces of furniture of this period are fitted with marble tops. Walnut and burl veneer. Possibly Grand Rapids, Michigan. 1850–1870. Height 104⅛". (Henry Ford Museum)

191. Illustration from A. J. Downing's *The Architecture of Country Houses.* New York. 1850. Downing indicated that "This furniture is remarkable for its combination of lightness and strength, and for its essentially cottage-like character. It is very highly finished, and is usually painted drab, white, gray, a delicate lilac, or a fine blue—the surface polished and hard like enamel. . . . [W]hen it is remembered that the whole set for a cottage bed-room may be had for the price of a single wardrobe in mahogany, it will be seen how comparatively cheap it is." (Privately owned)

ELIZABETHAN REVIVAL FURNITURE

Furniture-makers during the first half of the nineteenth century were inaccurate when they labeled their spool-, ball-, and spiral-turned products "Elizabethan," because the historical prototypes for this style were actually seventeenth-century English pieces made during the reigns of Charles I and Charles II.

The use of colorful needlework upholstery and spiral-twist turnings more closely related elegant American pieces to the Baroque style. Baroque indeed is the application of split spindles to the face of a chest or case piece.

Mass production, however, accounts for the primary expression of the Elizabethan style in the United States. Suites of "cot-

tage furniture" constructed from pine, painted white or other light colors, and decorated with arabesque and floral motifs, were available to almost everyone, since they were modestly priced. Those wishing to display to the world their superior financial station could order furniture with marble or slate tops.

A. J. Downing, in his 1850 publication, *The Architecture of Country Houses*, illustrated a set of furniture that he called Eliza-

192. Right: Victorian armchair in the Elizabethan Revival style. Many Victorian chairs were originally fitted with casters. This provided easy mobility. Pine and walnut. American. 1850. Height 38″. (Smithsonian Institution)

193. Below: Victorian bed in the Elizabethan Revival style. Spool beds were popular throughout the second half of the nineteenth century. This is a late example since it was constructed to receive a coil-spring mattress. Walnut. American. 1880–1890. Length 80″. (Henry Ford Museum)

bethan, figure 191. With the exception of the spool-turned table, the spool-turned towelrack, and the side chair, the pieces are Late Classical in form. Painted Rococo designs complete or unify this typically eclectic, mid-Victorian bedroom suite.

Spool-turned decoration appears on country furniture throughout the second half of the nineteenth century. Spool chairs, tables, and "what-nots" laden with treasured bits of bric-a-brac speak strongly about the general taste of grandmother's mother. Many a rural attic today still houses a spool bed like the one that tradition insists the fabled songstress Jenny Lind once slept in. The age of a spool bed, like most sleeping furniture, can best be judged by the kind of mattress and springs intended for use on it. The earlier examples have either pegs set in or holes bored through the headboard, footboard, and side rails to receive rope stringing. Mattresses were merely laid on a woven pattern of ropes—an altogether uncomfortable affair. After about 1850 manufacturers developed the coil-spring mattress. These were designed to sit on top of wooden slats, much like those used today.

LOUIS XVI REVIVAL FURNITURE

"The nineteenth century is, without doubt, a great one in many ways, and it is not a little singular that in the more personal service of architecture and the kindred art of furniture design it should do nothing but revive that which has been done before," complained the much-respected critic Harriet Prescott Spofford in 1878.

The Louis XVI Revival style was essentially an East Coast phenomenon in America. Commenting again in 1878, Mrs. Spofford noted that "At present the Louis XVI furniture is made in America with a nicety and a purity equal to that which characterises the best examples and its wonderfully beautiful carving is unrivalled by any that comes from abroad."

The spirit of furniture constructed in the Louis XVI style

differs greatly from the excessive exuberance expressed by the
Rococo style. Straight lines and marquetry surfaces, often enriched
by gilt and ormolu trim, provided a degree of sophisticated ele-
gance that few fully understood and even fewer could afford. Leon
Marcotte, a French immigrant, was by the 1860's one of New
York's most celebrated decorators. Listing himself in New York
Business Directories during the late 1840's and early 1850's as an
architect; slightly later as a furniture dealer in the finest sense
while in partnership with his father-in-law, Ringuet Le Prince; and
finally in partnership with Detlef Lienau, the fashionable architect,
Marcotte moved in high social circles. Speaking of Marcotte's firm,
Ernest Hagen's praise indicates the respect Marcotte commanded,
even from a competing New York cabinetmaker: "They worked
principally in the pure Louis XVI style and done the best work.

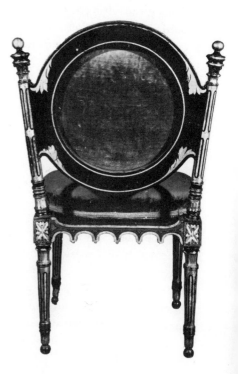

194. Right: Victorian side chair in the
Louis XVI Revival style. Carved,
painted, and gilt decoration add distinc-
tion to this diminutive piece. Such ex-
travagant furniture inspired Mrs. Spof-
ford to observe that the Louis XVI style
was "well suited to the frivolities of the
life too frequently led nowadays by
the extraordinarily wealthy." Wood is
unidentified. American (?) 1860–1870.
Height 30″. (Lockwood-Mathews Man-
sion Museum of Norwalk, Inc.)

195. Far right: Victorian side chairs and
cabinet in the Louis XVI Revival style.
These pieces are from a suite consisting
of two sofas, a pair of small cabinets, a
large cabinet, six side chairs, two lyre-
back chairs, two armchairs, and a fire-
screen. By family tradition, they were
purchased by the John Taylor Johnsons
from Leon Marcotte. Ebonized maple
and fruitwood. New York. *Circa* 1860.
Height of chair 39″. (The Metropolitan
Museum of Art)

This style is really the best of all and will never go out of fashion, and, if not overdone . . . is simply grand."

METAL FURNITURE

Firms specializing in the production of cast-iron architectural elements such as "roofs, fronts, girders, beams, stairs, columns, etc." abounded in the eastern United States during the 1860's and 1870's. Lower Manhattan became deservedly famous for its numerous "mercantile palaces," distinguished for the extraordinary colonnaded façades created from cast iron, such as the Hanwaught store on Broome Street.

The use of metal for the structural parts of furniture was not

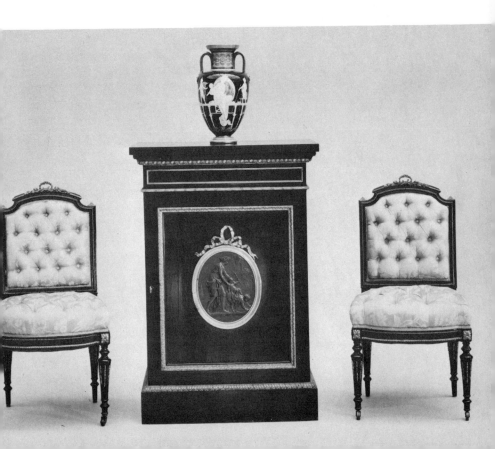

196. Engraved illustration from *The Illustrated Catalogue of the Great Exhibition.* 1851. This centripetal spring chair was patented by the American Chair Company of Troy, New York. 1849. (Privately owned)

a technique new to the nineteenth century. French craftsmen during the eighteenth century had fashioned supremely elegant furniture of polished steel and gilded bronze.

By 1840 experimental and sometimes dual-purpose furniture appeared on the American market. A flood of patents covering every conceivable new idea—from vibrating chairs and sofas that became bathtubs to pianos and fireplace mantels that converted to beds—resulted from the imaginative use of metals.

"A Day at the Ornamental Iron Works of Robert Wood," a heavily illustrated article about the "everyday actualities" of the iron industry in America, was carried in the July 1853 issue of the mid-nineteenth-century style dictator, *Godey's Lady's Book*. The editors noted with gratification that once allowed the privilege of inspecting Mr. Wood's large establishment on Ridge Road in Philadelphia, they were given "many new ideas in regard to the uses of which iron is applied."

Cast iron was used in the production of "the utmost variety of articles fitted for use in our homes, our fields, our gardens, stores, counting-rooms and summer resorts."

The invalid's chair, figure 197, labeled by the Marks A. F. Chair Co., New York, New York, was designed by C. B. Sheldon and patented on February 1, 1876. The cast-iron frame can be adjusted so that the back becomes level with the seat. Plush arms and cushions provided comfort for the patient.

Cast-iron furniture "made expressly for Gardens, Lawns, Piazzas, Summer Houses and house purposes" could be ordered in many patterns. In 1874 a Rustic Settee cost $10.00; a Grape Settee, figure 199, $9.00 to $15.00; a Gothic Settee, $17.00 and $20.00; a Grape Chair, $5.00; and a Morning Glory Chair, $6.00. The Grape Settee, marked "E. [Eugene] T. Barnum, Detroit, Michigan," is identical to that offered for sale by E. Booze of New York City in 1886.

Wire furniture in a seemingly endless variety of forms competed with cast-iron pieces for outdoor use. The advertisement of M. Walker and Sons of Philadelphia illustrated fifty-three pieces

198. Left: Garden chair. Wire and iron furniture was more easily moved and less expensive than cast iron pieces. American. 1870–1880. Height 38″. (Henry Ford Museum)

199. Right: Garden bench. This outdoor piece was manufactured by E. T. Barnum, Detroit, Michigan. Cast iron. 1880–1895. Length 36″. (Henry Ford Museum)

197. Below: Invalid chair. Designed by C. B. Sheldon and manufactured by the Marks A. F. Chair Company. New York, New York. This special-purpose piece was patented February 1, 1876. Iron and walnut with velvet upholstery. Height 46″. (Henry Ford Museum)

designed for the garden: flower stands, baskets, and trellises, along with serving carts and chairs.

The January 1917 issue of *Arts and Decoration* carried an advertisement by Joseph P. McHugh & Son on 42nd Street, New York, in which they offer "Big things for big houses" in the form of a canopied garden bench with a foldaway table. "There are special new models for the Porch, the new Metal Furniture for the Lawn and the English Garden Furniture has been further developed."

EASTLAKE FURNITURE

Charles L. Eastlake, the English author, hoped "to suggest some fixed principles of taste for the popular guidance of those who are not accustomed to hear such principles defined" in his book, *Hints on Household Taste: in Furniture, Upholstery and Other Details* (fourth edition, 1878). Eastlake noted, "Some of my critics have taken exception to what they not unjustifiably call my mediaeval predilections. . . . It is the spirit and principles of early manufacture which I desire to see revived, and not the absolute forms in which they found embodiment." Noting his influence in the United States, he commented on the "Eastlake style" there: "I find American tradesmen continually advertising what they are pleased to call 'Eastlake' furniture, with the production of which I have had nothing whatever to do, and for the taste of which I should be very sorry to be considered responsible."

What is American Eastlake furniture? An exact definition is difficult since during the 1870's and 1880's it represented something different to everyone. One manufacturer offered in 1878 a bamboo-turned, folding rocking chair that he blatantly labeled "Eastlake."

Scholars have recently associated the Gothic and Romanesque furniture and buildings of the American architect Henry Hobson Richardson with the designs and intent of Eastlake. The spool-

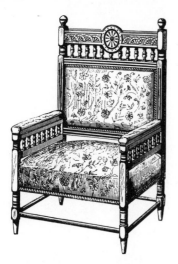

200. Illustration of an Elizabethan armchair from *Hints on Household Taste.* Written by Charles L. Eastlake. 1868. This piece is embellished with turned spindles, a device synonymous with the American phase of the Eastlake style. (Privately owned)

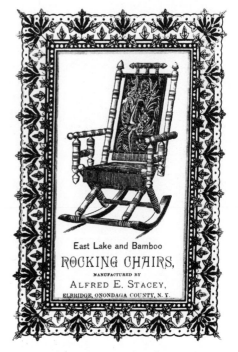

East Lake and Bamboo
ROCKING CHAIRS,
MANUFACTURED BY
ALFRED E. STACEY,
ELBRIDGE, ONONDAGA COUNTY, N. Y.

202. Advertisement. Popular versions of the Eastlake style were offered by Alfred E. Stacey during the 1880's. (Privately owned)

201. Illustration of a drawing-room sofa from *Hints on Household Taste.* Sofas in this form were manufactured by the English firm of Jackson & Graham. (Privately owned)

and spindle-turned pieces that Richardson designed for the Wo-burn Public Library (1878) and the North Eastern Library (1879) in Massachusetts are very similar to pieces illustrated by Eastlake in *Hints*. His desks and chairs of 1881, and especially the carved, paneled screens made for the State Capitol in Albany, New York, could have been inspired by Eastlake's published sketches.

In America, as in England, Eastlake's ideas added further incentive to the revival of handcraftsmanship that had been initi-ated by William Morris and resulted in the Arts and Crafts Move-ment in England.

Harriet Prescott Spofford, a very influential New York author,

204. Lieutenant Governor's chair in the Eastlake style. From the Albany State House. Designed by H. H. Richardson (1838–1886). Mahogany. American. 1880. Height 65″. (State of New York; photograph courtesy Museum of Fine Arts, Boston)

203. Eastlake-style armchair. Wood from "the spreading chestnut tree" was used in the construction of this spool-turned chair, which was presented to Henry Wadsworth Longfellow by the children of Cambridge, Massachu-setts, on his seventy-second birthday. Massachusetts. 1879. Height 47″. (Longfellow House)

writing in *Art Decoration Applied to Furniture* (1878), refers to Eastlake's expressed principles: "Mouldings should be carved from the solid, not made of detached slips of wood glued on a surface; that doors should be hung on long, ornamented, noble hinges; that surfaces should be left in their native hue, never varnished, but if painted at all, painted in flatted color, with a line introduced here and there to define the construction, with an angle ornament (which may be stencilled at the corners); that mitered joints shall be abolished; that joints, moreover, shall be tenoned and pinned together without the nails and glues in use at the present . . ."

Simplicity is the outstanding characteristic of the American Eastlake style. Massive pieces are decorated with carved designs. Turned members emphasize and enhance vertical lines.

JAPANESE REVIVAL FURNITURE

American manufacturers were certainly never shy about borrowing ideas for designs from foreign sources. The Japanese Bazaar at the Philadelphia Centennial Exhibition of 1876 sparked a craze that extended to every facet of American production.

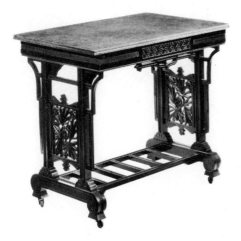

205. Left: Victorian table in the Japanese Revival style. This piece has incised lines that are often associated with the products inspired by Charles Locke Eastlake's *Hints on Household Taste*. Maple painted black with marble top. American. 1870–1890. Length 34⅜". (Henry Ford Museum)

206. Right: Victorian chest with mirror in the Japanese Revival style. Herter Brothers was one of the first American firms to incorporate hand-painted Japanese tiles into the designs of its furniture. This piece probably originated in their shop. Maple. Probably Philadelphia. 1870–1890. Height 82". (Lyndhurst, National Trust for Historic Preservation)

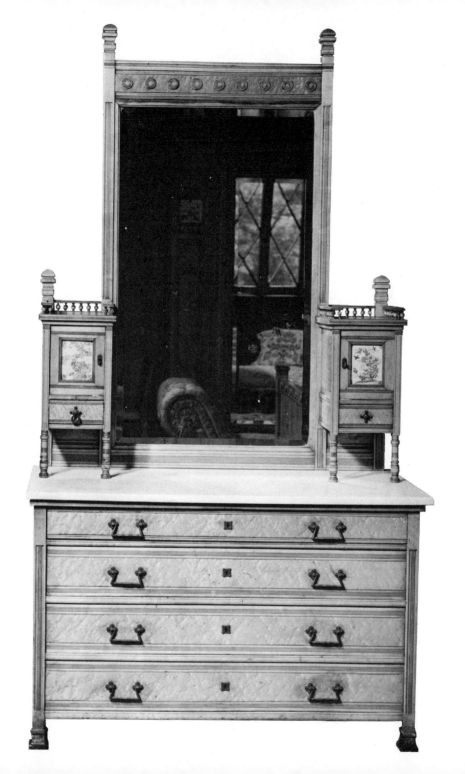

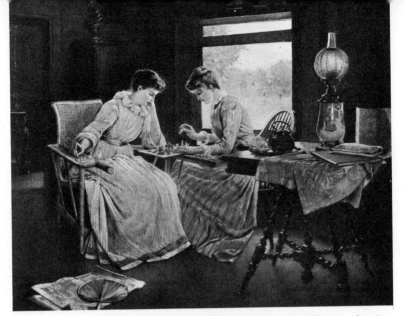

207. "The Critical Move." Lithograph published by Carson & Simpson in 1892. One of the comely young ladies sits in a woven cane chair. A Japanese-inspired fan lies on top of the newspaper. 7½" x 9½". (Patricia Coblentz)

Kimbel & Cabus, the New York firm that had promoted East-lake furniture so strongly, orientalized much of their production during the late 1880's.

In Philadelphia Herter Brothers supplied William T. Carter with an elaborately inlaid bedroom suite in 1876 and was one of the first firms to introduce Japanese hand-painted tiles into the design of its pieces, figure 206. The tile exhibits at the Centennial were very popular, and tiles soon spread throughout American homes in a decorative flood washing over floors, walls, bathrooms, fireplaces, and even ceilings.

Popular magazines during the 1880's promoted Japanese products. "Stamped Japanese Quilts are in active demand. They are sold for use in the gardens in summertime. 'Lawnspreads' is the term sometimes given them."

Oriental pieces, at first imported by ambitious merchants from Far Eastern ports, were soon manufactured here. The agent A. Cummings of New York City offered rattan furniture during the 1870's.

208. Victorian child's rocking chair in the Japanese Revival style. The outline of a Japanese fan is worked into the design of the back of this diminutive piece. Cane and maple. American. 1880–1900. Height 22¾". (Henry Ford Museum)

209. Victorian platform rocker in the Japanese Revival style. Rocking chairs with a stationary base were called "platform rockers" during the late nineteenth and early twentieth centuries. Reed and rattan. American. 1900–1910. Height 47". (Henry Ford Museum)

210. Victorian table and side chair in the Japanese Revival style. Kilian Brothers of New York charged $8.67 in 1876 for an imitation bamboo chair much like this example. Maple. New York. 1875–1880. Height of chair 33⅞". (The Metropolitan Museum of Art)

In the 1880's American firms everywhere jumped aboard the bandwagon. A. Meinecke & Son of Milwaukee, J. E. Wall of Boston, Ardi of Grand Rapids, New York, and Hong Kong, and the Nimura and Sato Company of Brooklyn competed in an ever-expanding Oriental market. Not only were pieces made of imported materials, but native woods were turned to simulate them. "The so-called 'bamboo' furniture is made almost entirely from bird's-eye maple, so turned in the lathe as to look like bamboo. It is sold to some extent, especially in the southern states, at prices rather above those for plain furniture. As the natural color of the wood is retained, the bedroom sets are unique and cheerful."

RUSTIC FURNITURE

Man has probably always crafted furniture from tree roots and branches; however, such rustic pieces were especially popular in England at the close of the eighteenth century. During the nineteenth century the fad continued and spread to America, where A. J. Downing, in his 1844 publication, *Cottage Residences,* expressed the opinion that "rustic seats, placed here and there in the most inviting spots, will heighten the charm, and enable us to enjoy at leisure the quiet beauty around." "Organic" furniture sharply contrasted with machine-made products of the new industrial age. Reflecting Victorian taste, the tête-à-tête, figure 211, was constructed from tree branches and roots and used in the gardens at Lyndhurst, the Hudson River Gothic mansion designed by Alexander J. Davis, Downing's close friend. The inspiration for the garden seat by the tree at the left and the table at the far right in the painting of a New Hampshire country home, figure 214, might well have been an article on rustic furniture that appeared in 1858 in *The Horticulturist,* a periodical founded by Downing.

Though the pieces illustrated were created by Victorian romantics seeking to evoke their return to the simpler life, there

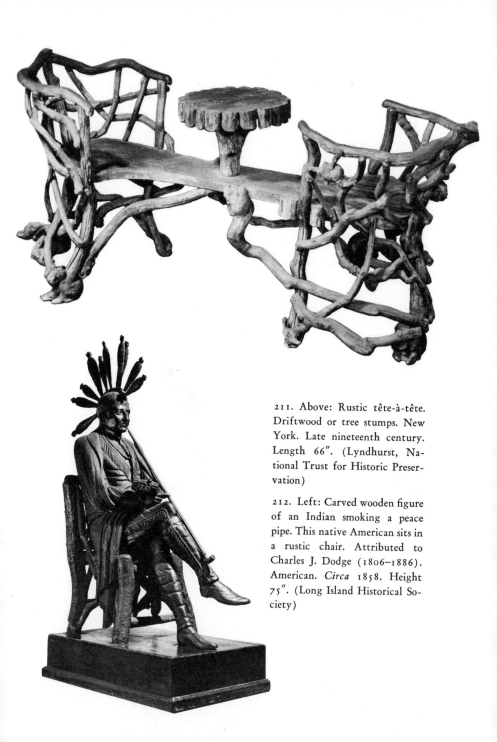

211. Above: Rustic tête-à-tête. Driftwood or tree stumps. New York. Late nineteenth century. Length 66″. (Lyndhurst, National Trust for Historic Preservation)

212. Left: Carved wooden figure of an Indian smoking a peace pipe. This native American sits in a rustic chair. Attributed to Charles J. Dodge (1806–1886). American. *Circa* 1858. Height 75″. (Long Island Historical Society)

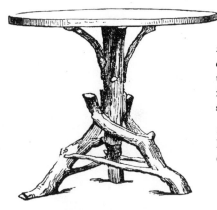

213. Left: Illustration from *The Horticulturist*, a popular American magazine that featured two articles on rustic furniture in 1858. (Henry Ford Museum)

214. Below: Painting of a country house. Oil on canvas. New Hampshire. *Circa* 1865. Height 22", width 36". (Cary F. Baker)

were many rural Americans who from lack of money made organic wooden pieces for daily use in their cabins and farmhouses. These were, of course, discarded as soon as they could be replaced with "store-bot" furniture.

TURKISH FRAME FURNITURE

Though Thomas Sheraton had indicated that metal coil springs were to be used in the construction of the exercise riding-horse he

illustrated in his *Cabinet-Maker and Upholsterer's Drawing Book* of 1793, coil springs did not achieve popularity until the mid 1800's. Following French upholsterers' examples, English and American workmen used springs in chairs, sofas, and circular ottomans covered in tufted upholstery and referred to as "Turkish Frame" pieces.

Furniture-makers in the 1860's and 1870's offered their clients "unprecedented comfort." Sears, Roebuck in 1897 advertised a $45.00 parlor suite for only $23.00 consisting of "1 Tete-a-tete, 1 Rocker, 1 Gent's Easy Chair, 1 Parlor or Reception Chair: . . .

215. Right: Victorian armchair in the Turkish Frame style. This extraordinary piece of furniture is fitted with twisted braid fringe at the base. Maple and pine frame. American. *Circa* 1880. Height 40″. (Henry Ford Museum)

216. Above: Early photograph of a Victorian daybed in the Turkish Frame style. This upholstered beauty was available in satin, silk, or leather. It was exhibited at the Chicago Exposition in 1893. (Smithsonian Institution)

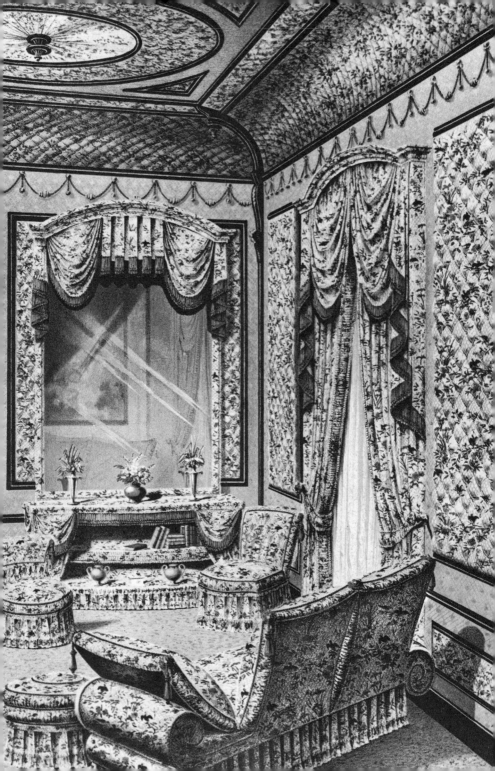

The upholstering or cover of this suit is in the latest design and pattern of imported goods . . . and trimmed with a heavy worsted fringe. This suit is made with good steel spring seats and spring edges and every piece is made with spring backs."

BENTWOOD FURNITURE

Though considered by one nineteenth-century critic to be curvaceous beyond "those limits which the eye follows with pleasure,"

217. Left: Advertisement of Carrington DeZouche & Company. Philadelphia. 1876. Visitors to the Philadelphia Centennial marveled at this colorful interior created from gaily printed floral fabrics trimmed with red binding and accented by red and black fringes and tassels. (Privately owned)

218 and 219. Below: Illustrations of bentwood rocker No. 503 and bentwood armchair No. 504A from the sales catalogue of the Sheboygan Chair Company, Sheboygan, Wisconsin. These pieces were available in mahogany, walnut, ebony, or antique elm. Late nineteenth century. (Henry Ford Museum)

Sheboygan Chair Co., Sheboygan, Wis.

Sheboygan Chair Co., Sheboygan, Wis.

No. 503. Rocker.
MAHOGANY, WALNUT, EBONY OR ANTIQUE ELM.
POLISHED.

No. 504A. Arm Chair.
MAHOGANY, WALNUT, EBONY OR ANTIQUE ELM.
POLISHED.

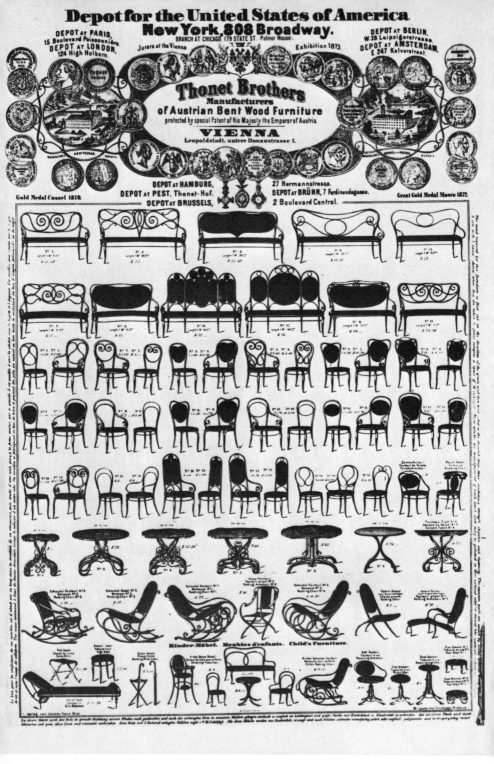

the bentwood chair, first manufactured about 1840 in Austria by Michael Thonet, has enjoyed a popularity that continues today.

The Thonet furniture display at London's Crystal Palace Exhibition in 1851 presented for the first time to a large, international audience the virtues of the Thonet products—"neatness, lightness, and great strength."

In the years immediately following the Civil War the domestic manufacture of bentwood all but captured the inexpensive furniture market. These American pieces, however, had to compete with "authentic Thonet chairs, tables, stools, settees, chaise lounges" and other "Austrian Bent Wood furniture produced by special patent of His Majesty the Emperor of Austria" that was being sold in furniture depots in New York, Chicago, and Boston.

220. Advertisement published by Thonet Brothers, Manufacturers of Austrian Bent Wood Furniture. This firm maintained several American depots, including those in New York and Chicago, where their merchandise was sold. 1891. (The New-York Historical Society)

THE NINETEENTH-CENTURY COUNTRY STYLES

PAINTED AND DECORATED FURNITURE

Painted and decorated country furniture of the nineteenth century is becoming a favorite with collectors. Bright, colorful decoration, applied in a myriad of patterns and designs, has great appeal. Country furniture makes it possible to live and decorate with antiques at a fraction of the cost of more formal pieces.

The techniques used in the decoration of country furniture include a great range of freehand painting and elaborate graining with specially designed combs.

Painted decoration often looks freely formed and its application seemingly unplanned, such as the "smoked" gray-and-white decoration on the top of the nightstand, figure 222. This embellish-

221. Above: Child's cradle. The inside is painted red and the outside is painted in an all-over flame pattern of red, green, and yellow. The large rockers are painted green. Pine. Ohio. *Circa* 1850. Length 27½". (Henry Ford Museum)

222. Left: Two-drawer night-stand with drop leaves. Made by Philip H. Saunders (1800–*c.* 1866). Saunders is listed in the Salem, Massachusetts, City Directories from 1851 to 1866 as a carpenter. The top and leaves of this diminutive piece are smoke-decorated in gray and black. Pine. Salem. 1820–1840. Height 29¼". (Henry Ford Museum)

223. Above: Side chair. Marked Hitchcock and Alford, Hitchcocksville, Connecticut. Maple and hickory. 1829–1843. Height 34⅝". (Henry Ford Museum)

ment contrasts dramatically with the strong red-and-black graining of the case and legs. Formalized gold-leaf motifs were stenciled on the Hitchcock chair, figure 223. Hitchcocks were one of the most popular mid-nineteenth-century seating forms in New England. Even though they were mass-produced and inexpensive, a rural matron who owned a set could rest secure in the knowledge that her furnishings were superior to those of most of her neighbors.

Another popular method of decoration was the application of paint to a pine piece in an attempt to make it look as if it had been crafted from expensive imported woods. In 1814 E. Morse of Livermore, Maine, painted the chest, figure 224, in shades of brown and yellow to imitate mahogany. Each drawer and the top are

224. Left: Chest of drawers. Made by E. Morse. Pine. Livermore, Maine. 1814. Width 36⅝". (Henry Ford Museum)

225. Right: Armoire. The style of this cupboard is similar to eighteenth-century examples from Normandy; however, the wood and hardware are typically American. This cupboard is from the French settlement that existed at Louisville, Ohio, from about 1820 to 1840. Poplar, painted and grained. Height 78". (Henry Ford Museum)

226. Far right: High chest of drawers. This piece stands on high ogee bracket-like feet and is painted dark blue-green with an overall decoration of five-petal flowers and thumbprint designs in red and buff. Pine. Pennsylvania. *Circa* 1830. Height 54⅜". (Henry Ford Museum)

banded in imitation dentil molding. When viewed from a distance of several feet, this charming case piece appears to be the product of an urban cabinetmaking shop.

REGIONAL COUNTRY FURNITURE

Both the French in the Mississippi River Valley and the Germans in western Pennsylvania were well established by the mideighteenth century. Furniture-makers within the communities tended to cling tenaciously to the forms that the earliest settlers brought with them from their homeland. In the early part of the nineteenth century tradition persisted; however, as communications and pub-

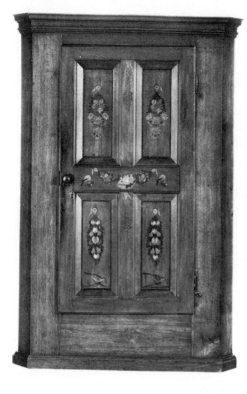

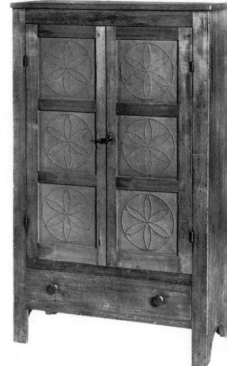

lications increased, people gradually demanded the more fashionable furniture of the urban world. Furniture forms changed, and by the third quarter of the nineteenth century all that remained of the old-style pieces were those that had been relegated to upstairs bedrooms and attics.

SOUTHERN COUNTRY FURNITURE

Southern country furniture of the nineteenth century, if modest in design, was both sturdy and functional. Local craftsmen preferred the native pine that was close at hand and easily fashioned

227. Far left: Schrank. The painted decoration of pendant fruit and floral motifs is similar to that found on an eighteenth-century Hudson River Valley *kas*. Walnut. Zoar, Ohio. *Circa* 1850. Height 72½". (Henry Ford Museum)

228. Left: Pie safe. The punched tin panels are painted light brown. The name "Moore" is stenciled inside the doors. Pine. Midwestern United States. 1850–1880. Height 54". (Henry Ford Museum)

229. Right: Slat-back rocking chair. Poplar, oak, and other hardwoods. Alabama. Eighteenth or possibly nineteenth century. Height 46". (Old Tavern, Tuscaloosa County [Alabama] Preservation Society)

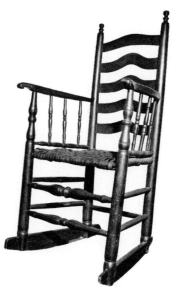

to more expensive woods shipped in from the North or imported from South America.

A surviving eighteenth-century form might have been the inspiration for the style of the five-slat-back rocking chair, figure 229, fashioned by a slave owned by Mims Jemison of Alabama during the 1830's or 1840's. The turned spindles under the arms and the vigorously turned posts and front stretchers would seem to indicate a much earlier date for this piece. Because the rockers are set in slots cut into the bottoms of the posts, one must be tentative about assigning it a nineteenth-century date, even though tradition associates it with Mr. Jemison, who died as a cavalryman in the Seminole Indian War (1835–1842).

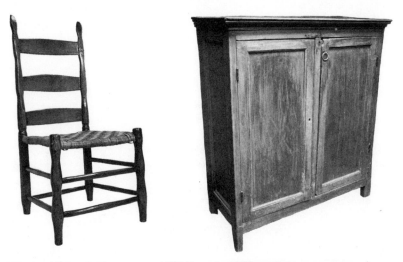

230. Above left: Slat-back side chair. Several variations of this general form have been found in the Alabama area. Southern pine, maple, hickory. Alabama. Mid nineteenth century. Height 34½". (Mr. and Mrs. James B. Boone, Jr.)

231. Above right: Pie safe. White pine and poplar painted dark gray-green. Greene County, Alabama. 1800–1850. Height 56½". (Mr. and Mrs. James B. Boone, Jr.)

232. Below: Museum interior. The bed with acorn finials was originally strung with rope to support the mattress. The bedcover is double woven in old rose, plum, and indigo blue. Southern pine. Mid nineteenth century. Length 78½". (Old Tavern, Tuscaloosa County [Alabama] Preservation Society)

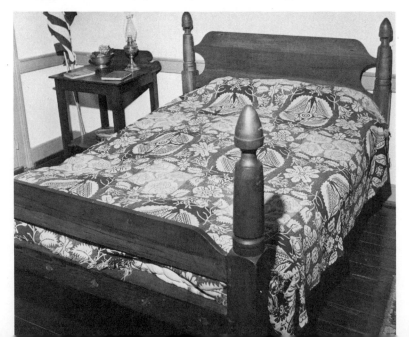

233. Shaker box. These wooden containers were made in numerous sizes. Birch with pine bottom and copper rivets. Canterbury, New Hampshire. *Circa* 1850. Length 5½". (Henry Ford Museum)

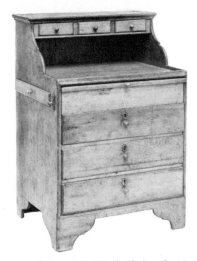

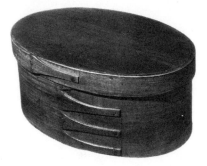

234. Shaker desk. Much Shaker furniture has wooden drawer pulls. White pine and ash. American. 1800–1850. Height 25¹⁄₁₆". (Winterthur Museum)

SHAKER FURNITURE

"Labor to Feel the Life of God in your soul; labor to make the way of God your own; let it be your inheritance, your treasure, your occupation, your daily calling. Labor to God for your own soul as though there were no other soul on earth." Thus taught Mother Ann Lee, a simple millworker who many believed carried "the candle of the Lord in her hand."

Leading a small band of followers from England and religious persecution in 1774, this remarkable woman in 1775 founded the first Shaker community at Watervliet, New York. Communal societies patterned after this first settlement sprung up from Maine to the Middle West. Membership grew by conversion since celibacy was a tenet of the Shaker religion. Converts forsook all property and possessions in the outside world to join church families, segregated by sex. "Think not that ye can keep the laws of Zion while blending with the forms and fashions of the children of the unclean."

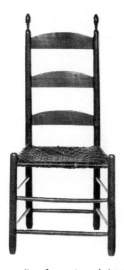

235. Left: Shaker side chair. Some Shaker chairs are fitted with a device in the back leg that enables the sitter to tilt backwards. Maple. Probably Hancock, Massachusetts. *Circa* 1850. Height 40″. (Henry Ford Museum)

236. Below: Museum installation. The Shakers, a celibate, religious, communal society founded by the English millworker, Ann Lee, established some thirty colonies across America by 1840. Talented craftsmen, who thought of work as a form of prayer, created some of America's simplest, yet most beautiful, furniture. The room interior shows slat-back chairs hanging from pegboards, a Shaker practice that created more interior living space. (Milwaukee Art Center)

In functional buildings furnished with unadorned furniture, orderliness and cleanliness were achieved by hanging clothing, candle shelves, even chairs, on pegboards, which lined the walls of most rooms.

Gifted Shaker craftsmen created some of America's simplest

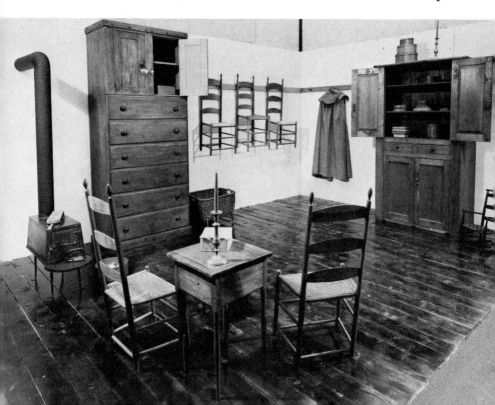

yet most beautiful furniture. "That which has in itself the highest use possesses the greatest beauty." Simplicity and fine workmanship are characteristic of Shaker products. "Fancy articles of any kind, superfluously finished, trimmed, or ornamented, are not suitable for Believers. . . . Whatever is fashioned, let it be plain and simple, unembellished by superfluities which add nothing to its goodness or durability."

Members of the United Society of Believers in Christ's Second Appearing were "the people called Shakers." The popular name evolved from a shaking dance that was part of their religious service.

NINETEENTH-CENTURY WINDSOR FURNITURE

Plank-bottom chairs were the common seating form of rural nineteenth-century America. Eighteenth-century Windsor prototypes inspired a multitude of designs that today are eagerly sought in out-of-the-way antique shops by collectors of country antiques. The value of a piece depends on design, structural condition, and finish. For the connoisseur original paint and decoration are of particular interest. For the less sophisticated collector, however, these considerations are not important, since the piece will probably be subjected to refinishing anyway. The novice collector often deals his pocketbook a serious blow by stripping away the original finish, which is always much more desirable than the orange shellac or spar varnish that dealers in "Early American" display so proudly.

When a piece of furniture is structurally unsound, few buyers are able to make the necessary repairs themselves. The cost of professional restoration should be added to the price tag of any "bargain" to determine just how great the bargain really is. In the case of simple country furniture, repairs can often exceed the actual price of the piece. Obviously, restored furniture is much less valuable than that which is totally original.

Good basic design is the elementary requirement in selecting

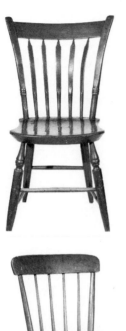

237. Left top: Windsor side chair. Pennsylvania and Ohio arrow-back chairs are more robust than New England versions. This example has boldly turned front legs, a smartly shaped seat, and flaring back. Pine and maple. Pennsylvania. 1830–1850. Height 31¾". (Henry Ford Museum)

238. Left bottom: Cottage-style side chair. Cottage-kitchen, plank-bottom chairs were wholesaled in Grand Rapids furniture marts as late as 1897, where they sold for $1.87 a dozen. Pine, maple, and ash. United States. 1860–1900. Height 31½". (Henry Ford Museum)

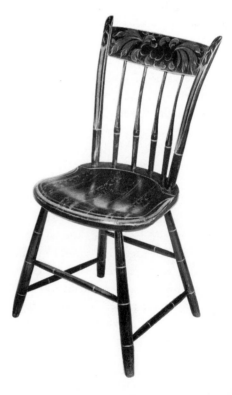

239. Right: Windsor side chair. Simple country chairs with turned spindles and shaped back posts terminating in a "rabbit's ear" were produced from Maine to Michigan. Maple, pine, and ash. New England. 1840–1860. Height 32¾". (Privately owned)

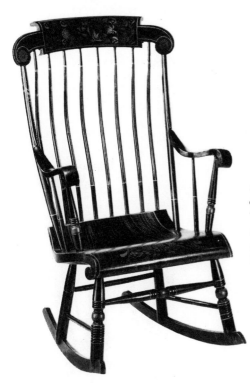

240. Boston rocker. These chairs were ornately painted, grained, and stenciled. Their cost to the purchaser was determined to some extent by the elaborateness of the decoration. Pine, maple, mahogany, and ash. New England. 1840–1860. Height 45″. (Henry Ford Museum)

a piece of antique furniture. A poorly executed Windsor chair was of little value when first made, and today such an example would be relatively worthless. An antique, no matter how old, must satisfy the basic principles of sound design and workmanship to be worthy of being collected.

Some collectors enjoy telling about the historical or family associations of their antiques. If George Washington had spent as many nights in bed as there are beds he is reported to have slept in, he would surely have lived to the age of three hundred. Historical association, when firmly established, does, however, add significantly to the price tag attached to an antique.

There are many variants of nineteenth-century painted Windsor-type chairs. Rod-backs, step-downs, arrow-backs, rabbit-ears, and cottage types are some of the more popular forms collected today. Until recently, rocking chairs were considered an eighteenth-

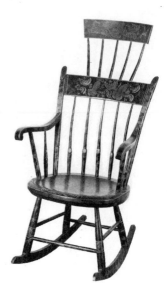

241. Hitchcock rocking chair. Lambert Hitchcock, the founder of the famous Hitchcock Chair Company of Hitchcocksville, now Riverton, Connecticut, made this decorated chair about 1828. Pine, maple, and hickory. Height 42″. (Hitchcock Chair Company)

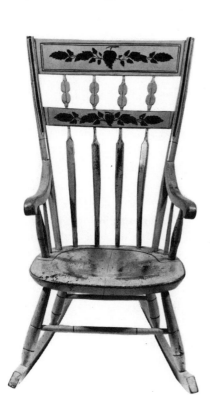

242. Above: Comb-back Windsor rocking chair. The painted decoration on this stylish country piece was executed without the aid of stencils. Pine, maple, and ash. New England. 1840–1860. Height 43″. (Shelburne Museum, Inc.)

243. Left: Arrow-back rocking chair. Acorn, green leaves, and line decoration lend an air of elegance to this yellow-painted country rocker. Pine, maple. New England. 1840–1860. Height 45″. (Privately owned)

century innovation that, during the early years of the nineteenth century, became a symbol of comfort for the aging. During this period many "straight" chairs were converted by the cutting of a wedge-shaped slot into the bottom of the legs and inserting a narrow rocker. The Boston rocker, figure 240, the Hitchcock, figure 241, and the comb-back Windsor, figure 242, are constructed in this manner; however, they were never intended to be anything but rocking chairs and represent a stage of transition to the method of attaching the rocker seen on the arrow-back, figure 243.

Though rare indeed, seventeenth-century rocking chairs are known. One slat-back example was constructed with enlarged back posts to receive a rather cumbersome rocking device. It seems logical that such early forms were inspired by the rockers attached to massive Jacobean-style oak cradles.

Benjamin Franklin owned a "great armed chair, with rockers" that was fitted with "a large fan placed over it, with which he fans himself, keeps off flies, etc. while he sits reading with only a small motion of his foot."

THE LATE VICTORIAN
STYLES

COLONIAL REVIVAL FURNITURE

Just after the Civil War, Americans, in an attempt to reaffirm
their ties with a more peaceful past, turned with zeal to the collect-
ing of antique furniture. The distinguished art critic Clarence
Cook noted in 1881 that "All this resuscitation of 'old furniture'
is a fashion . . . that has been for twenty years working its way
down from a circle of rich, cultivated people, to a wider circle of
people . . . who have natural good taste."

Decorators, both of the professional and "lady-at-home" vari-
ety, had little idea of what authentic antiques looked like. In fact,
the displays of "Household Goods" of the Revolutionary period
and the "Log Cabin in 'Ye Olden Times'" at the Philadelphia

244. Title page from *Early New England Interiors*. Written by Arthur Little and published in 1878. This illustration shows the rear view of the Benning Wentworth House at Little Harbor, New Hampshire. Little's effort fanned the kindling interest in early architecture. (The New York Public Library)

Centennial Exposition, 1876, confused the issue, since objects from several periods were intermingled and much heralded in newspapers and periodicals across the country.

American manufacturers quickly sensed the commercial possibilities of purveying the old and focused their attentions on the production of "Colonial" furniture.

The designs of Colonial Revival pieces are many times based upon early prototypes; more often, however, they represent only a vague approximation of furniture from the past.

Probably the best-known manufacturer of Colonial Revival furniture was Wallace Nutting of Framingham, Massachusetts. His

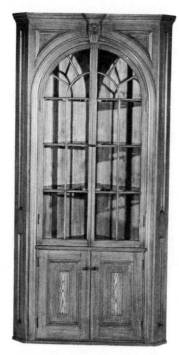

245. Colonial Revival corner cupboard. At first glance, this rather handsome cupboard might easily be mistaken for an eighteenth-century piece. Pine, painted and grained. United States. 1900–1925. Height 85½". (Henry Ford Museum)

faithful seventeenth- and eighteenth-century reproductions were based upon authentic antiques in his personal collection. Over the last fifty years, Nutting furniture has developed signs of wear and use that occasionally fool the uninitiated. He was meticulous about marking his reproductions. They are sometimes identified with a paper label; more often, however, they are stamped or branded.

So as she sat at her wheel one afternoon in the autumn,
Alden, who opposite sat, and was watching her dexterous fingers,
As if the thread she was spinning were that of his life and his fortune."—LONGFELLOW.

A BEAUTIFUL WEDDING

OR BIRTHDAY PRESENT.

THE OLD FLAX SPINNING WHEEL CHAIR.

In its construction every part of the wheel is used.

Novel, Artistic, Durable.

Made in Oak and Cherry.................... $20 00
Made in Mahogany......................... 25 00
Made in Gilt................................. 40 00
LIBERAL DISCOUNT TO THE TRADE.

WM. B. SAVAGE,
No. 43 West Street, Boston, Mass.

247. Advertisement for "The Old Flax Spinning Wheel Chair" from the *Decorator and Furnisher*. 1887. (Privately owned)

Wallace Nutting's painstakingly crafted pieces were certainly superior in design to the "Furniture of our forefathers, The most complete line of thoroughly correct Colonial Reproductions" made by the Barnard & Simonds Company at Rochester, New York. Like many early twentieth-century manufacturers, this firm exhibited at the Furniture Marts held during January and July in

246. Illustration from *The Ladies Home Journal*, June 1912. This sketch was used as the lead-in to an article by Nellie Snead MacDonald entitled "What Is New in the Shops for the Bride's New Home?" She offered to assist the prospective bride: "I want to bring you in touch with the New York shops, and then if you care to know more details, or to discuss what I tell you about, pray write me, only please send a stamped, addressed envelope for a reply." (Detroit Public Library)

the Furniture Exhibition Building at Grand Rapids, Michigan. Their December 1902 advertisement from the Grand Rapids Furniture Record offered "200 Patterns of Dining Chairs in Oak and Mahogany; 150 Pieces for the Parlor, Library and Hall."

The Bishop Furniture Company, also of Grand Rapids, illustrated in an early twentieth-century catalogue a "Colonial Parlor Rocker" that they felt secure in claiming superior to any that had ever been placed on the market of equal design and so low a price: "COD—$7.65, Price Cash with Order—$7.27."

Frank Lloyd Wright, the American architect and designer, despised the Colonial Revival. His scorn might have been prompted by exposure to fanciful creations like the Old Flax Spinning Wheel Chair, figure 247. Certainly this extraordinary chair violates the principles he summarized with the statement, "form follows function."

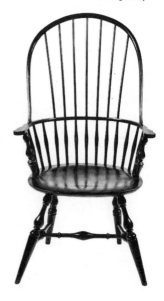

249. Colonial Revival Windsor armchair. Made by Wallace Nutting. Pine, maple, and hickory. Framingham, Massachusetts. 1917–1922. Height 48". (Theodore Roosevelt Birthplace)

248. Illustration from title page of the *Wallace Nutting Period Furniture* catalogue. Published *circa* 1920. Nutting took great pride in the fact that his shop was located at the center of "Old American Life." "By the above it appears that my shop is at the crossroads of the ancient Commonwealth of Massachusetts. Though the land reaches the railway station, a walk of two blocks is required. Cross the track to the north side and take the first left." (The New York Public Library)

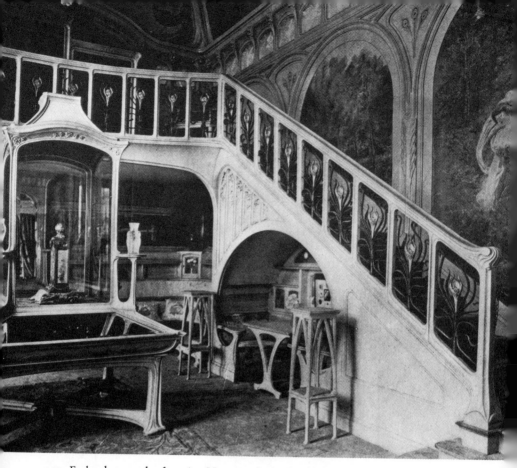

250. Early photograph of an Art Nouveau display in the French Pavilion at the St. Louis Exposition of 1904. (Cooper-Hewitt Museum of Design, Smithsonian Institution)

ART NOUVEAU FURNITURE

The New York and Chicago furniture manufacturing firm of S. Karpen and Brothers offered in their sales catalogue of 1907 "A Short History of Decorative Periods and Their Modern Application."

"L'Art Nouveau is a term given to a new school of design which had its birth a little over fifteen years ago. The title L'Art Nouveau was devised by Monsieur S. Bing, who gave the name to

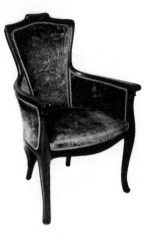

251. Left: Art Nouveau armchair. Attributed to Edward Colonna. This chair was probably designed while Colonna was working for S. Bing in the Rue de Provence, Paris. Walnut. *Circa* 1900. Height 39″. (Lillian Nassau, Ltd.)

252. Below: Art Nouveau dressing table and chair. These highly sophisticated Art Nouveau pieces, made by the Gorham Silver Company of Providence, Rhode Island, in 1903, were designed by William Codman. Ebony and boxwood encrusted with silver and ivory inlay. Length of dressing table 50″. (Rhode Island School of Design Museum of Art)

a building in the Rue de Provence, Paris, where he installed a number of artists desirous of producing decorative work. L'hôtel de L'Art Nouveau has remained the most active center for the propaganda of the revival now in progress. Strictly speaking, L'Art Nouveau is the creation of a new style; it is a revolt against the

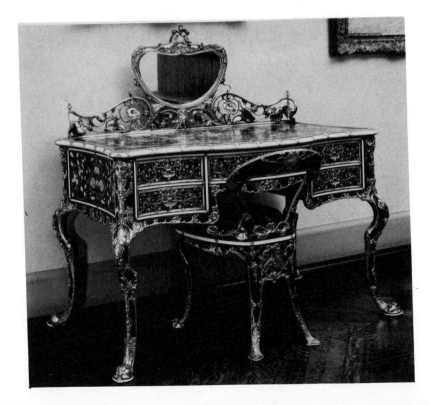

classic, which throughout the nineteenth century artists and crafts-men have seen fit to do no more than copy. It is a cry on the part of artists and artisans for the right to create something new and to give free scope to their powers of origination and to express their original ideas.

"In its fundamental aspects L'Art Nouveau is a return to nature; it is to nature that the artist must go for his inspiration in the creation of the L'Art Nouveau idea. 'Art,' it claims, 'should be nature arranged and adorned and not a mere rearrangement and readornment of some older art.' It demands 'that the novice be a thinker instead of a mere copying machine or dry book of antique details.' "

Despite the fact that Karpen was one of the few American manufacturers who attempted to popularize the French style, Edward Colonna, a naturalized American, shortly after 1900 worked with S. Bing in Paris and became one of the outstanding designers in the modern curvaceous style. Many Americans were first exposed to L'Art Nouveau at the French Pavilion installed at the St. Louis Fair of 1904. The room full of naturalistic forms

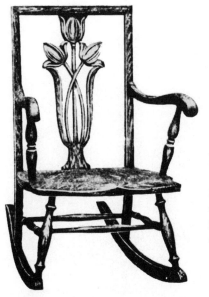

253. Illustration from trade catalogue published by the Bishop Furniture Company of Grand Rapids, Michigan. 190(?). Mass-produced American Art Nouveau furniture is only a pale shadow of the handcrafted, expensive European pieces. (The Metropolitan Museum of Art)

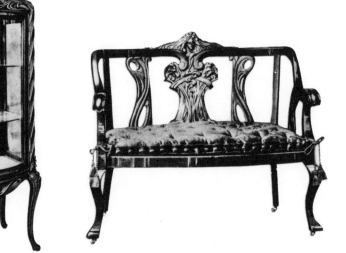

254, 255, and 256. Illustrations from a trade catalogue published by S. Karpen & Brothers Furniture Company. Chicago and New York. 1907. Though Karpen pieces still remain unidentified, their catalogue of over a thousand designs indicates that the firm was one of the leading domestic producers of furniture in the Art Nouveau style. (Henry Ford Museum)

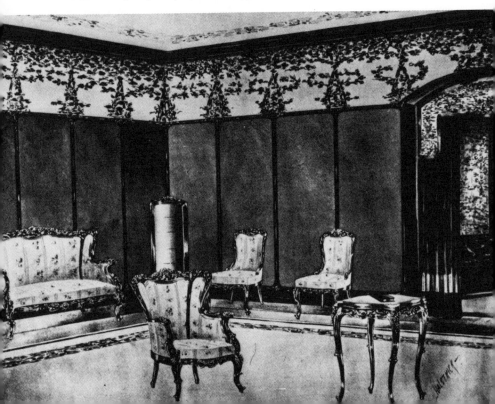

surprised and enchanted midwestern types, and one woman, stunned by the display, exclaimed, "It's beautiful, it's so beautiful that it's the most beautiful thing I've ever seen."

A much-diluted version of the Art Nouveau style emanated from Grand Rapids, Michigan, which by the opening years of the twentieth century had become one of the largest furniture manufacturing centers of the world. Countless firms like the Bishop Furniture Company Americanized the style and incorporated naturalistic carving and inlay in the designs of their mass-produced machine-made pieces. The L'Art Nouveau Parlor Rocker, figure 253, offered by Bishop in the first years of the twentieth century, was available in either quartered golden oak or mahoganized birch at $6.89 cash with order or $7.25 COD. Bishop explained, "L'Art Nouveau designs in parlor rockers are becoming very popular but on account of the expense of nice carving and select materials retail dealers are unable to handle them in large enough quantities to make the price within the reach of the person of moderate means. By making large quantities of this rocker, as well as our other designs, the price is reduced to a minimum and we can sell it at about the same price as the retail dealer has to pay for it. The material is selected for fine grain effects, and the back and arms are strongly mortised so it is just as strong as a large massive rocker. The entire surface is rubbed and polished. Retail value of rockers of similar design and equal quality $10.00."

CRAFT FURNITURE

Many English artists, furniture designers, and craftsmen, excited by the progressive ideas of Charles L. Eastlake and William Morris early in the 1880's, consciously banded together into medieval guildlike organizations. Their intention was to unite the fine and applied arts in the manufacture of furniture. The pieces they created, though of good design and fine craftsmanship, never achieved popular acceptance because of prohibitive cost.

257. Left: Plank chair. Manufactured by the Limbert Arts and Crafts Furniture Company, Grand Rapids and Holland, Michigan. Oak. 1900–1910. Height 38¼″. (Providence Art Club)

258. Above: Cover illustration from a trade catalogue of the Limbert Arts and Crafts Furniture Company, Grand Rapids and Holland, Michigan. The Limbert firm took great pride in their handcrafted furniture. (Henry Ford Museum)

One such organization, the Century Guild, was founded by the architect and designer A. H. Mackmurdo in 1882. Mackmurdo furniture frequently displays Art Nouveau design elements in the decorative painting and fine inlay work on square, angular quartered forms. In fact, Mackmurdo is credited with being the first designer to use ornament that is indisputably Art Nouveau.

English designers were very influential in the creation of the European Art Nouveau, and their furniture was exported to both the Continent and the United States. Here in America these pieces were the basis for the beginning of the Arts and Crafts movement.

The internationally famous American graphic artist Will Bradley was commissioned by Edward Bok, editor of *The Ladies' Home Journal,* to design room interiors and furnishings for his magazine. They were published with great fanfare in numerous issues during 1901 and 1902, figures 260 and 261. The furniture, generally more curvilinear in form than that of other American designers, is vaguely reminiscent of the work of the Scotsman Charles Rennie Mackintosh.

The Arts and Crafts movement attracted many American

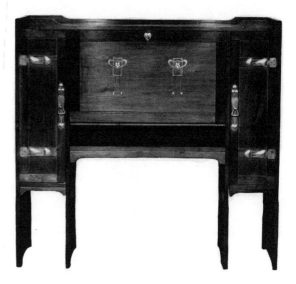

259. Desk. Designed by Maud R. Sharpe. Walnut with inlaid decoration of copper and pewter. American. 1904. Height 49″. (The Brooklyn Museum)

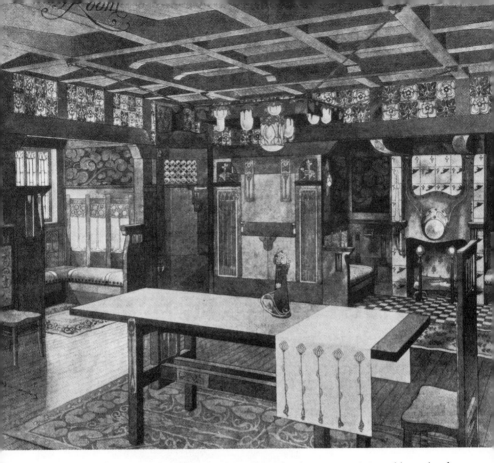

260. "A Bradley House by Will Bradley. The dining-room is in golden oak; the frieze and fireplace are in Delft-blue tiles, the seats upholstered in greenish-blue leather. The oak floor is deeper in tone than the paneling. The wall in the chimney-nook is hung in leather the color of the seats, embossed in a darker tone. From the paneled oak ceiling is hung by chains an electric light fixture in hammered iron and bronze, with opaline glass globes. The fireplace hood and andirons are in iron and bronze, and the hearth is set in greenish-blue tiles. In the smaller picture the windows looking into the bay are of stained glass. The portières are in Delft blue worked in blues, browns, greens and rose.

"The same color scheme may be carried out less expensively. In place of oak, white wood may be used, with wall-paper or stained plaster for the frieze. The small chairs and two of the tables could be used in place of those shown in the large picture. The large table could be used without benches. Having candles at each end does away with the sometimes unpleasant obstruction of a candelabra centrepiece. The benches will fit snugly under the table when not in use. The smaller of the large chairs is designed to go with the table of slot-and-pin construction. The two sideboards and large chair would naturally be out of place in this room." (The New York Public Library)

261. "The Reception or Living Room: The woodwork is of deep ivory with a dull wax finish; ceiling beams, a deep rich rose; floor, oak; frieze, a thin oil glaze in deep tones on coarse canvas; panels, clear and opalescent glass in blue-grays, greens and rose-pink; electric fixtures, gun-metal gray and bright wrought and cut steel, inset with colored glass, and enameled, with opalescent globes; rugs, blue-grays, greens, reds and yellows. The window-seat is upholstered in golden brown. The lower wall spaces of the nook are set in narrow rose-colored tiles; the upper ones show a greenish-gray ground, stenciled with bird pattern in gray. The fireplace is of rose-colored tiles and bronze repoussé copper." (The New York Public Library)

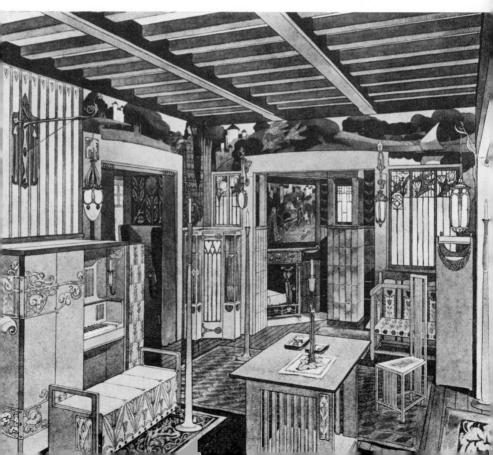

artists and craftsmen. In Providence, Rhode Island, Sydney R. Burleigh, Charles W. Stetson, John G. Aldrich, and others formed the Art Workers' Guild, and they handcrafted carved and painted furniture that they likened to medieval artifacts.

First at Grand Rapids and finally at Holland, Michigan, the Limbert Arts and Crafts Furniture Company handmade pieces using production techniques that the firm claimed had their origins in the far past: "Limbert furniture is made by the Dutch at quaint Holland in America. The evils of an ever growing cosmopolitan situation at Grand Rapids recently has caused the firm to move westward to a more picturesque and secluded location where workmen are free from the excesses of city life."

SORRENTO FURNITURE

Demonstrations of jigsaw cutting were given at the Philadelphia Centennial and, within the years that immediately followed, an

262. Illustration of a treadle-operated scroll-sawing machine taken from *Harper's New Monthly Magazine*, March 1878. This device gave faddists with an artistic bent the opportunity to "fashion all the lighter articles of household decoration and light fretwork panels for even heavy furniture." (The New York Public Library)

263. Ornamental designs from a nineteenth-century jigsaw manual. The illustration shows the first four letters of the alphabet. (Cooper-Hewitt Museum of Design, Smithsonian Institution)

endless procession of instruction manuals and pattern catalogues, such as *Sorrento and Inlaid Work* by Arthur Hope, Chicago, 1876, flooded the American market. Enthusiasts were encouraged to earn large sums of pocket money by cutting beautiful household ornaments and selling them to friends and art stores.

The craze survived the development of electrical power, and craftsmen like Alexander J. Osling (1867–1946), a German immigrant living in Waukegan, Illinois, continued to fashion fanciful pieces of furniture well into the twentieth century.

To create his unique forms, Osling traced patterns on wood and then slowly and carefully cut them out, using various-sized saw blades. Finally, the components were fitted together into highly original pieces of furniture.

FURNITURE OF HAIR, HIDE, AND HORN

"Appropriate" furnishings for a man's den during the 1880's and 1890's consisted of "trophy" pieces that could be constructed from the results of a successful hunt or that could be purchased at considerable cost in the best men's shops of both Europe and America.

The American phenomenon was essentially a response to the opening of the western lands. Ingenious craftsmen fashioned both

264, 265, and 266. Music cabinet, wall shelf, and table. All crafted by Alexander J. Osling. Mahogany, white holly, gumwood, and basswood. Waukegan, Illinois. Early twentieth century. (Henry Ford Museum)

steer and buffalo horns into fantastic pieces of useful furniture. These capricious pieces, like the organic or rustic furniture, were used not only in the most modest dwellings but were thoroughly at home in posh eastern hunting lodges and smoking dens. Abraham Lincoln and Theodore Roosevelt were both presented with gifts of horn chairs. The Philadelphia architect Frank Furness during the 1880's entertained in a smoking room furnished with horn pieces and enough "trophies to make a Nimrod's mouth water, in the shape of bear-skins, buffalo-skins, deer-skins . . . together with horns, antlers, and heads of many sorts. . . ."

Zoological decorating fads were not limited to masculine designs. A suite of horn furniture, consisting of a settee, an armchair,

267. Illustration of a giraffe hide made into a chair. Taken from the *Decorator and Furnisher*. It accompanied an article entitled "Curious and Interesting 'Fad' in Furniture" by William G. Fitzgerald. 1896. (Privately owned)

268. Right: Horn footstool. Steer horn with velvet cover. American. *Circa* 1900. Height 9″. (Henry Ford Museum)

269. Above: Horn armchair. Steer horn with leather upholstery. American. *Circa* 1900. Height 37⅛″. (Henry Ford Museum)

270. Right: Footstool. Stag legs and mohair cover. Michigan. *Circa* 1900. Height 18″. (Jeffrey Coblentz)

and a side chair, was made in Massillon, Ohio, in the 1890's and upholstered with pink floral damask, pleated and tufted, finished with braid and fringe, and fitted with delicate cloven-hoofed feet.

MISSION FURNITURE

The American Mission style probably started in 1894 when the Second Jerusalem Church was built in San Francisco, California. Lacking funds to purchase furnishings, the congregation built several chairs themselves and used these instead of the more usual pews.

Dora Martin, a decorator, noticed the pieces and mailed a model to Joseph McHugh, a New York furniture manufacturer. McHugh used fumed (smoked) ash for his first pieces, but fumed oak was the most popular material used to create furniture in this new style.

Writing in 1913, Gustav Stickley, the most influential and respected manufacturer of Mission furniture, commented, "Most of my furniture was so carefully designed and well proportioned in the first place, that even with my advanced experience I cannot improve upon it." Stickley began work on his square-cut, hand-finished oak "Craftsman" pieces in 1898, and at the furniture exposition in Grand Rapids, Michigan, in 1900 he first presented his designs to the public.

Stickley's rebellion against the Victorian "reign of marble tops and silk upholstery" was an immensely popular one, and before the demise of his "empire" in 1915, he attracted not only countless followers but also numerous imitators. In the "Craftsman" heyday, his activities were expanded to include the Craftsman Workshops near Syracuse, New York; the Craftsman Farms in New Jersey; the *Craftsman Magazine*; and the Craftsman Building in New York City, where all forms of the decorative arts were shown. This Craftsman center also contained a home-builders' exhibit, a library, and a lecture hall.

271. Left: Mission clock. Oak and brass. American. 1900–1915. Height 72″. (Henry Ford Museum)

272. Below: Illustration of a daybed. From *Quaint Furniture*, a sales catalogue published by Stickley Brothers. This oak piece was offered with Spanish morocco leather cushions. New York, 1906. (Privately owned)

273. Right: Mission sofa. Mission pieces usually had "fumed" or "weathered" finishes. Oak. American. 1900–1915. Depth 33½″. (Henry Ford Museum)

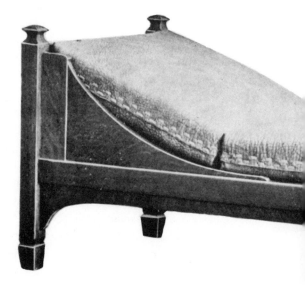

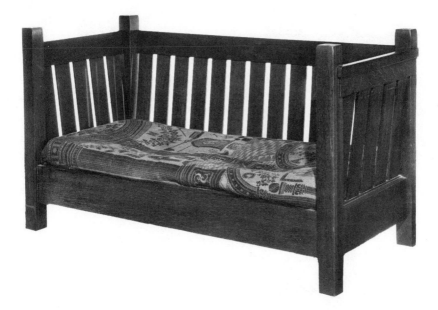

Elbert Hubbard (1856–1915), one of Stickley's most success-
ful competitors, established a "commune" at East Aurora, New
York, where young people could find "congenial employment,
opportunity for healthy recreation, meeting places, and an outlook
into the World of art and beauty." Craftsmen who worked on
The Roycrofts, a publication named after two seventeenth-century
English printers; on *The Philistine,* a second publication; and in

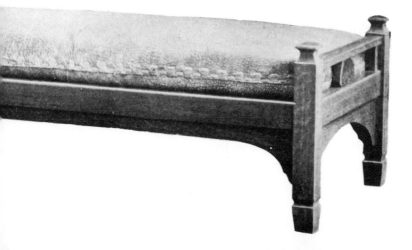

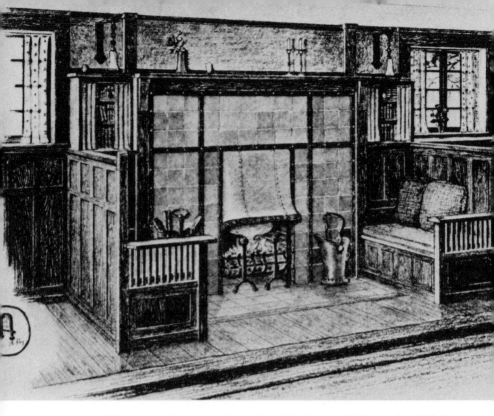

274. Illustration of an inglenook. Designed by Gustav Stickley and published in his *Craftsman Homes*. Stickley's registered trademark is evident in the lower left-hand corner of the illustration. (Henry Ford Museum)

the numerous furniture shops enjoyed the privilege of being exposed to the benevolent autocrat whose motto, "Not how cheap, but how good," disguised the fact that he was really a huckster at heart. With an eye ever toward the profit column on his monthly balance sheet, Hubbard managed to parlay his do-gooder activities with astonishing adroitness.

English manufacturers of Mission furniture called their products "quaint." The term reappears in numerous advertisements placed during the early 1900's by American department stores in *The Ladies' Home Journal* and other large circulating magazines. Bloomingdale's, the New York firm, offered in 1914 "A white

275. Side chair. Designed by the modern American architect Frank Lloyd Wright. George Niedecken, a Milwaukee cabinetmaker, is thought to have executed Wright's progressive furniture designs. Poplar. Early twentieth century. Height 42⅛". (Edgar J. Kaufman, Jr.)

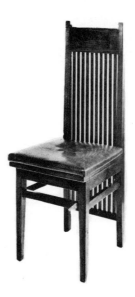

276. Mission table with a leaded glass-and-bronze Tiffany lamp and a Grueby art pottery vase. Stickley felt that Tiffany's work was totally compatible with his furniture and exhibited it in his Craftsman Building. Oak. New York. 1900–1915. Length 53¼". (Henry Ford Museum)

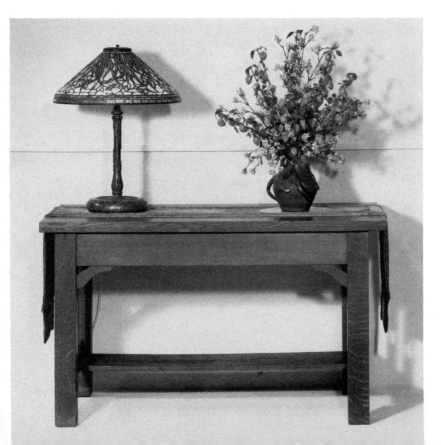

Byron n.y.
17719

277. Photograph of the studio in F. Berkley Smith's New York house. 1904. During the early years of the twentieth century, Mission furniture was used with the most ornate revivalistic pieces imaginable. The design of the fireplace is especially interesting. An Indian vase centers the mantel. (Museum of the City of New York)

enamel tea table (in the Mission style) designed for a girl's room. It is unusual and quaint."

Mission furniture represents an area of great interest to today's collectors. Much of it was handcrafted and satisfies the requirements of the purist who rebels against mass-produced furniture. It is still available in antique shops, and signed or labeled pieces are relatively inexpensive, thus making it accessible to people with only modest means. Mission furniture is timeless in style and blends successfully with contemporary pieces. Already large private collections have been formed, and museums are beginning to pay attention to these pieces, which represent one of the last examples of handcraftsmanship in America.

BIBLIOGRAPHY

ARONSON, JOSEPH. *The Encyclopedia of Furniture.* New York: Crown Publishers, Inc., 3rd edition, 1965.

Baltimore Furniture, 1760–1810. Baltimore, Md.: The Baltimore Museum of Art, 1947.

BIDDLE, JAMES. *American Art from American Collections.* New York: The Metropolitan Museum of Art, 1963.

BISHOP, ROBERT. *Centuries and Styles of the American Chair 1640–1970.* New York: E. P. Dutton & Co., Inc., 1972.

BJERKOE, ETHEL HALL. *The Cabinetmakers of America.* Garden City, N.Y.: Doubleday & Company, Inc., 1957.

BUTLER, JOSEPH T. *American Antiques 1800–1900.* New York: The Odyssey Press, 1965.

CARPENTER, RALPH E., JR. *The Arts and Crafts of Newport, Rhode Island.* Newport, R.I.: The Preservation Society of Newport County, 1954.

CHIPPENDALE, THOMAS. *The Gentleman and Cabinet-Maker's Director.* New York: Dover Publications, Inc., Reprint of the 3rd edition, 1966.

COMSTOCK, HELEN. *100 Most Beautiful Rooms in America.* New York: The Viking Press, 1958.

———. *American Furniture, Seventeenth, Eighteenth, and Nineteenth Century Styles.* New York: The Viking Press, 1962.

———. *The Looking Glass in America 1700–1825.* New York: The Viking Press, 1968.

CUMMINGS, ABBOTT LOWELL. *Rural Household Inventories 1675–1775.* Boston: The Society for the Preservation of New England Antiquities, 1964.

DAVIDSON, MARSHALL B. *Life in America.* Boston: Houghton Mifflin Company, 1951.

———. *American Heritage History of Colonial Antiques.* New York: American Heritage Publishing Co., Inc., 1967.

———. *American Heritage History of American Antiques from the Revolution to the Civil War.* New York: American Heritage Publishing Co., Inc., 1968.

———. *American Heritage History of Antiques from the Civil War to World War I.* New York: American Heritage Publishing Co., Inc., 1969.

DOWNS, JOSEPH. *Picturebook of the American Wing.* New York: The Metropolitan Museum of Art, 1946.

———. *American Furniture—Queen Anne and Chippendale Periods.* New York: The Macmillan Company, 1952.

DURANT, MARY. *American Heritage Guide to Antiques.* New York: American Heritage Publishing Co., Inc., 1970.

Early Furniture Made in New Jersey 1690–1870. Newark, N.J.: The Newark Museum, 1958.

EASTLAKE, CHARLES L. *Hints on Household Taste: in Furniture, Upholstery and Other Details.* New York: Dover Publications, Inc., Reprint, 1969.

ELDER, WILLIAM VOSS, III. *Maryland Queen Anne and Chippendale Furniture of the Eighteenth Century.* Baltimore, Md.: The Baltimore Museum of Art, 1968.

FALES, DEAN A., JR. *Essex County Furniture.* Salem, Mass.: Essex Institute, 1965.

———. *American Painted Furniture 1660–1880.* New York: E. P. Dutton & Co., Inc., 1972.

HEPPLEWHITE, GEORGE. *The Cabinet-Maker and Upholsterer's Guide.* New York: Dover Publications, Inc., Reprint, 1969.

HIPKISS, EDWIN J. *Eighteenth-Century American Arts: The M. and M. Karolik Collection.* Published for the Museum of Fine Arts, Boston. Cambridge, Mass.: Harvard University Press, 1941.

HORNOR, WILLIAM MACPHERSON, JR. *Blue Book, Philadelphia Furniture, William Penn to George Washington.* Philadelphia: Privately printed, 1935.

The John Brown House Loan Exhibition of Rhode Island Furniture. Providence, R.I.: The Rhode Island Historical Society, 1965.

KENNEY, JOHN TARRANT. *The Hitchcock Chair.* New York: Clarkson N. Potter, Inc., 1971.

KIRK, JOHN T. *Early American Furniture: How to Recognize, Buy, and Care for the Most Beautiful Pieces—High-Style, Country, Primitive, and Rustic.* New York: Alfred A. Knopf, 1970.

————. *American Chairs: Queen Anne and Chippendale.* New York: Alfred A. Knopf, 1972.

KOVEL, RALPH, and TERRY. *American Country Furniture 1780–1875.* New York: Crown Publishers, Inc., 1965.

LOCKWOOD, LUKE VINCENT. *Colonial Furniture in America.* 2 vols. New York: Charles Scribner's Sons, 1926.

MC CLELLAND, NANCY. *Duncan Phyfe and the English Regency 1795–1830.* New York: William R. Scott, Inc., 1939.

MC CLINTON, KATHARINE MORRISON. *Collecting American Victorian Antiques.* New York: Charles Scribner's Sons, 1966.

MONTGOMERY, CHARLES F. *American Furniture, The Federal Period 1785–1825.* New York: The Viking Press, Inc., 1966.

NAGEL, CHARLES. *American Furniture 1650–1850.* New York: Chanticleer Press, 1949.

NUTTING, WALLACE. *American Windsors.* Framingham and Boston, Mass.: Old America Company, 1917.

————. *Furniture of the Pilgrim Century.* Framingham, Mass.: Old America Company, 1924.

————. *Furniture Treasury.* 2 vols. New York: The Macmillan Co., 1948.

ORMSBEE, THOMAS H. *Field Guide to Early American Furniture.* Boston: Little, Brown and Company, 1951.

————. *Field Guide to American Victorian Furniture.* Boston: Little, Brown and Company, 1952.

OTTO, CELIA JACKSON. *American Furniture of the Nineteenth Century.* New York: The Viking Press, 1965.

RANDALL, RICHARD H., JR. *The Decorative Arts of New Hampshire, 1725–1825.* Manchester, N.H.: The Currier Gallery of Art, 1964.

————. *American Furniture in the Museum of Fine Arts.* Boston: Boston Museum of Fine Arts, 1965.

RICE, NORMAN S. *New York Furniture Before 1840.* Albany, N.Y.: Albany Institute of History and Art, 1962.

SACK, ALBERT. *Fine Points of Early American Furniture.* New York: Crown Publishers, Inc., 1950.

SACK, ISRAEL. *American Antiques from the Israel Sack Collection.* Washington, D.C.: Highland House Publishers, Inc., 1969.

SCHWARTZ, MARVIN D. *Country Style*. Brooklyn, N.Y.: The Brooklyn Museum, 1956.

———. *American Interiors 1675–1885*. Brooklyn, N.Y.: The Brooklyn Museum, 1968.

STILLINGER, ELIZABETH. *The* Antiques *Guide to Decorative Arts in America 1600–1875*. New York: E. P. Dutton & Co., Inc., 1972.

STONEMAN, VERNON C. *John and Thomas Seymour, Cabinetmakers in Boston 1794–1816*. Boston: Special Publications, 1959.

SWEENEY, JOHN A. H. *Winterthur Illustrated*. New York: Chanticleer Press, 1963.

TRACY, BERRY B., and GERDTS, WILLIAM H. *Classical America, 1815–1845*. Newark, N.J.: The Newark Museum, 1963.

TRACY, BERRY B.; JOHNSON, MARILYNN; SCHWARTZ, MARVIN D.; and BOORSCH, SUZANNE. *19th Century American Furniture and Other Decorative Arts*. New York: The Metropolitan Museum of Art, 1970.

WINCHESTER, ALICE. *The Antiques Book*. New York: Bonanza Books, 1950.

———. *The Antiques Treasury*. New York: E. P. Dutton & Co., Inc., 1959.

———. *Living with Antiques*. New York: E. P. Dutton & Co., Inc., 1963.

INDEX

Acanthus, 79
Adam, Robert, 103
Adam style, 103
Adams family, painting of, 133
Affleck, Thomas, 81, 86
"Age of Regionalism," see Queen Anne style
Aitken, John, 110
Aldrich, John G., 202
Allen, Charles, 85–86
Allison, Michael, 109
American Architect and Building News, The, 150
Anthony, Joseph, and Company, 110
Architecture of Country Houses, The (Downing), 134, 151, 152
Ardi, 166
Armchairs
 Art Nouveau, 194
 banister-back, 30, 31
 bentwood, 171
 Brewster, 24, 25, 26
 Carver, 25, 26
 Chippendale, 68, 69, 76, 81, 83
 Eastlake, 161
 Elizabethan, 160
 Federal, 106, 108, 119
 horn, 205, 206
 Queen Anne, 49, 50, 51, 58, 59, 61
 slat-back, 26
 Victorian, 136, 144, 169
 Windsor, 96, 98, 99
 Colonial Revival, 192
Armoire, 177

Art Nouveau furniture, 193–197, 199
Art Workers' Guild, 202
Arts and Crafts movement, 199
Arts and Decoration, 159
Ash, Gilbert, 79

Bagg, Thomas, 76
Ball feet, 36
Baltimore furniture, 111
Bamboo furniture, 165, 166
Bancker, Charles N., 109
"Bandy" legs, 43
Barnard, Hannah, 21
Barnard & Simonds Company, 191
Barnhart, John, 114
Barnum, E. T., 157, 158
Baroque style, 151
Barry, Joseph B., 114
Baudouine, Charles A., 141
Beds
 Chippendale, 75
 country (nineteenth-century), 180
 folding, 34, 35
 iron hospital, 138
 spool, 153
 Victorian (Renaissance Revival style), 148, 149
Belter, John Henry, 141, 142, 144
Benches
 garden, 158, 159
 Windsor, 99
Bentwood furniture, 171–173
Berkey & Gay Furniture Company, 148, 150

Bible, King James, design from, 21
Bible box, 18, 19
Billings, Andrew, 108, 109
Bing, S., 193, 194, 195
Bishop Furniture Company, 192, 195, 197
Blanket chests
 Pennsylvania German, 93
 pilgrim period, 17
Block-front furniture, 70–73
Bloomingdale's, 210
Bok, Edward, 199
Bombé-shaped pieces, 70
Bookcases, Gothic Revival, 136
Booth, Elijah, 90, 91
Booze, E., 157
Boston rockers, 185, 187
Boxes
 pilgrim period, 18, 19
 Shaker, 181
Bradley, Will, 199, 200
Brewin, Emma C., 145
Brewster, William, the Elder, 21, 26
Brewster chairs, 24, 25, 26
Brice House (Annapolis), 69
Bright, George, 119
Brinley, Francis, portrait of, 58
Brown, Gawen, 56
Brown, John, 95
Bulfinch, Charles, 119
Burleigh, Sydney R., 202
Burling, Thomas, 119
Burns and Trainque, 140

Cabinet, music, 204
Cabinet Dictionary, The (Sheraton), 112, 117
Cabinet-Maker and Upholsterer's Drawing Book, The (Sheraton), 99, 104, 109, 110, 169
Cabinet-Maker and Upholsterer's Guide, The (Hepplewhite), 104, 111
Cabinet Maker's Assistant, The (Hall), 130–131, 132
Cabriole legs, 40, 41, 43, 44, 46, 48, 52, 58, 60, 63, 71, 79, 144
Candlestands
 Chippendale, 74, 91, 92
 Federal period, 122
 pilgrim period, 26
 Queen Anne, 51, 52
Caning, 31, 32
Carrington De Zouche & Company, 171
Carson & Simpson, 164
Carter, William T., 164
Carved decoration, furniture with
 Chippendale, 80
 pilgrim period, 18, 43
Carver, John, 26
Carver chairs, 25, 26
Cast-iron furniture, 155–159
Centennial International Exhibition (Philadelphia, 1876), 12, 13–14
Century Guild, 199
Chairs
 Art Nouveau, 197
 balloon-back, 99
 bentwood, 173
 bow-back, 96, 99
 Brewster, 24, 25, 26
 cane, 164
 Carver, 25, 26
 cast-iron, 157
 centripetal spring, 156
 Chinese, 120
 Chippendale, 65, 68, 69, 73, 76, 78, 79, 81, 83, 85, 86, 88, 89, 90, 91
 Colonial Revival, 192
 commode, 68
 corner
 pilgrim period, 25, 26
 Queen Anne, 50, 51

Eastlake, 159, 161
 easy
 Chippendale, 65, 85, 86
 pilgrim period, 31, 32
 Queen Anne, 40, 59, 60
 "fancy," 100
 Federal style, 104, 106, 108, 110, 114, 120
 four-slat-back, 17
 garden, 157, 158
 giraffe hide, 205
 Hitchcock, 175, 176, 186, 187
 horn, 205, 206, 207
 invalid's, 157, 158
 iron folding, 138
 japanned, 112
 loop-back, 99
 "Martha Washington," 118, 119
 Mission, 207
 New York "Dutch," 49
 Old Flax Spinning Wheel, 191, 192
 pilgrim period, 17, 24, 25, 26, 28, 29, 30, 31, 32
 plank-bottom, 92, 183, 198
 "pretzel-back," 68–69
 Queen Anne, 40, 44, 45–46, 47, 48, 49, 50, 51, 58, 59, 60, 61, 89
 rocking
 arrow-back, 186, 187
 Art Nouveau, 197
 bentwood, 171
 Boston, 185, 187
 Colonial Revival period, 192
 Eastlake, 159
 Hitchcock, 186, 187
 Victorian, 143, 165
 Windsor, 186, 187
 roundabout, *see* Chairs, corner
 rustic, 167
 "Sample," 74
 Shaker, 182
 shield-back, 103
 slipper, 45–46
 "Speaker's" (Chippendale period), 86
 "stick," 99, 100
 Thonet, 173
 Victorian, 136, 139, 140, 143, 144, 154, 155, 165, 169
 wainscot, 17, 20

 Windsor, 95–100, 101, 112
 Colonial Revival, 192
 nineteenth-century, 183–187
 wire, 157, 159
 See also Armchairs; Benches; Seats; Side chairs
Chair-tables, 34, 35
Chaise lounges, Thonet, 173
Champlin, Christopher, 45–46
Chapin, Eliphalet, 67, 76, 77
Cheeseman family, 147
Chest-on-chest, Chippendale, 64, 66, 90, 91
Chest-on-chest-on-frame, Chippendale, 88
Chests
 blanket, *see* Blanket chests
 Chippendale, 71, 72
 Federal period, 116
 pilgrim period, 17, 18, 19–20, 22, 23
 Victorian (Japanese Revival style), 163
Chests-of-drawers
 Chippendale, 70
 country (nineteenth-century), 176–177
 pilgrim period, 18, 23, 33, 35
 Queen Anne period, 56, 57
 See also Highboys; Tallboys
Chickering, Jonas, 127
Chimney piece, Chippendale, 80, 81
"Chinoiserie," 40, 54, 56, 122
Chippendale, Thomas, 62, 69, 80, 81, 82, 85, 96, 120
Chippendale style, 14, 40, 45, 62–94, 117
Classical Revival movement, 103, 123
Claw-and-ball feet, 40, 46, 48, 51, 63–64, 68, 71, 74, 79, 84
Clocks
 Chippendale, 67
 Gothic Revival, 136
 iron, 138
 Mission, 208

shelf (Federal period), 108, 109
tall-case
 Empire, 128
 Queen Anne, 56, 57
 Victorian (Gothic style), 136
Codman, William, 194
Colden, C. D., 109
Colonial Revival furniture, 188–192
Colonna, Edward, 194, 195
Connecticut furniture
 Chippendale style, 75
 Queen Anne style, 42
Connelly, Henry, 110
Cook, Clarence, 188
Cottage Residences (Downing), 166
Couches
 Chinese, 151
 William and Mary period, 31, 40
 See also Daybeds; Sofas
Country furniture
 Chippendale style, 87
 nineteenth-century, 174–187
 See also Rustic furniture
Cradles
 Jacobean style, 187
 nineteenth-century, 175
 Windsor, 100, 101
Craft furniture, 197–202
"Craftsman" pieces, 207
Cromwellian furniture, 28–29
C-scroll motif, 30, 60, 83, 130
Cummings, A., 164
Cupboards
 corner
 Chippendale, 84, 92
 Colonial Revival, 190
 country (nineteenth-century), 177
 pilgrim period, 21, 22, 23, 26, 27, 28
 press, 21, 22, 23, 26, 27, 28

Davis, Alexander Jackson, 135, 136, 137, 138, 140, 166
Daybeds
 double-chair-back (Queen Anne style), 51, 52
 Mission, 208

Victorian (Turkish Frame style), 169
William and Mary style, 31, 40
 See also Couches; Sofas
Decorator and Furnisher, 205
Delft earthenware, 41
Derby, Elias Hasket, 106, 110
Desk-and-bookcase
 Chippendale, 70, 71
 Federal cylinder, 112, 113
Desk-box-on-frame, Cromwellian, 29, 30
Desks
 Chippendale, 71, 72, 76, 78, 79
 Eastlake, 161
 iron school, 138
 Shaker, 181
 slant-top (William and Mary style), 32, 33
DeWitt, John, 98
Dodge, Charles J., 167
"Dog-paw" feet, 108, 125
Downing, Andrew Jackson, 134, 151, 152, 166
Drake, Wm. H., 135, 136
Dual-purpose furniture, 35, 157
Dunlap, John, 88
Dunlap, Samuel, 121
Dunlap, William, 13
Duyckinck, Gerardus, 56

Early Classical furniture, 107
Early New England Interiors (Little), 189
Early Victorian styles, 134–173
Eastlake, Charles L., 138, 159, 160, 161, 162, 197
Eastlake furniture, 159–162, 164
Edouart, August, 147
Eglomisé decoration, 112
Egyptian motifs, 125, 145–147
Egyptian Revival furniture, 145–147
Elizabethan motifs, 18
Elizabethan Revival furniture, 151–153
Empire style, 108, 123–133
Endicott & Swett, 130, 131
Experimental furniture, 157

Fan motif, 66, 90
Federal style, 103–122
Findlay, Hugh, 114
Findlay, John, 114
Fitzgerald, William G., 205
Flax wheels, 26
Foot, Samuel A., 129
Footstools
 horn, 206
 pillar-and-scroll, 132
Franklin, Benjamin, 96, 187
"French foot," 74
Frothingham, Benjamin, 64
Furness, Frank, 205

Gadrooning, 78, 79
Gaines, John, 31
Galatian, William W., 98
Garrick, David, 85
Gautier, Andrew, 97
Gentleman and Cabinet-Maker's Director, The (Chippendale), 62, 80, 81, 96, 120
Geometric motifs, 17, 21
Gesso, 54, 57
Gillam, Charles, 22, 23
Girard, Stephen, 69, 110
Goddard, John, 45, 46, 64, 67, 70, 73
Goddard, Thomas, 75
Godey's Lady's Book, 138, 139, 157
Gorham Silver Company, 194
Gothic Revival furniture, 128, 134–140
Gould, Jay, 147
Gragg, Samuel, 101
Grant, Mrs. Anne, 48
Grant, Ulysses S., 79
"Great chairs," 20
"Great wheel," 23, 24, 26, 28
"Greek" style, 117
Grisaille decoration, 22, 23

Hagen, Ernest, 154
Haines, Ephraim, 110, 111
Hair, furniture made with, 203–207
Hall, John, 130–131, 132
Harper's New Monthly Magazine, 202
Hepplewhite, Alice, 104
Hepplewhite, George, 103–104, 111, 112
Hepplewhite furniture, 14, 103, 104, 106, 108, 111, 114, 116, 119

Herringbone pattern, 32, 42
Herter Brothers, 163, 164
Hides, furniture made with, 203–207
Highboys
 Chippendale, 64, 66, 67, 82
 Queen Anne, 41–42, 43, 46, 47, 53, 54, 56, 57.
 See also Chests-of-drawers; Tallboys
Hints on Household Taste, in Furniture, Upholstery and Other Details (Eastlake), 159, 160, 161, 162
History of the Rise and Progress of the Arts of Design in the United States (Dunlap), 13
Hitchcock and Alford, 175
Hitchcock chairs, see Chairs
Hope, Arthur, 203
Hope, Thomas, 145, 146
Horn furniture, 203–207
Horticulturist, The, 166, 168
Household Furniture and Interior Decoration (Hope), 145, 146
Hubbard, Elbert, 209–210
Hunt boards, Federal style, 114, 116

Illustrated Catalogue of the Great Exhibition, The, 156
"Indian shutters," 39
Inglenook, 210
Inlay, 32, 93, 104, 109, 112, 113, 116, 125, 194, 197, 199
Invalid's chair, see Chairs
Iron furniture, 138, 155, 157
 See also Cast-iron furniture
Irving, Washington, 140

Jackson and Graham, 160
Jacobean furniture, 16, 20, 187
Japanese Revival furniture, 162–166
Japanned furniture, 40, 54, 111, 112, 120
Jefferson, Thomas, 96, 97, 100

Jelliff, John, 140
Jemison, Mims, 179
Johnson, Edward, 16
Johnson, John Taylor, 155
Johnson, Thomas, 56

Kalm, Peter, 48
Karpen, S., and Brothers, 193, 195, 196
Kas, 22, 23
Kilian Brothers, 165
Kimbel & Cabus, 164
Kneeland and Adams, 76

Ladies Home Journal, 191, 199, 210
Lamp, Tiffany, 211
Lannuier, Charles-Honoré, 107, 108, 109, 125
Lasselles, J., 125
Late Classical furniture, 14, 129–133, 153
Late Victorian styles, 188–214
"Lawnspreads," 164
Learned, Reverend, 97
Lee, Mother Ann, 181, 182
Lehman, Benjamin, 80
Le Prince, Ringuet, 154
Lienau, Detlef, 154
Limbert Arts and Crafts Furniture Company, 202
Lincoln, Abraham, 142, 205
Lind, Jenny, 153
Lion's-paw feet, 125
Little, Arthur, 189
Logan, James, 60
Longfellow, Henry Wadsworth, 161
Looking glasses
 Chippendale, 76
 Queen Anne, 56, 57
Loomis, Samuel, 76
Loring, Joshua, 56, 57
Lothrop, Elizabeth, 44
Louis XVI Revival furniture, 153–154
Lowboys
 Chippendale, 65
 pilgrim period, 35
 Queen Anne, 43, 44
 See also Tables, dressing
Lyndhurst, 136, 137, 138, 147, 166

MacDonald, Nellie Snead, 191

Mackintosh, Charles Rennie, 199
Mackmurdo, A. H., 199
Mallard, Prudent, 144
Manwaring, Robert, 69
Marcotte, Leon, 148, 149, 154, 155
Mariner's star, 32
Marks A. F. Chair Co., 157
Marlborough legs, 73, 81, 85, 86, 88
Marot, David, 38
Martin, Dora, 207
Massachusetts furniture
 Chippendale style, 66, 68
 Federal style, 106
 Queen Anne style, 40
 See also New England furniture
McHugh, Joseph, 159, 207
McIntire, Samuel, 103, 104, 105, 106
Meeks, Joseph, & Sons, 126, 127, 130, 131
Meinecke, A., & Son, 166
Merritt, George, 136
Metal furniture, 155–159
 See also Cast-iron furniture; Iron furniture
Mirrors
 Chinese, 121
 Girandole, 124
 Ogee, 132
Mission furniture, 207–214
Morris, William, 161, 197
Morse, E., 176

Needlework pictures, 88–89
New England furniture, 104
 See also Connecticut furniture; Massachusetts furniture; Rhode Island furniture
"New England Kitchen of 1776," 12, 14
New York furniture
 Chippendale style, 77
 claw-and-ball design on, 63
 Empire style, 127
 Federal style, 107
 Queen Anne style, 46
Niedecken, George, 211
Nightstand, nineteenth-century, 174, 175
Nimura and Sato Company, 166

North, Simeon, 75
Nutting, Wallace, 189–191, 192

Oliver, Margaret, 112
Organic furniture, 166–167
Oriental motifs, 40, 48, 54, 56, 63, 120–122, 143, 162–166
Osling, Alexander, 203, 204

Pad feet, 41, 43, 44, 46, 48, 52, 58, 60
Painted decoration, furniture with
 Chippendale period, 88, 89
 nineteenth-century, 174–177
 pilgrim period, 20
Paschall, John, 51
Paulding, William, 136, 138
Pearson family, 29
Pediments, 64, 66, 67
Pegboards, Shaker, 182, 183
Pennsylvania German furniture, 92–94
Philadelphia furniture
 Chippendale style, 80
 claw-and-ball design on, 63
 Empire style, 127
 Federal style, 109
 Queen Anne style, 48, 63
Philadelphia Journeyman Cabinet and Chairmakers' Book of Prices, 110–111
Phyfe, Duncan, 104, 106, 108, 109, 117, 118, 129, 130
Piano, Chickering (Empire period), 127, 128
Piano stools, see Stools
Pie safe, 178, 180
Pilgrim styles, 14, 15–36
Pillar-and-scroll furniture, 129–133
Pimm, John, 56
Plank chairs, see Chairs, plank-bottom
Plastic blow-up furniture, 14
"Platform rockers," 165
Prince, Samuel, 79
Punderson, Prudence, 88, 89
Puritan Keeping Room, 17

Queen Anne style, 14, 38–60, 63, 66, 68, 89, 90

Quervelle, A. G., 126, 127
Quilts, Japanese, 164

Randolph, Benjamin, 74, 81, 85, 86
Rattan furniture, 164
Renaissance Revival furniture, 148–150
Renshaw, Thomas, 114
Revere-Little family (Boston), 69
Rhea, Robert and Janet, 20
Rhode Island furniture
 Chippendale style, 66, 67, 73
 claw-and-ball design on, 63–64
 Queen Anne style, 45
Richardson, Henry Hobson, 159, 161
Rocking chairs, see Chairs, rocking
Rococo motifs, 62, 64, 68, 77, 82, 153, 154
Rococo Revival furniture, 140–145
Rod-backs, 99, 100, 185
Roosevelt, Theodore, 205
Rosettes, 66, 83
Roundabout chairs, see Chairs, corner
Rustic furniture, 166–168
 See also Country furniture

St. Louis Fair (1904), 193, 195
Saunders, Philip H., 175
Savery, William, 52
Schrank, 94, 178
Sears, Roebuck, 169
Seats, garden, 138, 166
Secretary, Empire, 126, 127
Secretary-desk-and-bookcase-on-frame, Queen Anne style, 43
Seignouret, François, 144
Seltzer, Christian, 93
Settees
 cast-iron, 157
 chair-back (Federal style), 114
 Chinese, 151
 horn, 205
 Thonet, 173
 upholstered (Queen Anne style), 60, 61
 Victorian, 142, 144, 147

Windsor, 97, 99, 101
Sewing tables, see Tables
Seymour, John, 105, 106
Seymour, Thomas, 105, 106
Shaker furniture, 181–183
Sharpe, Maud R., 199
Sheboygan Chair Company, 171
Sheldon, C. B., 157
Shelf, wall, 204
Shell design, 42, 45, 46, 60, 66
Sheraton, Thomas, 99, 104, 109, 110, 112, 117, 168
Sheraton furniture, 14, 104, 108, 110–111, 112, 119
Short, Joseph, 119
Sideboards, Federal style, 104, 115
Side chairs
 caned (William and Mary style), 32
 Chippendale, 69, 73, 78, 79, 81, 88, 89, 90, 91
 Cromwellian, 28, 29
 designed by Frank Lloyd Wright, 211
 Elizabethan Revival, 153
 Federal style, 106, 110, 114
 horn, 207
 Queen Anne style, 44, 45–46, 47, 48, 49, 50, 51
 Shaker, 182
 slat-back (nineteenth-century), 180
 "spoon back" (Queen Anne style), 44
 Victorian, 139, 140, 154, 155, 165
 Windsor, 98, 99, 101
Side-runner construction, 20
Side tables, see Tables
Slipper chairs, see Chairs
Slipper feet, 46, 52
Slover and Kortright, 108
Smibert, John, 58
Smith, F. Berkley, 213
Sofas
 "camel-back," 86
 Chippendale, 86
 Eastlake, 160
 Empire, 128
 Mission, 209
 Récamier (Federal style), 117, 118
 See also Couches; Daybeds

Sorrento and Inlaid Work (Hope), 203
Sorrento furniture, 202–203
Southern furniture
 Chippendale style, 67, 83
 country (nineteenth-century), 178–179
 Federal style, 111
 Queen Anne style, 52
Southmayd family, 44
Space savers, 35, 157
Spade feet, 105, 106
"Spanish feet," 32, 36, 89
Spanish-Indian motifs, 35
"Speaker's" chair, 86
Spinning wheels, 26, 95
Spofford, Harriet Prescott, 153, 154, 161
Spool-turned decoration, 153
Springs, coil, 168–169
S-scroll motif, 30, 130
Stacey, Alfred E., 160
Stalker, John, 54, 56
Stetson, Charles W., 202
"Stick chairs," 99, 100
Stickley, Gustav, 207, 208, 209, 210
Stools, 20
 piano
 Empire, 127–128
 pillar-and-scroll, 132
 Thonet, 173
 See also Footstools
Sunflower motif, 18, 19

Tables
 breakfast (Queen Anne style), 53, 54
 card
 Chippendale, 83, 84
 Empire, 125, 126
 Federal, 105, 106, 108, 109, 116, 117
 center (Victorian style), 142
 chair-, 34, 35
 Chippendale, 65, 74, 78, 79, 80, 83, 84
 Cromwellian stretcher base, 29
 dressing
 Art Nouveau, 194
 Chippendale, 65
 pilgrim period, 35
 Queen Anne, 43, 44, 46, 47
 See also Lowboys
 drop-leaf (Queen Anne style), 48, 49, 53

Empire, 125, 126, 127
Federal, 105, 106, 112–115
foldaway, 159
gaming (Chippendale style), 78, 79
gateleg, 36
 Chippendale "spider," 79, 80
"handkerchief," 53
Hepplewhite, 111
Mission, 211, 214
mixing, 41
pedestal (Empire style), 126, 127
Pembroke (Hepplewhite), 111
pier
 Federal, 107–108
 pillar-and-scroll, 132
pilgrim period, 17, 29, 35–36
pillar-and-scroll, 132, 133
Queen Anne, 41, 43, 44, 46, 47, 48, 49, 53
sewing (Federal style), 112, 113
side (Federal style), 114, 115
Sorrento, 204
spool-turned, 153
tea (Mission style), 214
Thonet, 173
trestle, 17, 34, 35
tuckaway, 35–36
Victorian, 137, 142, 162, 165
work (Federal style), 105, 106
Tallboys, pilgrim period, 23, 33, 35
 See also Chests-of-drawers; Highboys
Tête-à-tête, rustic, 166, 167
Thonet, Michael, 173
Tieback, curtain (Victorian style), 148
Tiles
 Delft, 41, 200
 Japanese hand-painted, 164
Towelrack, spool-turned, 153
Townsend, Job, 45, 46, 67, 70, 73
Treatise of Japaning and Varnishing, A (Stalker and Parker), 54

Trotter, Daniel, 69
Trumble, Francis, 96
Trumpet turnings, 35, 49
Tulip motif, 18, 19
Turkish Frame furniture, 168–171
Turned furniture, pilgrim period, 23
"Turn-wheel," 23

Upholstering tools, German, 117, 118
Upholstery
 Chippendale period, 80, 85
 Federal period, 117
 Queen Anne period, 40, 58
 Turkish Frame style furniture and, 169–170

Van Braam Houckgeest, Andreas Everardus, 120–121
Van Rensselaer IV, Stephen, 125
Veneer, 32, 35, 41, 42, 133
"Venture" furniture, 75
Victorian styles, 14, 108
 Early, 134–173
 Late, 188–214
Vivant-Denon, Baron, 145

Walker, M., & Sons, 157
Wall, J. E., 166
Walton, Samuel, 109
Wardrobes, pilgrim period, 22, 23
Washington, George, 92, 96, 100, 109–110, 119, 121, 185
Washington, Martha, 68, 99
Washington, Mary Ball, 35
Washstand, Victorian (Gothic style), 139, 140
"What-nots," spool-turned, 153
Wilkin, Godfrey, 116
William and Mary furniture, 30–35, 40
Windsor style, 95–101
 nineteenth-century, 183–187
Wire furniture, 157–158
Wood, Robert, 157
Wood, William, 16
Wright, Frank Lloyd, 192, 211